# THE SOCIAL SCENE

**THE RALPH M. PARSONS FOUNDATION PHOTOGRAPHY COLLECTION
AT THE MUSEUM OF CONTEMPORARY ART, LOS ANGELES**

# THE SOCIAL SCENE

Max Kozloff

Emily Apter
Cornelia H. Butler
A.D. Coleman
Liz Kotz

**THE RALPH M. PARSONS FOUNDATION PHOTOGRAPHY COLLECTION
AT THE MUSEUM OF CONTEMPORARY ART, LOS ANGELES**

cover: Danny Lyon, *Untitled*, 1965
frontispiece: Lee Friedlander, *New York City*, 1965

This publication accompanies the exhibition "The Social Scene: The Ralph M. Parsons Foundation Photography Collection at The Museum of Contemporary Art, Los Angeles," organized by Cornelia H. Butler and presented at The Museum of Contemporary Art, Los Angeles, 4 June – 20 August 2000. Travels to the Palm Beach Institute of Contemporary Art, 7 October – 30 December 2000.

Editor: Stephanie Emerson
Assistant Editor: Jane Hyun
Editorial Assistant: Elizabeth Hamilton
Designer: Catherine Lorenz
Printer: Cantz, Ostfildern, Germany

ISBN: 0-914357-74-3

Printed in Germany
Distributed by RAM Publications & Distribution, Bergamot Station, 2525 Michigan Avenue, A-2, Santa Monica, CA 90404
phone: 310 453 0043  fax: 310 264 4888

Library of Congress Cataloging-in-Publication Data

Museum of Contemporary Art (Los Angeles, Calif.). Ralph M. Parsons Foundation photography collection.
     The social scene : the Ralph M. Parsons Foundation photography collection at the
     Museum of Contemporary Art, Los Angeles / essays by Max Kozloff, Cornelia H. Butler ... [et. al.].
          p. cm.
     Includes bibliographical references.
     ISBN 0-914357-74-3 (alk. paper)
     1. Photography, Artistic—Exhibitions. 2. Portrait photography—Exhibitions. 3. Documentary photography—Exhibitions.
     4. Museum of Contemporary Art (Los Angeles, Calif.).—Exhibitions.  I. Kozloff, Max. II. Butler, Cornelia H. III.
     Museum of Contemporary Art (Los Angeles, Calif.) IV. Title.

     TR645.L72 M878 2000
     779'.074794'94—dc21
99-086071

## INTRODUCTION AND ACKNOWLEDGEMENTS

Jeremy Strick, Director

Throughout MOCA's twenty-year history, photography's instrumental role in the program has been exemplified by such exhibitions as "A Forest of Signs: Art in the Crisis of Representation," "A Dialogue About Recent American and European Photography," "Sugimoto," as well as historical exhibitions in which photography has figured prominently, such as "W. Eugene Smith," and "Reconsidering the Object of Art, 1965-1975." Since the acquisition of The Ralph M. Parsons Foundation Photography Collection in 1994, selected photographs and portfolios have been used extensively in a number of MOCA's permanent collection exhibitions, integrated with contemporaneous works of painting, sculpture, video, and installation.

Shortly after the acquisition of these 2,300 photographs, an extensive installation of selections from the collection was on view in the same galleries that house the present exhibition. Entitled "Social Documentary Photography from MOCA's Permanent Collection," the installation presented a straightforward showing drawn from the major portfolios represented in the collection. This current installation provides a thematic presentation with the aims of exhibiting more work from the collection, drawing from several of the lesser-known bodies of work, and making an engaging and thoughtful presentation which resituates many of the pictures, both iconic and idiosyncratic, within a social narrative.

We are enormously grateful to The Ralph M. Parsons Foundation for generously underwriting the purchase of this significant part of MOCA's permanent collection. Longtime supporters of photography and of the educational mission of museums, the Parsons Foundation has contributed immeasurably to this institution and others by supporting the collection of photography and fostering the discourse around it. I thank all the trustees of the Parsons Foundation who enabled this partnership to happen and, for their individual commitment, Al Dorskind and Christine Sisley. We remain deeply indebted to Robert Freidus, a leading New York dealer and collector who assembled this impressive collection of photographs and whose committment contributed significantly to the reception of postwar photography. His cousin, Marc Freidus, facilitated this collection finding a home at MOCA.

Many people contributed to this first comprehensive installation of The Ralph M. Parsons Foundation Photography Collection at MOCA. Assistant Director Kathleen S. Bartels was instrumental in the negotiation of the purchase and was, from the beginning, supportive of the museum's commitment to building a photography collection. Chief Curator Paul Schimmel had the vision to solicit this collection for the museum and understands how it might function alongside the great, public photographic collections in Los Angeles and within the context of a museum of contemporary art. Associate Curator Connie Butler organized the exhibition and oversaw its publication, and envisioned the provocative thematic presentation. Curatorial Secretary Rebecca Morse contributed in myriad and invaluable ways to the successful completion of the exhibition and catalogue. As always, Senior Editor Stephanie Emerson worked tirelessly to realize this publication, with humor and intelli-

ROBERT FRANK
*Fourth of July — Jay, New York,* 1955

gence and in the face of a daunting schedule. Assistant Editor Jane Hyun and Editorial Assistant Elizabeth Hamilton were instrumental in all aspects of catalogue preparation. Also critical to the success of this publication were Catherine Lorenz, who conceived its beautiful design, and Brian Forrest, who provided photographic assistance for most reproductions in the book. Exhibitions Coordinator Stacia Payne expertly organized the travel of the exhibition and was supportive throughout. Thanks go to MOCA's entire curatorial department for their unwavering encouragement of this project.

We are indebted to MOCA's unsurpassed registrarial and installation departments for their support. Chief Registrar Robert Hollister and Associate Registrar Liz Bradley orchestrated the safe handling of the photographs. Acting Director of Exhibitions Jang Park and his staff handled all aspects of preparing the photographs for exhibition and created the beautiful installation.

Other individuals provided invaluable assistance to the realization of this project. I thank Jan Kesner, Los Angeles; Fraenkel Gallery, San Francisco; Edwynn Houk Gallery, New York; Pace/MacGill Gallery, New York; and John Pelosi, Esquire, and the Arbus Estate. Additionally, sincere thanks are due to the authors of the catalogue who graciously agreed to contribute to this publication: Emily Apter, A.D. Coleman, Liz Kotz, and Max Kozloff.

MOCA's commitment to building a photography collection would not have been realized without the support of the Board of Trustees and individual members who encouraged the purchase of such a historically important collection. We are particularly grateful to Leonard Vernon and his late wife, Marjorie. As major collectors of the history of photography and as dear friends of the museum, we honor them. Both were advocates early on of the crucial role photography might play within a museum of contemporary art, and it was partly through their vision that discussion about a major photography

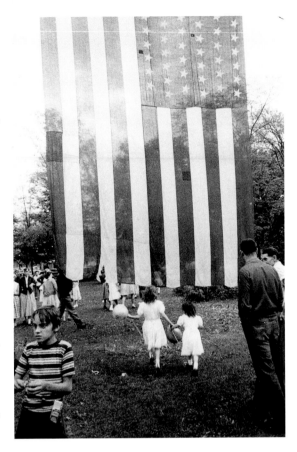

acquisition was initiated. Audrey Irmas who, with her late husband Sidney M. Irmas, built a renowned collection of photographic self-portraiture, provided initial support for the acquisition, understanding immediately its value to our growing permanent collection, and challenging the museum to grow in new directions. Her ongoing generosity allows the museum to continue its adventurous programming. President Gilbert B. Friesen, Program Liaison Lenore S. Greenberg, as well as all members of MOCA's board provide invaluable assistance and support of our exhibitions and programs.

Finally, I acknowledge the great photographers Robert Frank, Lee Friedlander, Helen Levitt, Danny Lyon, Roger Mertin, and John Pfahl, as well as the late Diane Arbus, Brassaï, and Garry Winogrand, whose seminal pictures make up The Ralph M. Parsons Foundation Photography Collection. It is their individually critical sensibilities, keen eye, and lifetime commitment to photography that has formulated an important history within twentieth-century art.

BRUCE DAVIDSON
*New York City, New York. Manhattan.*
*Spanish Harlem,* 1966
Published in *East 100th Street,* 1970

In 1966, a New York photographer, Bruce Davidson, brought his view camera into East Harlem to describe and evoke one of the city's poorest neighborhoods, East 100th Street. Before then he had photographed a teenage gang in Brooklyn, the struggles of the Civil Rights movement in the South, and the rusted industrial margins of New York. On a commercial assignment to Wales, Davidson took his camera down to the minefields, attracted by scenes, as he later said, of the "survival of the human spirit coming out of the deep caverns into the grim surroundings." As it happened, he could only photograph faces and surroundings; the "human spirit," through no fault of his own, was less visible.

After a pause, Davidson went back to East 100th Street, resuming his project there on an almost daily basis for nearly two years. Often accompanied by his fiancée, this white man mingled with the black people on the street, and for a time became something of a fixture in their street life. He gave his subjects the pictures he had made of them, with the hope—frequently successful, as it turned out—that he would be allowed to portray them inside their homes. Sometimes, he confessed, "I had to force myself to go to the block because I was afraid to break the painful barrier of their poverty."[1]

This implication of pain shuttles through the images he brought together and published in his famous book, *East 100th Street* (1970). Behind it lies a pictorial tradition, of which Aaron Siskind's 1930s campaign *Harlem Project*, and Helen Levitt's 1940s *A Way of Seeing*, are notable markers. Davidson's work, like Siskind's, is characterized by the effort to inform viewers of

a stressed people bonded in a close community. And *East 100th Street* has something of Levitt's lyric and lonely touch. But such affinities go deeper than style and setting; they are rooted in the ethnic background of these image-makers. For Siskind was and Levitt is, Jewish, and it is fair to say that recurrent attention given by Jews to blacks was, for some time before Davidson, unique among white photographers. Largely because of their own ancestral memories, even highly assimilated Jews retained a melancholy respect for the limbo of minority groups, a fact that shows up in the history of the photography of New York.

But in 1968, the city's Jews and blacks experienced a conflict over public schooling in which they traded violent ideological blows. The black governing board of Brooklyn's Ocean Hill district had transferred ten Jewish principals and teachers out of the neighborhood's schools for being "unsympathetic" to the black community. When local parents blocked the return of the teachers, who were reinstated by the Board of Education, the United Federation of Teachers called its members out on strike. Led by its president, Albert Shanker, the federation was conspicuously populated by Jews, and had earlier maintained a fine record of support for black civil rights. Only now, as it defended the principle of professional meritocracy, was it targeted by anti-Semitic broadsides that sent shock waves of fear through the Jewish middle classes, whose liberalism never fully recovered.

This strife affected the atmosphere in which *East 100th Street* was published. Leafing through the book's set-up portraits, one notes how they fluctuate in mood. Their tone is

determined on the one hand by the subjects' need to present themselves favorably, and on the other by the photographer's desire to reveal their hardship. The results Davidson obtained are an unstable blend of these two compatible, but not convergent, possibilities. People pose among their few possessions within cracked walls; occasionally, the scene is artfully ramified by mirrors that reflect figures behind or to the side of the camera. The wide-angle view seems to extend their cramped space, bare but for the presence of religious or patriotic icons and some family mementos. But for all their hard-nosed, realist style, these pictures contain an uncertain emotional content. Desolate, trash-filled alleys tell only of squalor, but in the interiors a certain social tension fails to speak its name. Instead of being at ease among themselves, the people tend to *demonstrate* their personal connection: a manner conveyed through performance rather than expressed in behavior. And this conduct suggests the sitters' reserve in the presence of a stranger, as well as it implies Davidson's distance, possibly at times a regretful distance, from them.

*East 100th Street* illustrates many features of its genre, American social documentary photography. By the 1960s, that mode had traveled far from its historical genesis in Lewis Hine's reformist mission and activist temper. Hine's example was replaced by work conceived with far more subjective motives. It is fair to say that photographers now sought to convince a public of the existence of social injustice on the basis of a sensitive individual's experience, rather than a narrative edited by the corporate media.

W. Eugene Smith's career as a *Life* magazine photographer exemplifies the conflict of one who, once employed by the media, rebels against the group-think and mercantile restraints of the corporate mold. But even after Smith left the magazine, he continued to employ the heroic stance and rhetorically compassionate approach with which he first illustrated *Life*'s pages.

*Minimata* (1971-75), his far later, dark rhapsody about the effect of mercury poisoning on a Japanese fishing village, still proposes itself as reportage suitable for a mass-media public. Using a conventional photo-essay format, Smith emphasizes the struggle between a negligent corporation and the ordinary people it has victimized, with the verdict hanging in the balance.

In the late 1960s, Smith's approach would have looked irrelevantly wholesome to younger practitioners. His Hollywood-style theatrics and implicit moral self-congratulation no longer answered to the conscience of those shamed by the Vietnam War. These younger photographers would investigate oppressions closer to home, as Danny Lyon did in Texas prisons, and Bruce Davidson did on East 100th Street. But the scenes there lacked a satisfying narrative structure and afforded no prospect of a happy ending. Instead, one had a view of whole communities locked within a social cage, the key misplaced by indifferent jailers. Here were dismal, insoluble states of affairs, examined by visitors with short-term entry who enjoyed, but did not exactly feel comfortable about, their own freedom. The pictures could be said to argue against the plight of neglected or lost souls, but exposure to this world strangely enough began to seem infectious, as if viewers themselves were incarcerated in some kind of mental prison. With sad initiative, the photographers showed us both what captivity looks like and how it feels. The title of Lyon's book, *Conversations with the Dead*, aptly conveys this frame of mind.

Documentary photography highlights the existence of social boundaries without egress for those crowded within them. Always transgressive, the genre exemplifies a move from a media culture to a shadowed social zone. And, whether officially assigned or not, that move is impelled by curiosity about people averted from notice, or caring, or exposure. The distance traveled may at times be geographically noteworthy, but it is more

significant as a "downward" passage into a minority culture or an enclave perceived as a netherworld. Far exceeding the compass of editorial illustration for magazine articles, documentary picture surveys began to appear in hard-hitting book form by the 1970s. We viewers taken into these marginal spaces were intended to engage with them as charged areas, resonant with meanings created by inhabitants, yet evidently filtered and interpreted by one of our own.

As practiced, documentary photography expands that charged atmosphere, relaying back to readers an off-limits revelation of misfortune's turf. But this effect is of course blinkered: the picture sequence might show faces and conditions, but cannot in itself (that is, without text) disclose their histories. The tribulations of impoverishment or caste are clearly discernible in these campaigns. But any sense of psychological disparity or kinship between the seen and the seers exists as no more than a tone, manifested by the artifice of the image itself. Social documentary photographers are centered by their consistent professional impulses. But in the "field" they are psychologically unanchored; they take empathetic measures to compensate for the fact that they do not share the mindset of those they depict or, defensively, they highlight their own alienation.

We think of "documentary" as a picture of conditions that are discovered by photographers rather than of scenes that are already familiar to them. When he visualized his own black community during the 1950s and 1960s, New Yorker Roy De Carava projected such warm intimacy with his subjects that we cannot think of his work as part of the documentary genre. The same goes for Larry Clark's *Tulsa* (1971), a photographic diary of life in his renegade, druggie band. De Carava's luminism may be studied, and Clark's artfulness may be offhanded; still, both have much in common with the family album. Even as they evoke dark tidings, their soft-edged work tends to read as private history. But it is

carried outward with such poetic insight that it has the conviction of reverie. By contrast, the movement of documentary photography acts as a kind of visual penetration, amplified by highly specific material detail. The picture is built up of data, through an observational mode nominally designed to inform and instruct a public. This premise is nevertheless suspended in the work itself which might, as is often hoped, lead toward melioristic attitudes or, with unwelcome effect, reinforce collective prejudices. In theory, documentary photographers do not necessarily side with the public, as if to look through its eyes. Rather, they search for the means to activate certain conclusions with which to touch the decency of a liberal audience. For all its attentiveness to "evidence," documentary photography is unhesitatingly used as an imaginative form of rhetoric, whether reportorial in style or political in its goals.

These maneuvers are rarely straightforward. Members of an in-group partake of its memories but lack a perspective on them beyond their own perimeter. Outsiders, in contrast, are likely to be detached, and they may even have an overview, but they also know themselves to be excluded from the group's self-awareness. Though social documentary photographs transmit indisputable information about a physical environment, their visual sampling is often debated by those with vested interests or cultural stakes in the cause at issue. This is normal.

An intermediary from one group assumes the right to represent others for motives whose good will, after all, may be asserted but not established, except, at best, in retrospect. So it is no wonder that uncertainty is brewed in documentary encounters that move forward on the principle of a trust that is somewhat nebulous. The picture often reflects conflicting reactions that come variously to its surface. These circumstances cannot help but invite us to ask about the decorum of the photographer's approach and

emotional tone. On the part of its subjects, for example, the occasion of the image might register a current of suspicion and a fear of exploitation. And on the part of the photographers, there may be anxiety about being accepted or guilt arising from their ability to walk away from a difficult situation. Still further, all this might be encapsulated by an aesthetic processing which, at any moment, could be gladly affirmed at the cost of human solicitude, or the feelings of those portrayed. Sometimes, too, the impact of the documentary picture derives from an unintended outcome: our regret for its coercions, or our knowledge that a worse fate than the one depicted is in store for its subjects.

To gain an idea of the intensity of this negotiated contact in social documentary, one needs only to compare it with the practice of street photography, where the abrupt configuring of faces, gestures, and surroundings is a product of bodies in independent movement. Garry Winogrand's whole career, for instance, is predicated on this undiplomatic mode of address. There may well be an element of cultural tension and even shock wrested out from the chaos by his roving eye. But as it is transmitted in a glimpse, it lacks the intractable, weighted purpose of the documentary campaign. That purpose is effected through protocols of consent and appointments in time; it uses a discursive form that imbues the proceedings with the portents of a story.

To be sure, some documentary picture-makers employ the piecemeal, buoyant glimpse of the street shooter as a camouflage for what is really a sustained scrutiny. In her book *Falkland Road* (1981), Mary Ellen Mark seems to move among Bombay's prostitutes in the guise of an invisible witness. So, too, does Eugene Richards, in his *Cocaine Blue, Cocaine True* (1994), an account of drug addiction in Brooklyn and Philadelphia. Generally, no more of a scene is afforded than what would be available to an actor pressured by its urgencies at any undetermined moment. The

photographer, the one frequently thought to be the agent or the alter ego of the viewer, operates as a participant tossed about in what occurs. Formal documentary seems to tread into, and bring a self-conscious halt to, activities. By contrast, a seemingly potluck documentary appears merely to slip into happenings with a random aim. Of course, such an apparent forfeiture of leverage and control is a device, a means to figuratively immerse us in events as they unfold. You ask how the photographer gained such startling access, and how the subjects condoned this point-blank witness to actions they had every reason to keep hidden. Such artificial companionship displayed by the photograph resembles the scenography of movies, which represent people conducting themselves as if they were not aware of being observed by a camera. From Robert Frank and W. Eugene Smith, through the films of John Cassavetes and *cinéma vérité*, and on to Richards and Nan Goldin, this tradition maintains itself.

An emphasis on the unguarded moment is testimony of a voyeuristic method. None of its practitioners would deny that the documentary genre is permeated by a kind of keyhole mentality. But there is a difference between a situation where subjects have consciously lowered their defenses and one where they are truly spied upon. While surely a moral difference, it can not be calibrated until the observers' personal and professional interests are appraised within the environment of the intended viewers' cultural values. Further, there is always the issue of the instrumental function of the imagery. We do not judge the work of an anthropologist, a news photographer, or a paparazzo—all of them recognized voyeurs—by one standard. A photographer's violation of a political dissident's right to privacy is objectionable; the invasion of a celebrity's, less so; and a wrongdoer's, least.

Donna Ferrato took some famous, nonconsensual, yet valuable photographs of a

husband battering his wife in the privacy of their bathroom (published in *Living with the Enemy*, 1991). The fact that Ferrato was on an assignment (for Japanese *Playboy*) to celebrate the couple's high-end lifestyle betrays the often fortuitous element in photographic documentary. Workers who employ a snapshot approach know that it is impossible to prepare for a key moment; they can only be ready with quick reflexes for the instant a situation presents itself.

Insisting upon a candid perspective, *The New York Times* demands that its photographers neither pay nor set up their subjects. It is not just that spontaneous behavior seems to underwrite news value, but that it appears to authenticate the impression that an event is news. But in the era of photo-ops and hyperactive publicity, people more often tend to collude with media attention, whether foolishly or wisely, rather than merely tolerate it. (Before the 1960s, subjects were relatively innocent about the intrusive lens; thereafter, their consent to be photographed was determined by more knowing and sometimes complex attitudes.) Documentary photography, in any event, can partake just as much in the hasty opportunism of reportage as in the poise of formal portraiture. These styles exist as very different, interchangeable tools with which to define a set of phenomena that recur as variations on the theme of grief. For in the end, documentary sets itself apart from other genres less by its methods than by its will to search deeply into the shortcomings of society vis-à-vis the misfortunes of others.

When an artistic impulse reinforces supposedly investigative work, the effect can be simultaneously moving and abrasive. Viewers who expect the picture to be "about," say, the predicament of a group, are accustomed to the presumed selflessness of the pictorial exposition. It mattered very little to the public that Walker Evans's selflessness was infused with his artistic sensibility; it was the transparent style of his images that

counted. But Diane Arbus's style called attention to her own personal responses as an artistic phenomenon—an art designed not so much to investigate as to illuminate. As it re-circuits description into an imaginative world, the artistic motive of Arbus's work also transforms the misfortune of its subjects into a ferocious presence. The result is something more than a report, yet less than documentation.

Consider one of Arbus's best-known pictures, *A Jewish giant at home with his parents in the Bronx, N.Y.* (1970). To call this a normal family picture would be about as accurate as regarding Richard Avedon's famous photograph of the Dior-clad model Dovima with the elephants of the Cirque d'Hiver (1955) as a simple society portrait. Though the effect of both of these images relies on gross disparities in the size of their protagonists, the fashion shot is only a mimicry of physical danger (the elephants are tethered), whereas the Bronx apartment truly radiates with psychic turmoil. You can sense it in the confrontation between the parents and the colossus who is their son, shown within their own living room, but as if from opposite worlds. They regard each other across the divide of his incurable and monstrous disease at a moment of reckoning, which Arbus so blazons with flash and distends with wide angle as to make the image look like a crime scene. The parents are reduced to helpless, circumspect dolls; the disheveled, bent, and crippled son is turned into an alien.

For its theatrical—and candid—exposure of debility, this image can hardly be matched. But on 23 September 1999, *The New York Times* published an anonymous photograph which, from now on, must act as its gentle pendant. It depicts that same father adjusting the tie of that same son, Eddie Carmel, in an apparently robust state nine years before the Arbus image. The handsome young man, dressed in a natty sport jacket, stands tall. Both he and, by comparison, his diminutive dad, are smiling proudly as they rehearse the

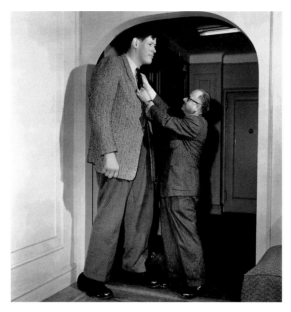

ritual of a young boy being readied for appearance in society. This picture appears good-natured in the manner of a Norman Rockwell anecdote. But despite, or maybe even because of, its clichéd character, it remains a heartbreaking scene.

Were it just of a juvenile receiving his father's attention, the photograph would most likely have delivered only its intended, and forgettable, meaning. Instead, we have a power-ful-looking adult who belies, not the affection of the moment, but its normalcy. At first, one might imagine that the euphemistic address of the image is tripped up by the physical problem, the agromegaly, it records, until one sees that the "problem" is the real subject, treated by those concerned with great honorableness and sweet acceptance. Of course, this is an inside view, which the family members give of themselves.

Arbus, the outsider, will have none of this cherished relationship and its delicacy. She arranges symbolic gestures so as to emphasize that the son is a spectacle to his parents, and the three of them a spectacle to her, the photographer, who has somehow gained entrance. A documentary premise still functions in this tableau, but any implication that it should transmit a caring attitude has been stripped away. In this stripping process, Arbus announces her realist stance far more than her material descriptions. The charade in which she has these subjects pose is intended to

expose a "truth" about deformity—that it transfix-es those close to it as well as those removed from it. Eddie Carmel's parents are represented evidently as if they are "our" stand-ins, but the photographer also depicts them as trapped in their own nightmare. The effort Arbus takes to drive home this vision is animated neither by judgment nor malice, but by fascination. Eddie Carmel, having his tie arranged, is an image of incipient pathos; Eddie, unshaved, bedraggled, and misshapen, is an occasion for terror. Arbus took the documentary mode and, with the clearest of insights, made it terrible. This was no longer news in any conventional sense; it was new and steely art.

During the 1970s, there occurred a number of political events and social changes that drastically affected photography and, reciprocally, were *influenced* by photography. One of these was the belated discovery of the medium as the dominant form of visual communication in the twentieth century. By mid-decade, it would have been possible to acknowledge that the modern age could chiefly be understood as a pictorial one. A strange scene evolved, rent simultaneously with complaints that we were over-saturated with promotional photographic images (abetted, of course, by TV), and also by excitement over the obvious fact that the effects of those images, in their unfathomed depths, were yet to be analyzed. On one hand, there developed moral disapproval of the society of the spectacle and, on the other, the advent of scholarly media studies.

A history of that period in photography cannot exactly trace a decline in documentary activism. However, historians can show that many new and immensely talented documentary photographers took possession of an artistic self-consciousness. In the work of Larry Fink, origi-

Issac and Eddie Carmel, New York,
1 July 1961. Published in *The New York Times*,
23 September 1999

nally employed as a photographer for social reform projects, and of Rosalind Solomon, whose background is upper-middle-class and advantaged, a decided aestheticism asserts itself. Their development of a theatrical, flash-lit style, lurid and yet cold, owed a lot to the example of Weegee and Lisette Model, amplified by Diane Arbus. Like Arbus, both Fink and Solomon wielded a medium-format camera with the virtuosity of the much smaller 35-millimeter; yet they each achieved an informational layering characteristic of the larger view cameras. Fink's forays into black-tie social clubs, gallery openings, and balls are often suffused with caricature. For her part, Solomon traveled in the Third World, where she found an Andean peasant woman breast-feeding a lamb, and everywhere people gripped by the intoxication of archaic rituals, their eyes glistening from within dark recesses.

A viewer quickly learns better than to look for sympathy in these dazzling *tableaux vivants*. Every person and thing that Fink frames has such a baroque, sensuous presence that he can even bring off New York soirees as primal dramas. In contrast, his images of a coarse, working-class family in Martinsville, Pennsylvania, are composed with a debonair elegance. With pictures like these, the sheer animal magnetism of the actors blots out the thought that they could have been regarded with an old-time aim to raise a public's consciousness. Regardless of the social class or ethnic origin of their subjects, these documentarians produce work in which an indiscriminate glamour has settled.

If this was the least probable outcome of a documentary impulse, it was the first and most likely to have offended students of media. Pictures that appeared to sharpen what were already hard social cases could only be judged abusive in outlook. We do not hear that the photographers plead guilty to charges of exploitation, or that subjects felt exploited. No matter. It was the assertion of unwonted power that offended—the

surveillance and supposed indignity inflicted upon the impoverished by the privileged of the world.

This argument is reinforced by the evidently sensational motive inherent in the photographs themselves, built as they are upon a charisma evoked through voluptuous embodiment. Figures swim in an artificial luminism that is freely created through the camera—not as a celebration of its subjects, or an exhibition of class animus, but as an attribute of imaginative and amoral art. What we find in these pictures is the inappropriate but deliberate application of paparazzo or illustrational styles to social documentary, a mode of genre crossover prevalent in art of the 1970s. Irving Penn could photograph New Guineans with an anthropologist's approach in order to profile a fashion content. Intending to visualize people of other cultures only as picturesque still-life, he truly objectified them through his process. In contrast, Larry Fink and Rosalind Solomon are photographers of action. They retain the roving, transgressive spirit and charged atmosphere of documentary, but dispense with its inquisitive rationale. In their work we are made witnesses to a kind of homeless documentary, steeped in its own effects.

Throughout the 1970s, there rose up a volatile public sensitivity to images, especially their sometimes prejudicial social implications. A viewer's or a subject's reality was recognized as likely to be very different from the artist's. Feminism and multi-culturalism reexamined and stigmatized the perpetration of sexist, patriarchal, homophobic, and ethnic stereotypes. Discriminations rampant in public statement, which had long been endured in silent anger, were openly protested, and their authority, the unreflective authority of popular discourse and media, was questioned. Such welcome currents of outrage not only fostered the artistic energy and confidence of disenfranchised groups, they also heated the atmosphere for those who practiced social documentary.

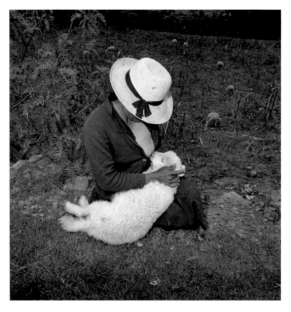

But the decade had still more complications to offer image cultures. Here was an era stained during its middle years by the Watergate scandal and marked at its very end by the ascension of a movie actor to the presidency. These events helped to raise the simmering level of mistrust for official statement and the communications empire to something of a boil. Among academics and intellectuals, photography's claims to objective report and truthful witness were treated with wholesale derision. At the same time, photographic history was now regarded, most critically, as an archive of repressive controls in police dossiers, paternalistic institutions, and surveillance systems. These putdowns were at loggerheads with each other. One cannot assert that institutional controls of photography were effective as material identification if one affirms that photographers, by the very nature of the work they do, are traffickers in falsehoods. Critique of the medium during the 1970s and 1980s was fraught with ideological conflicts. As these conflicts struggled to define themselves, we lost sight of much of the ambiguity in the pictures themselves, and of our unpredictable responses to them.

To be sure, social documentary often raises disturbing issues because it employs competitive ideological programs. The images themselves are projected outward and necessarily flutter into mixed constituencies. But photographs do not record programs; they describe material conditions from the viewpoint of an imperfect witness. If that witness places a high value on personal subjectivity, he or she introduces an "unreliable" element that tends to move outside the nominal control of corporate management. One image-maker's belief may not challenge such management, but it is not necessarily amenable to it, either. Photographic documentary is a complex of tensions between the subjective and reportorial poles of worldly testimony. The existence and endurance of the best Magnum photojournalists, a Susan Meiselas, or a Gilles Peress, reflects these tensions, raised to a notable pitch.

Meanwhile, there are tensions within the public, too. For instance, one cannot predict that an interest group will react unanimously when a protest is lodged by one or more of its members against a photographic representation. Identity politics in the 1970s and even the 1980s had mistakenly assumed that cultural identities were monolithic. But minorities do not vote *en bloc* for or against the same issues; they do not have uniform attitudes or self-images. Cultural critics—outsiders, after all—often supposed that a group needed apology for an offending image, even when the group did not indicate that an offence was given. A community's wounded pride should be taken seriously, but so should its material and social damages, or simply its flawed reality. Documentary photography threads its way between these two considerations, as if negotiating a minefield. Given such circumstances, the genre is always at fault, yet can potentially be of service.

However, over time artful motive, at least the kind that intruded itself, came to be seen as an enemy of service. It was too late, of course, to insist upon any purity of photographic objective,

ROSALIND SOLOMON
*Catalina Valentin's Lamb, Ancash, Peru,* 1981
Courtesy of the artist

or visual strategy. And it was too much to expect from photographers, indebted to a system for their livelihood, that they should be unconditionally resistant to it. Ever since John Grierson, who coined the phrase "documentary" in reference to 1920s films of social reportage, the practice had stressed interpretive feeling as much as respect for fact. Grierson demanded both, and the best of those who followed him understood their mission as a composite, a double responsibility, always to be visualized under risky and shifting conditions. By the mid-1970s, though, one saw a tendency that moved away not only from artful fascination with the "other," but from the implication that feeling—subjectivity, itself—was part of the documentary project.

At first sight, it seemed odd that The Museum of Modern Art (MOMA) in New York should take the lead in sponsoring this tendency. MOMA, through its Director of Photography, John Szarkowski, previously backed Garry Winogrand, showcased Arbus, supported Davidson, and later exhibited Fink and Solomon. The museum performed as a significant advocate for emotionally involved documentary photographers. But in 1976 it focused on a virtually unknown photographer, William Eggleston, as the herald of a new and very different color documentary. Eggleston, a Southerner, worked in a vernacular idiom similar to that of postcards, realtor's bulletin boards, and family snapshots. His flat, bland scenes around Memphis and the Mississippi country revealed the South as a landscape of vagrant and casual tints. People seldom appeared in these vistas, and when they did, they had no more than walk-on roles. Through Eggleston and Stephen Shore, a like-minded, though more formal pastoralist, we were given a view of American culture through an inventory of its nondescript artifacts—its gas stations, backyards, featureless suburbs, strips, and auto dumps. Such images promoted the factual emphasis of documentary tradition, but

they did not truck with charged atmosphere, and they were not likely to raise the hackles of minority groups. One would search in vain for the slightest spark of transgression in this work. For it was the dingbat culture at large that Eggleston and Shore took for their subject: a thing finished, public, and common. If this was a netherworld, it was one we all shared.

True vernacular documentary, of course, had long been recognized as a storage area of occasional marvels that could be scavenged by curators with a Surrealist eye. Released from institutional archives and bereft of their original context and function, hack images from insurance company files or consumer tests could blaze with real enigma. Their impact was recovered in a key book of the period, Larry Sultan and Mike Mandel's *Evidence* (1977).

But MOMA looked upon Eggleston's pictures as artistic phenomena that could be traced back in the general development of American photography to Walker Evans and, behind him, to Eugène Atget, the architectural documentarian of early twentieth-century Paris. Both of these artists were involved with the semiotic textures in their field of operations. At the same time, the Depression of the one, and the Paris of the other, were evoked with poignant light as cultures that had tragic import. Evans and Atget transformed the ordinary into the exceptional through a strange poetic resource, for they sensed the passage of time as a fatal influence upon the *vanitas* of their environment.

There would be trouble in legitimating Eggleston, if such was the goal, as a worker in this line. Atget and Evans had a consciousness that identified with high culture, but they chose to work in a taciturn and plain style. Eggleston had no such association; he could describe the everyday, but he had no emotional response to it. One could say that the contemporary material provided him no such outlet, but it is more accurate to note that his aesthetic required a

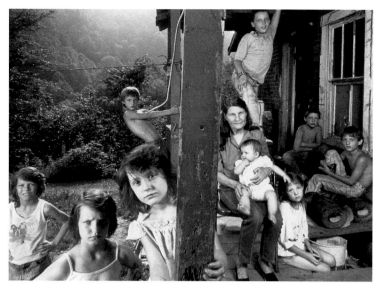

particular disengagement. This remoteness was not to be confused with an objective stance. On the contrary, Eggleston's reduced visual vocabulary was in some respects akin to art-world minimalism, a slack mode of looking which enjoys prestige in photographic aesthetics right through today. It is really an art style that colonizes the documentary approach, though with just enough presence to offer, by contrast, some insight into the vicissitudes of documentary as itself, a cultural expression.

There could be no doubt that by the 1980s, documentary photographers had developed a sensibility that seemed to over-qualify them as reporters. Yet this sensibility lacked appeal for the clientele of conceptual photography in the gallery world. As image-makers, they had frequently overstepped the mandate established for them by media standards. At the same time, they produced work that was too discomforting and political to be put up on the living room wall. Museums did not feel at ease with it, foundations saw no compelling reason to fund it, and publishers expected little from its market. Yet documentary imagery still trickled out in books, proving that, while the genre eluded categorization, it was difficult to ignore.

Documentary photography's intransigence, its habit of touching nerves, keeps it alive. Such was Chauncey Hare's *Interior America* (1978), a study which morphed the state of the

fallen industrial proletariat of its day into a nightmare—where Evans had once studied it in an elegiac mood. Hare crossed Evans-like subject matter with Arbus's style to produce not a lament, but an indictment of powerlessness. Sometimes, too, a book appeared with vapid imagery, but with insinuating texts and an inflammatory theme. One thinks of Bill Owens's early *Suburbia* (1973), or Jim Goldberg's work on San Francisco's *Rich and Poor* (1985). Credit of a sort should be given to these manipulative albums for unsettling the complacency of American class consciousness by expedient means, fair or foul.

Throughout the 1980s and 1990s, social documentary bodies of work could be aligned with each other by their conscious stylistic choices, which echoed each other through a coherent tradition. As that tradition defined itself, style's relationship to documentary became more pronounced. Style serves the purposes of fantasy, hypothesis, narrative, and enigma—deliberately unresolved states that are imaginatively proposed rather than discovered. So, for example, Shelby Lee Adams could orchestrate seemingly classic Farm Security Administration subject matter from the 1930s, the country folk in Harlan County, Kentucky, into the protagonists of a Southern Gothic fable (*Appalachian Portraits*, 1993). The historical time had passed when a photographer would have felt impelled to plead their cause. Adams, rather, portrays extended families who sit on wooden porches or within bareboard rooms as the survivors of an ingrown and ruined folklore. The havoc of mental and physical disease flickers across their smiling faces. Yet, never had privation been portrayed with such luxuriance and finesse, aided by symphonic lighting and virtuoso grouping. A long distance had been traveled from the moral uncertainties of Bruce Davidson's *East*

SHELBY LEE ADAMS
*Leddie with Children*, 1990
Published in *Appalachian Portraits*, 1993

*100th Street* to the tang and confidence of this Appalachian portfolio. But Adams still leaves you disoriented and in an emotional lurch. He describes and even dramatizes his scenes with unsparing detail, then makes sure to modulate them with caressing tones. Somewhere, he crosses the line between *paying* attention to the pathos before his eyes (eyes which look back), and *calling* attention to the devices of his style. The result is inconclusive yet calculated: an artistic dissonance. More and more, documentary photographers of interesting ambition courted the risk of this dissonance.

A vital contradiction, inherent in the genre, energizes our contacts with documentary photography. Often, theorists posture from a safe distance about social injustice, but do little in real life to redress it. In contrast, photographers have gone, and still go, into harrowing scenes or harm's way to record serious problems. Their imaginative capacities vary, but in a bodily sense, they are active witnesses who bring back hard evidence. Still, viewers are not literally involved in the predicament of subjects—they are engaged with a picture. And that picture may have qualities of its own which may be admirable or give pleasure. The sum of these qualities could be a kind of beauty. If charged atmospheres and voyeuristic motives may be extended by pictorial beauty, when a photograph opens us unforgettably to the lives of others, it might radiate a moral beauty. The impression it makes, then, may be described as elegiac—a pictorial evocation of scenes to which, as Arthur Danto remarks, "the natural response is sorrow." The contradiction in the documentary mode is its potential to oscillate between two very different outcomes: a sense of urgency and a veil of sorrow.

What function does social documentary perform right now, in the entertainment and digital communications environments that have evolved frantically within the last fifteen years? An answer gradually suggests itself. The edgy witness of documentary slows down perceptions that have become too feverish and distracted, and its insights uncover the psychic travails, not just the physical hardships, that human beings suffer. With an eloquence found no where else in its medium, social documentary offers a weighted counterexample to all those exciting or indifferent but lightsome visual inputs that just whiz by. It asks that its subjects not be forgotten, and it develops the pictorial means to support and make vivid their memory. For in the end, the documentary mode is not to be relegated to history—it makes history.

Note
1. Bruce Davidson, *Bruce Davidson Photographs* (New York: Agrinde Publications, Ltd., 1978), 13.

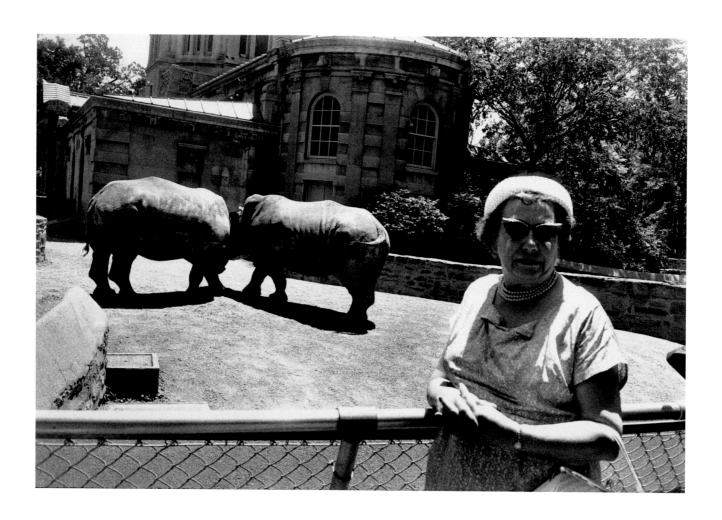

GARRY WINOGRAND
*Untitled*, 1963

In their pursuit of images of a troubled 1960s America, Diane Arbus and Garry Winogrand perhaps represent opposite poles of post-New York School documentary aesthetics. Both photographic projects emerged in the late 1950s, at a moment when older models of liberal social documentary had ceased to function amidst the enormous social upheavals of the post-World War II era, and as a once-thriving "picture magazine" culture found itself challenged by television and changing audiences.

While earlier photographers of social dysfunction and decay, from Jacob Riis to Walker Evans, were implicated in a modernist fascination with marginality, they nonetheless sublimated this gaze to an avowedly reformist project, presenting their damaged subjects as potential objects of governmental aid and charitable concern.[1] By the 1960s, however, the camera itself became, in Arbus's words, "a kind of license" to look, as a newly liberalized photojournalism increasingly sought out social margins, and once dissident forms of photographic modernism encountered the changing conditions of an expanding media culture. If Arbus's emotionally confrontational work pushes to extremes the inherent power ambivalence and subjective discomfort so often repressed in earlier documentary photography, performing a kind of "stress test" on the photographic encounter, Winogrand's chaotic urban images perpetually press the limits of what kinds of visual information can be contained within the photographic frame, performing a related test on pictorial models.

Arbus, as we know, focused on the portrait: on the individual, or often the couple or family. Her groupings were bound by a certain implied intimacy or connection—a structure reinforced by the occasional exception, such as the *Two girls in matching bathing suits, Coney Island, N.Y.*, from 1967, which depicts the pair side-by-side in their matching striped bikinis. In Arbus's 1972 Aperture monograph, groups appear in the final section (devoted to mentally handicapped patients photographed at Longwood, N.J.), that evoke a different kind of shared condition. Carefully posed and framed in nearly-archaic modes of formal frontal portraiture, generally isolated from any setting (except for certain domestic interiors, which themselves function as extensions of those portrayed), Arbus presents these as distinct individuals, unique subjects with a history, a complex interiority, an inner life.

And indeed, the images' effect rests on our capacities for identification with the subjects—our speculation about their lives and feelings, our awareness of the possible incongruities between how we see them and how they may see themselves. Commentaries on Arbus, both sympathetic and critical, are full of stories about her encounters with her subjects: her pursuit of them, relationships with them, identification or fascination with them. For all the criticism of Arbus's voyeurism or exploitation, hers nonetheless appears as a deeply humanist project, one recording the contact between photographer and human subjects in all its problematic intimacy, complexity and potential danger.

Winogrand, the inheritor of the twentieth-century project of "street photography," restlessly documented the chance encounters and

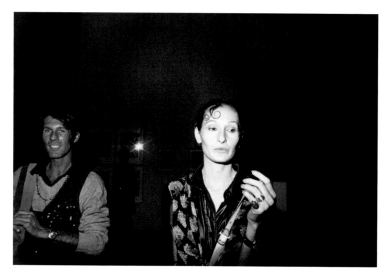

groupings of the public urban scene. Where couples and occasionally families crop up, they always appear amidst the crowd, the social landscape. After the early portraits of boxers and performers, relatively few solo subjects appear in Winogrand's published work: in separate images from *The Animals* (1969), an older woman wearing sunglasses stands in front of two rhinoceroses, and an anonymous male worker cleans the window on an aquarium holding two enormous white whales. In other 1960s shots, a man stares out of an airport phone booth, and various young women stand in front of store windows or stride across city streets—all subjects momentarily isolated against urban or suburban surroundings. From all accounts, Winogrand shot them on the fly, rapidly, quasi-instinctively. He did not know these people nor, most likely, even speak to them. The resulting images are famously "casual" in their framing and presentation—distorted by the wide-angle lens, often tilted and off-center. The people portrayed may occasionally be solitary figures, but they are not "individuals," their pictures not "portraits." While Winogrand's titles share a generic quality with Arbus's (and most modernist documentary, with its claim to neutral recording of "facts"), they note places or occasions: London, New York, Hard Hat Rally, Central Park—situations, not subjects.

When we look at Winogrand's images, what we see are precisely these "situations"— chance configurations, architectural and social,

which both stage and dominate the people in them: people who are "subjects" mostly in the sense of being "subjected to," "subjected by." Everything seems to bear down on and confine them: the street, the light, the frame, other people. Yet we enjoy looking at them, perhaps speculating about how they came to be where they are, doing what they're doing: Why is that woman with the ice-cream cone (*New York City*, 1968) laughing? Is the young demonstrator with blood streaming down his face (*Demonstration Outside Madison Square Garden, 1968*, 1968) badly hurt? While we could stop to dissect Winogrand's endless young women with Arbus's eye for "the gap between intention and effect" in personal self-presentation, noting their visible bra lines, occasional bulges, and now-dated 1960s coifs and attire, to do so would clearly go against the grain of the images—Winogrand's title *Women are Beautiful* (1975) does not appear to be ironic. To adopt Roland Barthes's model of photography as an object of three "practices"—to do (the photographer), to undergo (the subject), and to look (the spectator)—these images would seem to position both spectator and photographer as detached viewers taking in the photographic scene, rather than addressing us as potential subjects or eliciting our troubled identifications with those on view.[2] It's the 1960s, and certain shifts in style of dress and social display are presented to largely comic effect, yet a strange vulnerability ensues.

In a 1977 interview with Charles Hagen, Winogrand dismissed the rhetoric of those photographers, like Arbus, who claimed to reveal truths based on risk-taking encounters and carefully-developed "intimacy" with their photographic subjects, countering that "they're really talking about their own comfort." Instead, he contentiously asserts, "I have never seen a photo-

GARRY WINOGRAND
*Untitled*, c. 1969

graph from which I could tell how long the photographer was there, how well he knew it." Regarding Arbus, Winogrand challenges, "How do you know from the photographs—forget all the rhetoric—from the photographs, that she didn't rush in an make 'em, bang, and rush out like a thief?"[3] And indeed, the only explicit "danger" Winogrand reports while taking photographs was a serious injury he incurred while photographing a football game from the sidelines, when he was accidentally hit by three charging players—an anecdote echoing, in now ludicrous form, the once-heroic documentary ethos that "the best images come from situations of physical risk."

Instead, Winogrand poses his photographic risks as mostly formal, pictorial: "testing what's possible within the frame," finding places where "the content is on the verge of overwhelming the form." His only criteria (echoing that of Donald Judd) is that an image be "interesting." Thus, in deciding what to print, "if it looks interesting, I look at the contacts: hopefully, if all is going well, looking at the contacts is a similar kind of adventure as shooting is."[4]

It would be easy to attribute these strategic differences to certain all-too-familiar dichotomies of gender: Arbus, the vulnerable, risk-taking, and ambivalently "liberated" female artist, whose own sense of marginality is empathetically enacted in her culturally transgressive identifications with transvestites, "freaks," and other socially marginal figures; Winogrand, the physically imposing, macho adventurer charging into crowds to snap images, aggressively pursuing attractive women on city streets to produce almost textbook examples of sexist "objectification." And indeed, such accounts appear with unsurprising frequency in the critical commentary on their work.

And yet, there is enormous aggression in Arbus's work, and an enormous pathos in Winogrand's. Norman Mailer is said to have protested that "giving a camera to Diane Arbus is like putting a live grenade in the hands of a child."[5] According to the limited accounts we have from her more well-known portrait subjects (such as those recounted by Germaine Greer and Ti Grace Atkinson in Patricia Bosworth's *Diane Arbus: A Biography*), Arbus was capable of using harassment and deceit, as well as her famously disarming charm, to get the pictures she wanted.[6] But even without such accounts, anyone with a grasp of portrait conventions immediately understands the implicit aggression, as well as the seduction, of Arbus's move to present her subjects within the modes of the European grotesque. Arbus's postwar career in middlebrow fashion photography, constructing reassuring fantasies for upscale public consumption, may have prepared her all-too-well for revealing the darker anxieties which under-gird tenuous gender and class ideals. After ten years in fashion photography, she knew how to make people look good on camera—or not. As photohistorian Colin Westerbeck notes, Arbus's innovative use of flash in daylight "gave an unnatural feel to the pictures. It gave her subjects a certain fun-house presence, picking up the shine on faces in a way that made them physically gross, even grotesque, or that brought a care-worn quality to them."[7]

Arbus's use of techniques of lighting, framing, and camera angles to subtly recast the figure draws on models from Expressionist painting—for instance, the grotesque deformations of the body in Egon Schiele's work, a project with deep roots in older European pictorial forms (e.g., Bosch) as well as in the almost quintessentially modernist pursuit of extreme forms of subjective self-dissolution. Arbus undoubtedly inherits this model of "revelation through distortion" via her teacher, the Viennese émigré photographer Lisette Model, whose own photographs of drag performers and transvestites were (along with those of Brassaï) among the first to systematically probe gendered subjectivity and the social construction of sexuality.

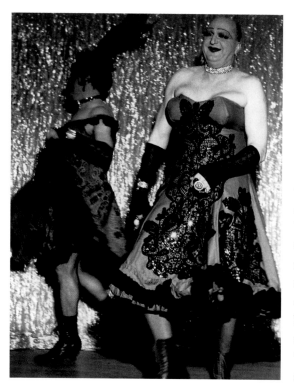

The implications of this crucial relationship with Model (who, along with Richard Avedon, was perhaps the central figure for Arbus) have yet to be critically engaged, perhaps because the extent of Model's photographic production remains unpublished and little-known. The larger art historical question, of how transplanted central European émigré cultures significantly formed postwar American artistic practice, is vast and relatively unexplored. Yet particularly for a figure such as Arbus, who drew so deeply on the Weimar-era portraiture of August Sander, a sense of how earlier portrait models and conventions are structurally transformed in the postwar American context is essential. Where Sander included socially marginal and physically disfigured individuals in a larger social typology, Arbus pursued them systematically, making them the template for even her more apparently "normative" subjects.

If, by the postwar era, the single physiognomic likeness no longer seems to hold access to the complexity and fragmentation of modern subjectivity, Arbus paradoxically reinvigorates the bourgeois portrait genre by putting once "unrepresentable" figures in center stage. Shot in the

full-frame frontality of formal portraiture, the social outcast becomes the model for subjectivity as such.[8]

In the emerging media culture of the 1960s, this strategy may have been less disruptive than it initially appears. Feminist art historian Ariella Budick has recently argued that Arbus's "images of sexually ambiguous figures and transvestites, as well as her representations of motherhood, constitute a critique of the rigidity of gender roles in the later 1950s and early 1960s, a period in which sexuality was clearly prescribed by social and ideological conventions."[9] Yet enforced norms require some awareness of "deviance," and Arbus's work of the 1960s was itself made possible by the relative accessibility of certain social "margins" to middle class social voyeurs—the 42nd Street freak shows and drag clubs catering to heterosexual clientele were, after all, already favorite haunts for edgier street photographers like Weegee and Model.

As the history of postwar censorship battles demonstrates, by the early to mid-1960s it is no longer a matter of the total *prohibition* of representation of sex/gender "deviance" (subjects long available in the increasingly "pop" sociological and scientific literature), but a question of how they would become visible, and in what modes of representation, in the increasingly "liberalized" urban media culture of which Arbus was an active participant—even if, reading Thomas Southall's account in *Diane Arbus: Magazine Work*, one is mostly struck by her failures. When it came to providing fully spectacularized forms

LISETTE MODEL
*Hubert's Freak Museum and Flea Circus,*
*Forty-second Street, New York,* c. 1945
Gelatin-silver print
The J. Paul Getty Museum, Los Angeles
opposite:
ROBERT FRANK
*Motorama—Los Angeles,* 1955

for representing social difference, and making these commercially viable and successful, Arbus was no Avedon. Her position was ambivalent. Nonetheless, I feel that by relentlessly imaging socially marginal lives as tragic and naive—as subjects offering no resistance—and by presenting non-normative female figures as almost uniformly monstrous, Arbus herself, in my opinion, offers less resistance than we might wish to the social anxieties and repressive capacities of mainstream American culture.

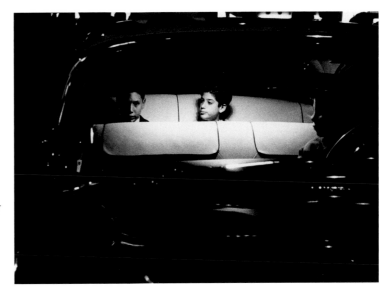

The pathos of Winogrand's work is harder to pin down in any single image: it accumulates almost horrifically over the years and the pages, over the dozens and hundreds of published images and, no doubt, over the literally hundreds-of-thousands of shots Winogrand took in his final years, which he left mostly developed and unprinted. The awkward status of these late, "unfinished" images should alert us to a structural failure or impossibility internal to Winogrand's project—a perception reinforced by our awareness that, according to his friend and colleague Tod Papageorge (who also edited *Public Relations*), the notoriously restless Winogrand had already begun to lose interest in printing his film by the late 1960s. By the 1970s, he seems to have relied on friends to print, edit and present his work: a curious state of affairs for a photographic project about voyeuristic looking.[10]

Unlike Arbus, who sought out individualized subjects, Winogrand initially followed the path of Robert Frank, finding images of misery in anonymous public scenes—grainy, chaotic scenes of distance, disconnection and anomie amongst the milling crowd. Yet, where Frank's *The Americans* (1959) portrays an almost stereotypical version of 1950s existential "alienation," Winogrand's images stay curiously flat; he holds certain scenes up for our inspection, but it is not always clear why. Later street images and airport scenes, in particular, can seem to have little or nothing going on. In one of his most acclaimed

photographs, Winogrand captures a back-lit scene of three glamorous women in short skirts and big hair, strolling down a sidewalk, next to a crippled figure in a wheelchair, half-hidden in shadow (*Hollywood Boulevard, Los Angeles, California, 1969*). Yet even in images such as this, in which the most dramatic social contrasts are portrayed, the apparent social "message" is quickly obscured by chaotic surrounding detail: a group of women waiting for the bus, a taxi pulling up, a boy on a bench looking over at the scene, the large plate-glass window which reflects the female trio less clearly than an older group hidden behind them, the street sign which reads "Vine St/1600 N." Intelligible social "meaning" emerges, then ebbs away: "information" presented for analysis produces a sense of impenetrability and pathos instead.

Paradoxically, the deeply anti-humanist implications of Winogrand's project, and his actual assault on pictorially based models of photographic meaning, were grasped more clearly by his detractors than his friends. In a harshly critical review of *Public Relations* (1977) in the Society for Photographic Education journal *Exposure*, Candida Finkel argues that the book offers "a catalogue of incomprehensible events," and that Winogrand's camera is "a metaphorical weapon. He uses it to take away human vitality and integration with the world. His pictures show people who had been transformed in lifeless, rigid

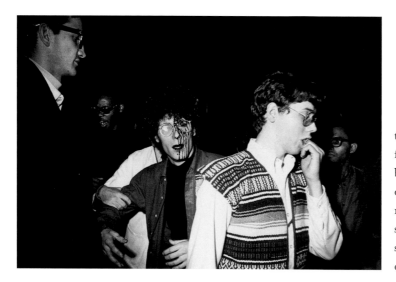

mannequins."[11] Protesting the amoral detachment of the professionalized mass media, Finkel decries the leveling effects of Winogrand's project, its failure to differentiate or make connections:

> All experience is democratized by the roving professional photographer. Beatings, blast-offs, parties, press conferences—it is all the same to him. The horrifying juxtaposition in *Public Relations* of violent demonstrations with fancy art openings implies that these public events are not morally distinguishable. These are no longer people; they are pictures.[12]

On the surface, such complaints only play into all-too-familiar models of modernist fragmentation and detachment. However, if Winogrand's systematic stripping away of human subjectivity from photographic *content* is, of course, deeply recuperable for photographic modernism—the confusion of human and machine, of animate and inanimate, are, after all photographic tropes dating back to Atget's days— what is less recuperable by art photography is his implicit stripping away of subjectivity from photographic *authorship*. As Finkel notes:

> Winogrand finds it difficult to make decisions about his pictures. . . He rarely prefers one image to another. I suspect that the reason is that he does not understand what the pictures mean. Facts require interpretation, and Winogrand has no time. He continually searches for more information rather than

analyzing what his pictures already contain.[13]

Within the confines of socially committed documentary or fine art photography, such failure to "make decisions" can only be a fault: both practices rest on models of selectivity, of differentiation, of favoring certain images and not others. For photography to function as a signifying practice that carries meanings, whether social or aesthetic, it must repress the non-differentiating, non-selective, quasi-automatic nature of its own apparatus: its threatening technical capacity to produce too many images. Within this ethos, to be an artist, to be an "author," is to edit: to subject the impartiality of the apparatus to human judgment and decision.

Winogrand's failure to do this is, of course, legendary: from the proliferation of "stacks of pictures all over the floor, boxes and boxes stacked up on top of each other" that a bemused Meyerowitz recalled from Winogrand's "cavern of an apartment" in New York of the 1960s, to the incomprehensible mass of material a horrified John Szarkowski encountered when preparing Winogrand's posthumous 1988 retrospective at New York's Museum of Modern Art:

> At the time of his death in 1984 more than 2,500 rolls of exposed film remained undeveloped, which seemed appalling, but the real situation was much worse. An additional 6,500 rolls had been developed but not proofed. Contact sheets (first proofs) had been made from some 3,000 additional rolls, but only a few of these bear the marks of even desultory editing. Winogrand's

GARRY WINOGRAND
*Demonstration Outside Madison Square Garden,*
*New York, 1968,* 1968
opposite:
GARRY WINOGRAND
*Kent State Demonstration, Washington, D.C.,*
*1970,* 1970

processing records indicate that he developed 8,522 rolls of film during his Los Angeles years, while the backlog grew larger. Part of the unedited work was shot in Texas; nevertheless, it would seem that during his Los Angeles years he made more than a third of a million exposures that he never looked at.[14]

As Szarkowski dryly remarks, "To expose film is not quite to photograph."[15]

For a curator or art historian, such quantitative excess can only function to erode the author function—and, by all accounts, Winogrand was artistically "out of control" in his final years in L.A. Bemoaning the "dogged, repetitive, absentminded, oddly ruminative work" of the later years, Szarkowski recounts Winogrand randomly, aimlessly, shooting from car windows: "he photographed whether or not he had anything to photograph, and . . . he photographed most when he had no subject, in the hope that the act of photographing might lead him to one."[16] Szarkowski speculates that "the technical decline of the last work was perhaps accelerated by Winogrand's acquisition, in 1982, of a motor-driven film advance for his Leicas, which enabled him to make more exposures with less thought,"[17] and laments, "Winogrand was at the end a creative impulse out of control, and on some days a habit without an impulse, one who continued to work, after a fashion, like an overheated engine that will not stop even after the key has been turned off."[18]

This specter, of the camera-without-operator, making exposures unharnessed by human agency, unmoored to human vision or desire, clearly haunts Szarkowski. Even if it represents a logical extension of a 35mm practice decried by Edward Weston as "machine-gun photography" (and correctly perceived by Weston as the antithesis and negation of his own model of aesthetic "pre-visualization"), this triumph of machine over man can have no place in fine art photography. Even Szarkowski's heroic, laborious, and almost stupefying effort to retrospectively

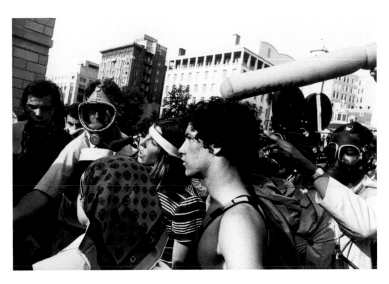

retrieve "good" images from this authorless mass comes up mostly empty. Unlike his own historical venture to aestheticize instrumental and amateur photographies in *The Photographer's Eye* (1966), this attempt to turn the "death of the author" into an occasion for the astute viewer/scavenger/collector fails.

The other alternative, which cannot enter the confines of art photography, is precisely to embrace the non-selectivity of the machine, to understand its relation to the principles of random accumulation in the work of John Cage and Robert Rauschenberg, and the conceptual projects of the 1960s and 1970s—as in Douglas Huebler's 1971 proposal to photograph "everyone alive," which mockingly embraces photography as a technology of arbitrary and unlimited social surveillance. Yet, ultimately, Winogrand is not a conceptual artist, nor can he admit the structures of archive, apparatus, and accumulation that nonetheless pervade his work. Unlike Huebler, Rauschenberg, or Ed Ruscha, he doggedly clings to an older photographic model of authorial agency, subjectivity and desire, even as it implodes around him during his final years, dispersed in the countless stacks of print, rolls of exposed but unprinted film, boxes of printed but unviewed contact sheets.

As countless images from *Public Relations* make clear, Winogrand was well aware of the changing conditions of mass-media culture, and its capacity to make the older, pictorial

models of 35mm documentary photography quaint and irrelevant. Arbus's project also went into crisis by the end of the 1960s, as the extreme focus of the classic square-format photographs gives way to the more off-kilter framing and blur of the late, untitled images, with their strange disavowal of authorial control. A certain distanced view on damaged life—the precarious detachment of photographic modernism—is no longer possible.

Arbus and Winogrand push this practice to some kind of breaking point. They represent the end of the line for a postwar documentary practice in which, in Benjamin Buchloh's analysis, "the masochistic identification with the victim" takes over.[19] The new projects of "subcultural" documentary which emerge in their wake will permit photographers like Larry Clark and Nan Goldin to claim positions of "insider" authenticity and belonging—and disavow the ambivalent power relations that make Arbus's and Winogrand's photos so painful and poignant, while nonetheless replicating their ceaseless social voyeurism.

Notes

This essay owes a great deal to discussions with Christopher Phillips and Lutz Bacher, and to the work of Benjamin Buchloh. The author has made several factual and editorial changes in response to objections from the Diane Arbus estate. Permission to reproduce the pictures in this volume was conditional upon making these changes.

1. The classic analysis of this failure of liberal/progressive social documentary photography is Martha Rosler, "In, Around, and Afterthoughts (on Documentary Photography)" (1981), in Richard Bolton, ed., *The Contest of Meaning: Critical Histories of Photography* (Cambridge, Mass: The MIT Press, 1989), 303-41.

2. From Roland Barthes, *Camera Lucida: Reflections on Photography*, trans. Richard Howard (New York: Hill and Wang, 1981), 9-10.

3. Charles Hagen, "An Interview with Garry Winogrand," *Afterimage* (December 1977): 8. By most accounts, Arbus received the lion's share of attention after the 1967 "New Documents" exhibition, and Winogrand's remarks may well reflect a large degree of professional rivalry, beyond his awareness of the fundamental incompatibility of their photographies. The reverse also appears true; according to Joel Meyerowitz, Arbus didn't especially like Winogrand's work. He claimed "she couldn't see it," adding that

Winogrand's images "seemed incredibly casual to people making more concrete-looking work;" in Colin Westerbeck and Joel Meyerowitz, *Bystander: A History of Street Photography* (Boston: Little, Brown and Co, 1994), 383.

4. Hagen, 9, 11.

5. Norman Mailer, cited in Thomas W. Southall, "The Magazine Years, 1960-1971," in Doon Arbus and Marvin Israel, eds., *Diane Arbus: Magazine Work* (Millerton, N.Y.: Aperture, 1984), 161.

6. See the accounts of Germaine Greer and Ti Grace Atkinson, in Patricia Bosworth's unauthorized *Diane Arbus: A Biography* (New York: Alfred A. Knopf, 1984). Despite the tremendous limitations of Boswell's account, it may be precisely the enormous repression on information about Arbus, enforced in part by her estate, that continues to make it essential reading.

7. Westerbeck, 384. Meyerowitz notes how Arbus's use of flash in daylight on the streets "introduced an idea that has really been picked up by everybody."

8. Of course, all such supposedly "unrepresentable" figures—the insane, the criminal, the sexual deviant, and the racial other—have been photographic subjects almost from the outset, but their images appeared in diverse scientific, anthropological, police and medical photographies, and not within "art" photography. Part of Arbus's innovation, following Sander, is to photograph the socially marginal subjects—previously relegated to instrumental practices—within conventions of bourgeois portraiture.

9. "Diane Arbus: Gender and Politics," *History of Photography* 19, no. 2 (Summer 1995): 123.

10. Meyerowitz recounts that "Garry was progressively pulling away from the darkroom, and my recall is that probably half the pictures in *The Animals* [published in 1966] were printed by Tod" (378).

11. Candida Finkel, "Public Relations," *Exposure* 16, no. 1 (March 1978): 41-42.

12. *Ibid.*, 41.

13. *Ibid.*, 42. Winogrand's constant recourse to a formalist vocabulary, his repeated insistence that his work was about photographic problems, about how things look in pictures, and not any kind of social commentary, has naturally drawn sustained criticism from politically oriented critics—especially given the overt sexual voyeurism of *Women are Beautiful* and the apparent misogyny or racism of certain images.

14. John Szarkowski, *Winogrand: Figments from the Real World*, exh. cat. (New York: The Museum of Modern Art, 1988), 35-36.

15. *Ibid.*, 36.

16. *Ibid.*, 38, 39.

17. *Ibid.*, 39-40.

18. *Ibid.*, 36.

19. From a talk in April, 1994. See my "Aesthetics of 'Intimacy,'" in Deborah Bright, ed., *The Passionate Camera: Photography and Bodies of Desire* (New York: Routledge, 1998) for a discussion of the "insider documentary" photography of Nan Goldin and others.

Installation view of the exhibition "New Documents,"
The Museum of Modern Art, New York,
28 February through 7 May 1967.

# DIANE ARBUS, LEE FRIEDLANDER, AND GARRY WINOGRAND AT CENTURY'S END

A.D. Coleman

The "New Documents" exhibition opened at New York's Museum of Modern Art on February 28, 1967, almost exactly a third of a century ago. Organized by John Szarkowski for the museum's Department of Photography, this show featured almost one hundred prints by three relatively unrecognized, younger photographers from the U.S.—Diane Arbus, Lee Friedlander, and Garry Winogrand—and came as a watershed moment in the evolution of contemporary photography.

What exactly did this exhibition signify?

At that time, MOMA's Department of Photography was one of the few departments solely devoted to that medium in any art museum in the world and was inarguably the most powerful of all. Szarkowski, installed as its director in 1963, had by then fulfilled all the curatorial commitments of his predecessor Edward Steichen and had begun to mount shows that he'd conceived and organized himself. Shortly after he assumed what Christopher Phillips has called "the judgment seat of photography,"[1] Szarkowski offered what numerous people in the field took as a full-blown theory of photography, enunciated in his 1964 exhibition and accompanying catalogue, both entitled "The Photographer's Eye."[2] That exhibition included not just prints by recognized photographers—Edward Weston, Aaron Siskind, Harry Callahan—but also imagery by lesser-known and even anonymous picture-makers, vernacular studio and press photography, and examples of what we might now call naïf photography.

The theoretical underpinning of this selection of pictures represented in large part a photographic version of high-modernist formal-ism as it had evolved in the critical writings of Clement Greenberg, Harold Rosenberg, and others who'd been coming to terms for some years with the Abstract Expressionist painters and sculptors. But no one had offered a photography-specific menu thereof as lucidly and engagingly written as Szarkowski's. Unlike theorists Greenberg and Rosenberg, however, Szarkowski leavened the high-art assumptions that served as his ground note with an egalitarianism suggesting that anyone, anywhere, at any moment, could (even accidentally) make a great photograph worthy of preservation, study, and placement alongside masterworks by those who'd devoted lifetimes to the medium. This located Szarkowski somewhere between Pop art's embrace of funky everyday culture and the rigors of the Abstract-Expressionists' address to the blank canvas in search of the white whale.

Photography had not until then enjoyed a steady supply of what the philosopher of science Thomas S. Kuhn would shortly identify as paradigms: magnetically charged new models of thought.[3] "The Photographer's Eye" provided not just a thought experiment about how to analyze lens-derived still images but a paradigm, a persuasive hypothesis about the bases and functions of photography and photographs, and a foundation on which to explore systematically the making of them: in short, a theory that suggested provocative possibilities for practice, including a set of experiments to test its hypotheses, an instrumentation, and even a methodology.[4]

What would an extensive oeuvre look like built upon, either consciously or intuitively, those carefully articulated grounds? To answer that

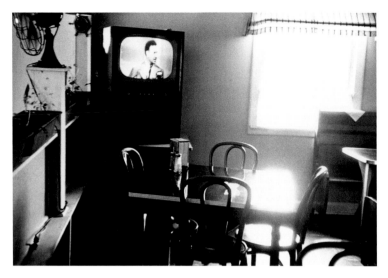

question, Szarkowski shortly thereafter turned to the work of three younger members of what historians would later identify as the New York School of photography,[5] bringing them together under the "New Documents" rubric: Diane Arbus, Lee Friedlander, and Garry Winogrand. All were under the age of forty; and, though they'd each received at least one Guggenheim Foundation Fellowship, none had yet come to any public prominence. MOMA's 1967 sponsorship of their work in this show made the careers of all three individually[6] while simultaneously associating them with each other indelibly and in perpetuity; meanwhile, the collective statement that emerged from their work in aggregate fell like a bombshell on the world of photography.[7] With his endorsement of their projects, Szarkowski ambitiously sought to reconfigure the very way in which photographs were understood, and to suggest thereby something about how the making of them could be redirected.

What did these three photographers, buttressed by Szarkowski's theorizing, have in common as practitioners—what paradigm did they constitute? And what drew other practitioners to these ideas? Arbus, Friedlander, and Winogrand all worked exclusively in black and white and used small- to medium-format cameras—35mm for Friedlander and Winogrand, 2 1/4-inch twin-lens reflex for Arbus. These are comparatively small, quiet instruments, ideal for unobtrusive sketching in the relatively dense social situations they all

favored, and light enough to be hand-held— permitting them quicker responsiveness to facial expressions, body language, and configurations of people and other objects in motion.

So these camera systems facilitated impulsive, rapid reactivity to nuances and details, along with a fluid, gestural-drawing methodology. The consequent camera-handling strategies, and the gritty, off-kilter imagery that often resulted, built on the example of older members of the New York School such as Lisette Model, Sid Grossman, Helen Levitt, and especially Robert Frank. They required an unprecedented acceptance of chance elements on every level of the photographic process. Working in this fashion, one often didn't know what had been netted with the lens until scrutinizing the developed film. Increasingly asymmetrical, unbalanced, fragmented, even messy, especially in contrast to preceding photography, this work demanded of both photographer and viewer an openness to radically unconventional formal structures.

For their raw subject matter this trio, and counterparts in their cohort,[8] favored the urban/suburban milieu of American car culture in the Vietnam War era. They sometimes photographed in private spaces, and occasionally in rural areas, but most often in interior and exterior public spaces: offices, lobbies, airports, restaurants, buses and subways, but especially the streets of towns and cities across the country—what had just been named the "social landscape."[9]

The resulting imagery emanated an aura of authenticity reminiscent of *cinéma vérité*, augmented with a tone of hip cynicism and *épater le bourgeois*, combined with a general fascination

ROBERT FRANK
*Restaurant – U.S. 1 leaving Columbia,*
*South Carolina*, 1955
opposite:
GARRY WINOGRAND
*Untitled*, 1964-75

with public behavior, an acceptance of the bizarre and grotesque and marginalized, and a distinct hint of cultural criticism—though nothing approximating a social critique emerges from the work of any one of them, nor from their collective output. Indeed, the theory itself, as outlined by Szarkowski, like formalist theory in general, insists that serious, contemporary, and creative photographic image-making has no compatibility whatsoever with such a political, polemical motive. Here's how Szarkowski described the tendency he chose Arbus, Friedlander, and Winogrand to represent in his wall label for "New Documents":

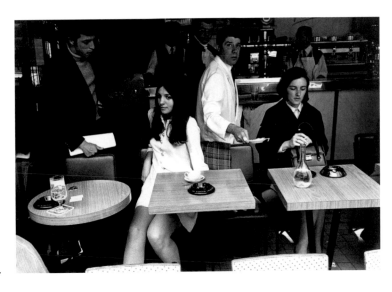

> Most of those who were called documentary photographers a generation ago, when the label was new, made their pictures in the service of a social cause. It was their aim to show what was wrong with the world, and to persuade their fellows to take action and make it right.
>
> In the past decade a new generation of photographers has directed the documentary approach toward more personal ends. Their aim has been not to reform life, but to know it. Their work betrays a sympathy—almost an affection—for the imperfections and frailties of society. They like the real world, in spite of its terrors, as the source of all wonder and fascination and value—no less precious for being irrational...."[10]

This non-political, anti-theoretical posture denies categorically and consistently that such photographs are in any way about their literal subject matter, insisting instead that photographs are entirely about themselves and in no way concerned with either the photographer's inner life or whatever took place in front of the lens at the moment of exposure. As a stance, it became not just widespread but almost mandatory among practitioners of this genre of photography.

That's a particularly problematic position to defend in regard to photographers whose work primarily involves not just the human presence but intricate social interactions in the complex environment of the modern city—the polity at work and at play in the polis. Not to put too fine a point on it, formalists have generally (and, in my opinion, wisely) eschewed, say, portraits of recognizably interracial couples carrying chimpanzees, fully dressed in children's clothing, through a crowded zoo,[11] on the reasonable grounds that such subject matter carries so much cultural baggage as to overwhelm whatever formalist inquiry any resulting image might encode.

Yet one could also argue—as did Szarkowski in many of his writings and, albeit gnomically, Winogrand himself[12]—that this constituted the most extreme pushing of the envelope, a walking of the razor's edge in which one constantly confronted formalist purpose as content with the risk of falling into the trap of the denotations and connotations of the imagery's contents, its literal subject matter. The work was to be understood as a mix of formal play with neutral (if ironic), apolitical observation of human social behavior, something like Stendhal's "mirror held up along a highway" with attitude.

What's more important here is that this first public association of the work of Arbus, Friedlander, and Winogrand proved so germinal that from the paradigm it embodied there sprang a school of photography that remained vital and energized at least through the early eighties. That paradigm still has countless serious practitioners; moreover, it has influenced many workers in

other forms of photography.

Because it's the question underlying this selection of work from the 1960s through the early 1980s in The Ralph M. Parsons Photography Collection at The Museum of Contemporary Art, Los Angeles, one must ask: What does this work mean to us now? Is it merely an historic artifact, a fascinating but exhausted relic of the photographic energies of the 1960s and 1970s? Does it remain resonant?

One of the reasons that Kuhn disowned the application of his model to a field such as ours is that in art, old paradigms never die; instead, they undergo a conversion process that turns them from belief system into style. Though as a paradigm it drew a large and devoted cluster of adherents, the "new documentary" Szarkowski identified, with its presumably "more personal ends," didn't demolish or permanently impeach or even put much of a dent in the preceding form, which we might call "classic documentary." Indeed, certifiably at this very moment we have more photography projects worldwide premised unabashedly on the classic documentary paradigm than ever before.

But a number of other, more recent projects that I'd classify as classic documentary in terms of the purpose Szarkowski ascribed to them ("to show what was wrong with the world, and to persuade their fellows to take action and make it right") have, since the late 1960s, come to us evidencing the influence of the "new documen-

tary" approach. The work of Gilles Peress, James Nachtwey, Susan Meiselas, Eugene Richards, Alex Webb, Bastienne Schmidt, Larry Fink, Raghubir Singh, Donna Ferrato, Nick Waplington, and a horde of other young to mid-career documentarians and photojournalists clearly reflects their close study and absorption of the camera-handling and image-construction techniques of Arbus, Friedlander, and Winogrand. In effect, they've reversed the challenge, looking for ways to construct pictures as complex as the issues they address without falling into the traps of formalism. So the formal and stylistic experiments represented by the work of Friedlander and Winogrand have in fact permeated the field and even seeped into the public's idea of photographic practice, to such an extent that now one can even find front-page photos in newspapers and advertising images in magazines replete with those trademark mannerisms.

Moreover, these same photographers and their contemporaries—Nan Goldin, Richard Billingham, Larry Clark, Arlene Gottfried, Steve Hart, to name a handful—not only utilize pictorial strategies straight out of the "new documentary" approach, but make their own presence at the scene manifest in the photographic work and/or its accompanying text, both as an autobiographical element and as an acknowledgment of their inevitable "perturbation" of the situations they seek to describe. That tendency found its way into the work of the "new documentary" approach in several forms: the anxious energy that radiates from so much of Arbus's work, her palpable awe, admiration, fear, or disdain for her subjects, her in-your-face proximity to many of them; Winogrand's grab-shooting, mosh-pit immersion

LEE FRIEDLANDER
*Colorado 1967,* 1967
opposite:
LEE FRIEDLANDER
*Bellows Falls, Vermont,* 1971

in the crush and flow of crowded streets; Friedlander's own shadow and reflection as elements either central or incidental in image after image, in addition to his direct self-portraits. Drawing on the work of all three, but especially that of Arbus, the personalization of the documentary mode is widespread today.

Hence we can say that, collectively, Arbus, Friedlander, and Winogrand revised the ways in which photographers use their cameras, which changed the look of the resulting photographs. And they made the photographer's participatory role in the photographic event a foregrounded given, transforming both the behavior of photographers and the way in which we interpret their work.

Diane Arbus's death by her own hand in 1971 abruptly and prematurely truncated her address to the set of questions implicit in the "new documentary" paradigm. From the record, we know that up until then she'd redacted her output stringently; during her lifetime, aside from her commissioned work, she'd exhibited and published far fewer than one hundred images. Yet, almost three decades after her death, the scholarship devoted to her work has not even attempted to identify that group of images she herself approved for public presentation. Instead, from her posthumous retrospective[13] to the most recent book of her work (*Untitled*, a selection from her final, unfinished project),[14] various figures in the field have actively inflated the small set of images to which she committed herself fully, adding to them pictures she'd never endorsed for exhibition or publication. This has seriously confused the criticism of her work, and will continue to do so until it's rectified by rigorous research.

With all that said, we must also recognize that what at least two generations of photographers have taken from Arbus include the example of a photographer (perhaps especially a woman photographer) willing to engage with what

fascinated her—whether out of glee, out of reverence, or out of revulsion. One can find traces of her spirit in the work of photographers as different from each other as Nan Goldin, Larry Fink, Susan Lipper, and Joel-Peter Witkin, and it seems likely that the permission that's implicit in her work—to pursue whatever one considers to constitute the forbidden—will remain her most enduring legacy.

If, within this troika, subject matter and content are most closely allied in Arbus's work, they're most widely separated in Lee Friedlander's. He has ranged furthest afield in that regard—producing extended suites of images of everything from public monuments to jazz musicians, including portraits, self-portraits, nudes, floral studies, street scenes, industrial scenes, and desert landscapes. He's also produced by far the most tightly redacted oeuvre—editing and sequencing all of his monographs himself.

Friedlander, much more than his two partners in this paradigm, seems genuinely detached from his nominal subject matter, concerned principally with picture-making problems and strategies. People in public, generic statuary, nude women, and cacti appear as relatively arbitrary and, indeed, interchangeable raw material in his process; what he has to say about them as such seems almost irrelevant, and one would not turn to any of his interpretations for information regarding those subjects. Instead, they appear in his work as a variety of game

boards, the premises for thoughtful, calculated, highly intellectualized play with the possibilities of photographic image construction. He's treated his various projects as carefully considered building blocks; the result is among the most precisely constructed oeuvres of his generation of photographers. It's from that example, and from his sense of image-making as a form of gamesmanship, and of course from the elegance and dry wit of his specific formal solutions to particular imagistic problems, that photographers will continue to draw lessons for the foreseeable future.

Garry Winogrand's version of the project, by all accounts (even that of his staunchest supporter, John Szarkowski[15]), simply fizzled out in the decade before his death, terminating in increasingly random, voracious, compulsive, and non-productive shooting. Of all the members of this triumvirate, he alone manifested no real concern with the process of redacting his own work, preferring instead to generate an endless stream of negatives. His immense, undifferentiated heap of images poses a vast and probably insoluble conundrum for criticism and scholarship.[16] In some ways, then, he represents the collapse of the "new documents" paradigm, or at least one ultimately failed experiment therein.

Yet, even though extracted from his output by others, the two best of Winogrand's books—*The Animals* (1969) and *Public Relations* (1977)—and numerous other individual images retain their compressed, coiled power, as well as

their lyricism, their exuberance, their frequent manic energy, and (whether he recognized and admitted it or not) their deflationary, caustic, and often cruel wit. Of these three photographers, Winogrand most insistently walked the presumed fence between formal innovation and social commentary. He adamantly refused to speak of the latter; nonetheless, the tension between these two ways of reading his pictures constitutes the undeniable central energy source of the later ones, and even the early work—up through *The Animals*,[17] at least—cannot disguise its constant attention to the human condition. And, regardless of who edited and sequenced it, *Public Relations*[18] forms a coherent statement that probes through photographs the questions raised during the same period by the sociologist Erving Goffman and the social historian Daniel J. Boorstin, among others.[19] It demands analysis as a multifaceted, sardonic commentary on the ways in which observation—in this case by the mass media—changes the situation observed. (As a photographer present at the public events he describes in these images, Winogrand himself stands of course ironically—and self-consciously—implicated in the very activity he's scrutinizing.)

Finally, what of the form itself—small-camera street photography addressing the "social landscape"? Photographers have, of course, worked in the streets from the very beginning, so neither the street as proscenium nor the questions it evokes came bundled with the "new documentary"; they existed as challenges for photographers before that moment in 1967, and will persist long after that form's impact has been fully absorbed.[20] So long as streets exist, and laws don't prohibit photographers from working there, variations of this genre will proliferate.

At the moment, however, it's out of

GARRY WINOGRAND
*Presidential Candidates' Press Conference,
Providence, R.I., 1971*, 1971

fashion. Postmodern theory has proposed that all the questions that thoughtful photographers had begun to ask in the late 1950s and early 1960s—about the non-neutrality of photography, about lens-based observation and photographic seeing, about the tension in a photograph between its transcriptive, descriptive, translative, and interpretive aspects—were insignificant, and had in any case been answered satisfactorily. In fact, those questions endure, still open, and such answers as we have for them—in the work of Arbus, Friedlander, and Winogrand, among many others, along with the theories of Szarkowski and some of his successors[21]—remain provisional. Now that, in effect, all of those individuals have gained admission to the pantheon, and all the results of their theory and practice have entered the canon, we stand poised at a particular moment of stasis: the pause between several generations that grew up with this work and its makers as living entities, and those generations now to come, who will treat them as a distinct chapter in the medium's history and exemplars of an established tradition to either draw from or ignore. What they had to say to the last third of the twentieth century is in any case indelibly inscribed on the record.

Notes

1. Christopher Phillips, "The Judgement Seat of Photography," *October* 22 (Fall 1982): 27-63.
2. John Szarkowski, *The Photographer's Eye* (New York: The Museum of Modern Art, 1966). The exhibition ran at MOMA from May 27-August 23, 1964. Subsequently, it traveled.
3. Thomas S. Kuhn, *The Structure of Scientific Revolutions* (Chicago: The University of Chicago Press, 1970).
4. The book version of *The Photographer's Eye* quickly became one of the fundamental college-level teaching texts in the rapidly expanding pedagogy of photography.
5. See Jane Livingston, *The New York School: Photographs 1936-1963* (New York: Stewart, Tabori, & Chang, 1992).
6. It also effectively turned them into house brands at the museum. All three remained deeply identified with MOMA throughout their careers and—in the cases of Arbus and Winogrand—after their deaths.
7. Two concurrent traveling shows, both with catalogues, explored the same territory in different ways: curator Nathan Lyons's "Toward a Social Landscape" at the George Eastman House, which opened on December 16, 1966, and ran through February 20, 1967; and curator Thomas H. Garver's "12 Photographers of the American Social Landscape," whose debut took place from January 9 through February 12, 1967 at the Rose Art Museum of Brandeis University in Waltham, Massachusetts. Most historians of the period tend to discuss all three exhibitions in tandem—e.g., Gerry Badger, "From Humanism to Formalism: Thoughts on Post-war American Photography," in Peter Turner, ed., *American Images: Photography 1945-1980* (New York: Viking Penguin, 1985), 17-18; and Jonathan Green, *American Photography: A Critical History 1945 to the Present* (New York: Harry N. Abrams, 1984), 106. A full discussion of the "New Documents" show and its impact requires further consideration of the interaction between these three surveys.
8. Those included in the two other concurrent survey shows mentioned in note 7, above, for example.
9. Thomas H. Garver credits the term to Lee Friedlander; his source for the phrase is a quote in a brief biographical note about Friedlander accompanying a portfolio of reproductions in *Contemporary Photographer* 4, no. 4 (Fall 1963): 15. See Garver, "Acknowledgments," in the exhibition catalogue *12 Photographers of the American Social Landscape* (Waltham, Mass.: Rose Art Museum, Brandeis University, 1967), unpaginated.
10. Undated, unnumbered one-page typescript on MOMA letterhead, from the archives of MOMA.
11. The reference here is to the famous Winogrand image, "Central Park Zoo, New York City," 1967.
12. For Winogrand's version of this pronouncement, see Dennis Longwell, "Monkeys Make the Problem More Difficult: A Collective Interview with Garry Winogrand," in Peninah R. Petruck, ed., *The Camera Viewed: Writings on Twentieth-Century Photography*, vol. II (New York: E. P. Dutton, 1979), 118-128.
13. Doon Arbus and Marvin Israel, eds., *Diane Arbus*, exh. cat. (New York: The Museum of Modern Art and Aperture, 1972).
14. Diane Arbus, *Untitled* (New York: Aperture, 1995). For my critique of this project, see Coleman, "Why I'm Saying No to This New Arbus Book," *New York Observer* 9, no. 37 (2 October 1995): 25.
15. John Szarkowski, *Winogrand: Figments from the Real World* (New York: The Museum of Modern Art, 1988). See also Ben Lifson, ed., *The Man in the Crowd: The Uneasy Streets of Garry Winogrand* (San Francisco: Fraenkel Gallery, 1999).
16. For more on this, see "On Redaction: Heaps and Wholes, or, Who Empties the Circular File?" in A. D. Coleman, *Depth of Field: Essays on Photography, Mass Media and Lens Culture* (Albuquerque: University of New Mexico Press, 1998), 25-34.
17. Garry Winogrand, *The Animals* (New York: The Museum of Modern Art, 1969).
18. Garry Winogrand, *Public Relations* (New York: The Museum of Modern Art, 1977).
19. See Erving Goffman, *Relations in Public: Microstudies of the Public Order* (New York: Basic Books, 1971), and Daniel J. Boorstin, *The Image: or, What Happened to the American Dream* (New York: Atheneum, 1962), subsequently republished as *The Image: A Guide to Pseudo-Events in America* (1982).
20. For a deeply flawed but still valuable history of the genre, including extended discussions of Arbus, Friedlander, and Winogrand, see Joel Meyerowitz, with Colin Westerbeck, *Bystander: A History of Street Photography* (Boston: Little, Brown & Co., 1994).
21. In addition to Lifson, Meyerowitz, and Westerbeck, these would include Stephen Shore and Robert Adams.

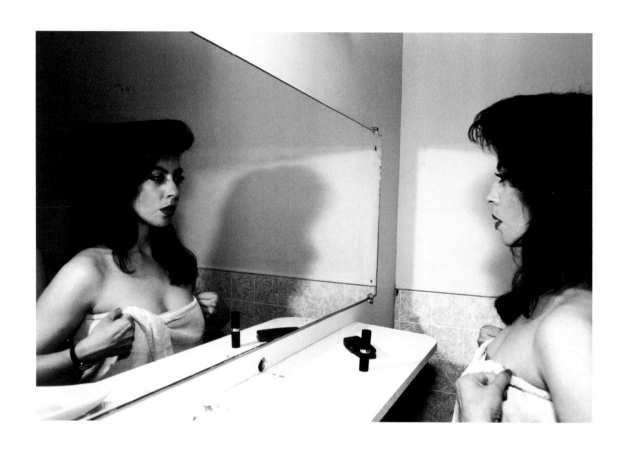

NAN GOLDIN
*Sandra in the mirror, New York City*, 1985
Published in *The Ballad of Sexual Dependency*, 1986

Photographic images of late twentieth-century subcultural, urban life draw on a recycled and periodized visual vocabulary of decadence. Offering a close fit between ethos and topos, between subject matter and style, the demimonde mystique can be traced to nineteenth-century fin-de-sièclism: from Max Nordau's technophobic vision of pathological over-stimulation in the metropole; to sexological decadence, from Krafft-Ebing and Freud; to Baudelaire's dandy, dedicated to artifice and urban evanescence; to the sulfurously amorous partnership of Rimbaud and Verlaine; to Des Esseintes's aboulia and over-the-top aestheticism; to the opium- and absinthe-induced physical wastage portrayed by Impressionist painting and Naturalist fiction; to the over-decorated interiors of courtesans and actresses; to the artist ateliers of Kiki's Montparnasse transiently occupied by Modigliani, Pascin, Foujita, Kisling, and Picasso; and to cartographies of the "zone"—the bars, cafes, cabarets, dance-halls, nightclubs, street fairs, and brothels—documented by Atget, Apollinaire, Paul Morand, Charles-Louis Philippe, and Pierre MacOrlan. This selective repository of turn-of-the-century clichés (belonging to a vast source-book) functions as an image archive of decadence upon which late twentieth-century re-imaginings of the demimonde have continually drawn. The "look" of contemporary Eros has become inseparable from portraits of erotic outlaws. Squatters in their own lives, washed-up or drugged-out souls whose nocturnal sensibilities simultaneously exude loneliness and clannish loyalty, experimenters in the art of racial, gender, and class crossover, they are the flora and fauna of enduring, visually fascinating subcultures.

That the demimonde, as a distinct mode of visual representation, is alive and well in current turn-of-the-century culture, is attested to by the popularity of photographs by Nan Goldin. There are copious imitations of the slide installation that she presented in the early 1980s under the title *The Ballad of Sexual Dependency*. Indeed the "Nan Goldin effect," appropriated by the fashion industry in what came to be referred to in commercial parlance as "heroin chic," has come to define what might be called "the look of Eros 2000." Aped, excoriated, or dismissed as a formula, mythologized in fin-de-siècle narratives of cultural self-destruction, mired in personal anecdotes about danger and despair in bohemia, rarely, it seems, do critics really ponder the particular merge of form and content that gives demimonde photography its distinctive, photogenic stamp, its decadent historicity, and it marked contrast to classic photographic images of modernity. The photographs of Goldin and her offspring—Jack Pierson, Mark Morrisroe, Wolfgang Tillmans—emerge as deeply imbricated in subcultural styles that mark the ephemeral history of fragile human relations and endangered communities. And yet, for all their pathos and pictorial beauty, they are also examples of what Liz Kotz has called "faux documentary" in their arrangement and composition of bodily attitude and baroque attention to surface.[1] With their signature mix of sleaze fashion and low-tech visual affect, the status of the work in this genre slides easily between genuine article and bad-faith

commercial artifact. This latent commodity use-value inherent in the work is reinforced by the apolitical nature of its social message. Positing the personal as political, this is work that has no "position;" rather it offers a historical tableau of fin-de-siècle political enervation that bespeaks cultural tail-endism, minimal aliveness, and survival at its most tenuous.

In Goldin's *The Ballad of Sexual Dependency*, the bodies seem to collaborate with the flashbulb in an anaclitic or co-dependent relationship. Goldin's photographs challenge normative boundaries between love and sexual addiction (sharply distinguished in the psychoanalytic literature) where love is defined as bonding with an introjected object, whereas the "adhesive attachments" of addiction are defined, at least in Joyce McDougall's scheme, as "sexual relations [that] remain tied to an external object that is detached from essential introjects, perhaps because they are missing, highly damaged, or too threatening in the external world."[2] Blurring the categories of love and addiction, there are no damaged goods vying with "good" introjectible objects. In her image repertoire, all the objects are willfully damaged or bad—whether victim objects or predators, they are histrionically abject.

Goldin's work does not, of course, appear in a vacuum in the history of photography. The influence of Larry Clark (famous for strung-out teens in *Tulsa*) and Diane Arbus (portraiture featuring the marginal, the anatomically odd) is frequently evoked. And David Wojnarowicz's early series entitled *Arthur Rimbaud in New York* (1978-79) is certainly an appropriate analogue in late-century chronicles of life on the wild side. In this black-and-white series, a head-shot of Rimbaud (a mask made from Etienne Carajat's 1871 portrait), is crudely pasted atop the artist's body. The composite figure of Rimbaud/ Wojnarowicz, posed in various down-and-out venues of Manhattan (the meat-packing district, the Bowery) confirms the formulaic parallelism between subcultures of gay decadence in 1870s Paris and 1970s New York.[3]

But leaving aside the affinities between Goldin and her contemporaries, it is perhaps Brassaï who "returns," so to speak, most strongly in current demimonde photography, specifically, the Brassaï of *Le Paris secret des années trentes (The Secret Paris of the 30's)*, originally conceived in the thirties as part of the comprehensive project *Paris de nuit* (Paris by Night), but censored until 1976. *Secret Paris* (or *Paris intime*, as Brassaï sometimes referred to it) comprises a virtual breviary of subcultural rubrics, among them nocturnal photogeny, same-sex sociability, venal intimism, urban solitude, surface decay, addiction, and the redefinition of family through the bonding of outcasts. These recurring topoi reprise familiar nineteenth-century subjects—the *fille de joie*, the *clochard*, cabaret and circus culture, *le high life*—but collapses them into a document of Parisian modernity in-the-making. Just as Goldin captures the extension of old New

MAN RAY
*Le violon d'Ingres*, 1924

York tenement life into 1980s downtown existence, so Brassaï traces the long arm of fin-de-sièclism as it stretched into the 1930s. Illuminated Paris, immigrant Paris, industrial and commercial Paris, are projected, not as emblems of a new era, but as images of an already aging modernity, profoundly indebted to the 1890s artistic fascination with the burgeoning industries of leisure, pleasure, tourism, consumerism, and popular entertainment. Brassaï, especially early in his career before he forged ties with Surrealism, was just this kind of ambivalent modernist: compelled by new technologies of the image, yet saddened by the incursion of craft and *techne* into the hallowed realm of art; adopting a Spenglerian view of the decline of European culture, while perfecting spellbinding visual testimonials to the beauty of society's defiles.[4]

Goldin and Brassaï excelled in photographic techniques that, each for their own time, problematize periodization in their use of medium and formal devices. The nocturnal sensibility, crystallizing around the different meanings of "negative," is crucial here. As Paul Morand wrote in his introduction to *Paris de nuit*: "Night is not the negative of day; black surfaces and white are not merely transposed, as on a photographic plate, but another picture altogether emerges at nightfall. At that hour a twilight world comes into being, a world of shifting forms, of false perspectives, phantom planes."[5] The "negative" signifies both medium and metaphysics, acting as a shifter between the materiality of the image imprint and the formlessness of nocturnal social formations. Whether it is through the conceit of multiple mirrors (the *mise en abyme*) unfixing the stable location of subject and viewer, or through the focus on mixed-class, mixed-race, same-sex communities of revelers (as in a number of nightclub scenes in *Secret Paris*) in which the legible contours of a stratified world give way to the ambiguities of unauthorized social partition and *remixage*, there

is a consistent thrust to suborn a socially fluid cosmopolitanism to the formal regimes of photographic medium. However, when Morand speaks of "false perspectives" and "phantom planes," it evokes not just the optical illusionism and visual control within photography's reach as an innovative medium, but also the haunting of formalism by runaway sociological content. Darkness and danger, phantasmatic light effects and street-life dereliction, aesthetic and social critical categories, all coalesce in Brassaï's photographic nocturne into a genre all its own.

In their periodicity, that is, in their historicist attention to period style and fashion, Brassaï's images offer a marked contrast to the timeless appearance of Man Ray's experiments in solarization and rayography. Even when Man Ray couched his technicity in humanist, phenomenological language—as when he wrote in the introduction to his 1934 album *The Age of Light*, that "these images are oxidized residues ... of an experience, not an experiment"—his subjects seem to be more like scientific specimens of classic modernity than personifications of urban folklore in a given era.[6] Where Man Ray's Kiki tended to be abstracted from context, her body contours transformed into an aesthetic pun (a musical instrument), her head-shots stylized into neo-primitivist facial masks, Brassaï's Kiki (*Kiki and Her Accordion Player at Cabaret des Fleurs, Montparnasse Boulevard*, 1932-33) is shown in the middle of a performance, leaning against a pillar, her hair matted with sweat, her beckoning fingers encased in black, fishnet gloves, her corsage drooping lasciviously like Cleopatra's serpent over her left bosom. Tackily attired, slathered in grease-paint in the style of one of Colette's music-hall sirens, her drooping gaze hooking the eyes of the accordion player who sits below, she is caught in her own act, performing the legend of "Kiki," diva of the dive.

Brassaï capitalized on such Montparnasse folklore. The photo captioned *Magic-City Dance*

*Hall, Cognacq-Jay Street* (1932) alludes to the underground map of nightclubs, cafes, and popular balls—proliferating from the 4th, 5th, 14th and 8th arrondissements to tougher districts in the 19th and 20th—that gave Paris its reputation for pleasure and danger. In *Magic-City*, dancing male couples sport every kind of masquerade: a bonneted *bergère* with sweeping satin skirt rubs shoulders with a naked male torso, sartorially garnished with a tam-o-shanter and a tie hanging down his bare back. In *Lesbian Couple at Le Monocle* (1932) a heavy-set butch in a dark men's suit stakes her body possessively around a bony, bare-armed woman in a scanty sheath. The bruises, blemishes, crumbs, cigarette leavings, dirty plate, and clothes, twisted into erotic foldings, enhance the intensely sexed aura of the sitters.[7] And in a picture of two embracing men, "top" and "bottom" are arranged in a charming set piece: Mr. "dark jacket, naked legs" is placed in inverse geometric pattern with Mr. "nude torso, trousered legs." Matching sets— same sex/crossed sex, duplicate/replicate, obverse/inverse, backside/frontside, lightness/darkness, black face/white face—are

compositionally honored in all of these photographs. This compositional sophistication seems to function as an alibi or decoy allowing illicit encounters to be ushered into public view. Alternatively, they read as high-end versions of the kind of crude snaps taken at artists' banquets or ateliers in which demimonde "families" reigned supreme. The wild Montparnasse painter Jules Pascin, famous for collecting "models of all shades," left pictures of an entourage composed of such international strays and misfits.[8]

Here the parallel with Nan Goldin begs to be redrawn, for Goldin begins her career with retro-clad drag queens and punk streetwalkers who seem, hyperconsciously, to be acting out portraits of Brassaï's famous *monstres sacrés* (Bijou, Babette, Colette, et al.). Like Brassaï, she has hit on a visual formula that typifies a theatricalized, decadent, "end of history" sensibility. Where Brassaï perfected the black-and-white version of "*la vie en rose*" in his depiction of "Paris as it looked at night; the windows that lit up or hid misery, the dives packed with drunks and whores, from which shafts of light, familiar melodies, and streams of obscene epithets spilled out into the street," Goldin masters the equally nostalgic "*vie en rouge*" as it appeared in the seedy corners of Boston and New York in the 1970s and 1980s.[9]

Despite the asymmetry of their reputations as artists, there is a way in which both artists are equivalent as controversial chroniclers of a demimonde Zeitgeist. While Goldin works predominantly in color and Brassaï in black and white, and while Goldin prefers the rapid fire of Polaroids, snapshots, and slides, while Brassaï is famous for bringing the concept of *longue durée* to photographic practice with his half-hour nightshot, both photographers stage the demimonde as

BRASSAÏ
*Young couple wearing a two-in-one suit at the Bal de la Montagne Sainte-Geneviève, c. 1931*

a pageant of seduction and nostalgia. Both have been accused of coaxing and posing their subjects to make them look more like "real life." Both have gained notoriety as "Atgets of the underworld," with pictures that perform a witnessing function, archiving vanished or endangered species of people and place. Both specialize in depicting "families;" that is, groups of rejects who support each other, having escaped dysfunctional homes. Both capture loneliness within sociality, arranging their subjects side-by-side yet alone, heads penitentially bowed, backs to the viewer. Both eroticize sartorial and cosmetic detail: spit-curls, feather boas, sequins, and body-paint function as visual magnets igniting excitement and fascination. Both deal in social stereotypes grouped in narrative sequences, romanesque to the hilt: drag-balls, sadomasochistic couples, gay men, and dykes. Finally, both have had their reputations as artists tainted and enhanced by their engagement with fashion. Brassaï worked on commission throughout his career for *Votre Beauté, Le Jardin des Modes, Coiffure de Paris*, and *Harper's Bazaar*, producing images that delivered the "Brassaï effect." Similarly, Goldin has done fashion shoots (for the Matsuda label, for example) that mimic her own style, heightening the impression of bohemian travesty, of decadence *au deuxième degré*, cleaned-up and de-fanged.

Auto-pastiche and cynical self-marketing are, of course, part of the appeal of a decadent or late aesthetic. As Gary Indiana points out in a recent issue of *Artforum* commemorating "the rise and fall" of the East Village art scene between 1979 and 1989, "Reagan was President, Communism was dead.... in the era of amusing fakery [the neighborhood] was ripe for exploitation as an artful copy of itself."[10] So even as they were creating art, the natives of the East Village art scene were pretty aware of their own commercial viability, resulting in art that was eminently marketable as the romanticism of urban decay. Now, while I may want to avoid passing judgement

on the re-purposing of decadent images once they enter the commodity bloodstream, the old problem of staging, especially the staging of closeted risqué life-worlds, is impossible to disengage from the interpretation of photographic subcultures.

With Brassaï the issue of staging is confounded by the mythology of his image sleuthing. He is habitually cast (indeed self-cast) as a midnight stalker, roving through the dives, dockyards, urinals, and *quartiers chauds* of Paris with Paul Morand or Henry Miller by his side, bursting in on brothel parties or sleeping couples, and catching his nightclub partners in unguarded moments. But one has only to look carefully at the photographs to see how contrived they are, especially the brothel scenes. *House of Illusion, rue Grégoire-de-Tours* (1932) distinguishes itself from soft porn through the artful arrangement of the couple in the mirror to produce a back and front *dédoublement*.[11] And if the aesthetic evidence did not suffice to make the case for his interventionism, recent scholarship has shown that Brassaï's preference for magnesium flash powder (which produced softer shadows, but was smelly, disruptive, and dangerous) over the newly available and far more discreet flash-bulb meant that few images could be made spontaneously or without the collaboration of his subjects.

That Brassaï was keen on perpetuating a myth of his own unobtrusiveness is borne out by an observation by Michael Sand: an original version of Brassaï's *La toilette dans un hôtel de passe, Rue Quincampoix* (c. 1932) "unveiled a clear reflection of the photographer, trademark cigarette in hand, in the mirror at the image's upper left-hand corner" [which] he dodges out of the final print.[12] Staging one's own absence or lack of appearance on the scene goes hand-in-glove, it turns out, with staging the scenes themselves. Anne Wilkes Tucker has recently documented the role of Brassaï's assistants, who were often not just technical factotums arranging

alcoholic excitement—that culminates in a report by a salesman of the pleasures he has enjoyed there: "We danced until midnight. She let herself go. I took her to a hotel on the rue Quincampoix. Did she ever want it!"[13]

Certainly most of *Secret Paris* could be keyed to literary sources—the sapphic and homo-erotic repertory is of a piece with Proust's *Sodome et Gomorrhe* (Brassaï writes wittily about how a photograph of Baron Charlus on the Princess of Guermantes's mantel sends his fickle lover Morel into a homosexual panic).[14] The famous shot of the "Cinzano-sipping lesbian," to borrow Terry Castle's phrase, could be an illustration for the Parisian dyke-bar scene in Radclyffe Hall's *The Well of Loneliness* or for any number of vignettes in Colette's *Le pur et l'impur*, a pseudo-documentary of Amazon Paris that included cameos of Renée Vivien, Natalie Clifford Barney, and the Duchess Matilde de Morny. And of course, Brassaï's scenography of nocturnal ambulation is arguably derived from the writings of Léon-Paul Fargue, MacOrlan, and André Breton, among others.

The point here is not to argue that, because they may have been scripted, Brassaï's shots of intimate Paris were faked or inauthentic. Rather, the point is to probe why some artists escape the stigma of *supercherie* while others do not. For, unlike Brassaï, Nan Goldin has had a very hard time overcoming appraisals of her work as, in the words of one critic, "hackish, overbearing... fake" and infused with "the bitter scent of fin-de-siècle fraudulence."[15] Perhaps this "bitter scent of fin-de-siècle fraudulence" ascribed to Goldin's work might, in retrospect, be traced to the fact that Brassaï was there first, haunting her work with an earlier era's representation of identity-performance, sexual transgression,

backdrops, camera angles, and lighting effects, but performers in a carefully orchestrated scenario. A Transylvanian electrician, employed by Brassaï as a bodyguard and jack-of-all-trades, stands in as a client in *La toilette dans un hôtel de passe*. This picture is particularly rich as a visual performative. The seedy flower-print fabric that hangs down in front of the bidet forms a makeshift curtain that seems ready to be yanked aside to gratify a bank of imagined voyeurs on the other side. Compositional preciosity is risked by the careful orchestration of darks and lights, specifically the rhythmic counterpoints between the dark, "curtain-like" top worn by the prostitute and the brilliant, white-fringed towel splayed against the dirty wall below the sink. The scripted feel of the image is reinforced by the sense that it may have been inspired by a literary source. The first chapter of Charles-Louis Philippe's celebrated turn-of-the-century demimonde novel *Bubu de Montparnasse* evokes a "Paris by night" phantasmagoria—shop windows glowing, carriage lights flickering, crowds surging down the Boulevard Sébastopol in a state of "lit up"

BRASSAÏ
*Mirrored wardrobe in a brothel,*
*Rue Quincampoix*, c. 1932

gender masquerade, and *toxicomanie*. Brassaï, though, trumps (but perhaps strengthens) Goldin by providing an anticipatory example of documentary photography that spurs investigation into the secret life of social interactions as they confound the normative typologies of bourgeois sexuality.

Notes

1.  See Liz Kotz, "Aesthetics of 'intimacy'," in Deborah Bright, ed., *The Passionate Camera: Photography and Bodies of Desire* (New York: Routledge, 1998), 204-215.

2.  Joyce McDougall, *The Many Faces of Eros: A Psychoanalytic Exploration of Human Sexuality* (London: Free Association Books, 1995), 183. McDougall is concerned to underline the difference between the English "addiction," and the French word most often used for it, "toxicomanie," meaning literally "a crazy desire for poison." While this makes sense in many contexts, McDougall's revision risks eliding the extent to which the craving for love, sex and drugs may act as alternates for each other within psychic economies of dependency.

3.  With respect to the significance of the fin-de-siècle parallelism in this early Wojnarowicz series, Mysoon Rizk has noted: "To examine and reconstruct his own life, Wojnarowicz found it helpful to imagine Rimbaud's, to fuse the poet's 'identity with modern New York urban activities mostly illegal in nature.' By characterizing both himself and Rimbaud in terms of 'mostly illegal' activities, Wojnarowicz underscored not only teenage rebelliousness and acts of delinquency they had in common but also the shared experience of growing up queer and outside society." Mysoon Rizk, "Constructing Histories: David Wojnarowicz's *Arthur Rimbaud in New York*," in *The Passionate Camera*, 179. My special thanks to Richard Meyer for bringing this essay to my attention.

4.  Brassaï, *Letters to My Parents*, trans. Peter Laki and Barna Kantor (Chicago: The University of Chicago Press, 1997), 63-64, 72.

5.  Paul Morand, *Paris de Nuit (Paris After Dark: Brassaï)*. English edition (London: Batsford, 1933), 1.

6.  Man Ray, in *The Age of Light* (1934), as cited by Roland Penrose, *Man Ray* (London: Thames and Hudson, 1975), 116.

7.  The sexuality of the image is mixed with cruelty, an impression backed up by recent biographical details pertaining to the identity of one of the sitters. Anne Wilkes Tucker reports findings by the historian Xavier Demange that suggest that the heavy-set woman in *Lesbian Couple at Le Monocle* was "a French weight-lifting champion... Before the war, she killed a man during an argument in her home; during the war, she collaborated with the German Gestapo and was allowed to torture female prisoners. The Resistance assassinated her in 1944." In Anne Wilkes Tucker, "Brassaï: Man of the World," in *Brassaï: The Eye of Paris* (Houston: Museum of Fine Arts, Houston, 1999), 43.

8.  Kiki left a description of this motley crew in her diary: "Montparnasse, so picturesque, so colorful! All the people of the earth have come here to pitch their tents; and yet, it's all just like one big family.... The crowd goes to look for a ray of sunlight at the cafés. The models meet one another there.... In the evening, I meet my little playmates once more: Foujita and the pretty Youki; ...To make a long story short, Montparnasse is a village that is as round as a circus. You get into it you don't know just how, but getting out again is not so easy!" In Billy Klüver and Julie Martin, eds., *Kiki's Memoirs*, trans. Samuel Putnam (Hopewell, N.J.: The Ecco Press, 1996), 184, 186, and 187.

9.  Brassaï, *Henry Miller: The Paris Years*, trans. Timothy Bent (New York: Arcade Publishing, 1975), 26.

10. Gary Indiana, "Crime and Misdemeanors," *Artforum* 38, no. 2 (October 1999): 117.

11. Brassaï's use of the *mise en abyme* conceit receives eloquent appraisal by Craig Owens. See Craig Owens, "Photography *en abyme*" in *Beyond Recognition: Representation, Power, and Culture*, Hal Foster, Jane Weinstein, Lynne Tillman, Barbara Kruger, eds. (Berkeley and Los Angeles: University of California Press, 1992), 21.

12. Michael Sand, "Nightlife," *Artforum* 32, no. 6 (February 1994): 17.

13  Charles-Louis Philippe, *Bubu de Montparnasse* (Paris: Librairie Universelle, 1905), 5.

14  Brassaï, *Marcel Proust sous l'emprise de la photographie* (Paris: Editions Gallimard, 1997), 107-108.

15. Jim Lewis, in his "thumbs-down" rating of the year in *Artforum*'s "Best and Worst Exhibitions of 1996" issue, *Artforum* 35, no. 4 (December 1996): 90.

## DIANE ARBUS

American, born Diane Nemerov in New York City, 1923. Began taking pictures 1940; studied under Lisette Model, New York, 1955-57. Worked with Allan Arbus (married 1941, separated 1959, daughters Doon and Amy). Published photography in *Harper's Bazaar*, *Show*, *Esquire*, *Glamour*, *The New York Times*. Instructor at Parsons School of Design, New York, 1965-66; Cooper Union, New York, 1968-69; Rhode Island School of Design, Providence, 1970-71. Recipient: Guggenheim Fellowship, 1963, 1966; Robert Leavitt Award, New York, 1970. Died by suicide in New York, 1971.

The Ralph M. Parsons Foundation
Photography Collection

DIANE ARBUS
Exhibition catalogue. New York:
The Museum of Modern Art, and
Millerton, N.Y.: Aperture, 1972.
Edited and designed by Doon Arbus
and Marvin Israel.

80 of 80 black-and-white silver prints,
each signed by Doon Arbus; posthumously
printed by Neil Selkirk.

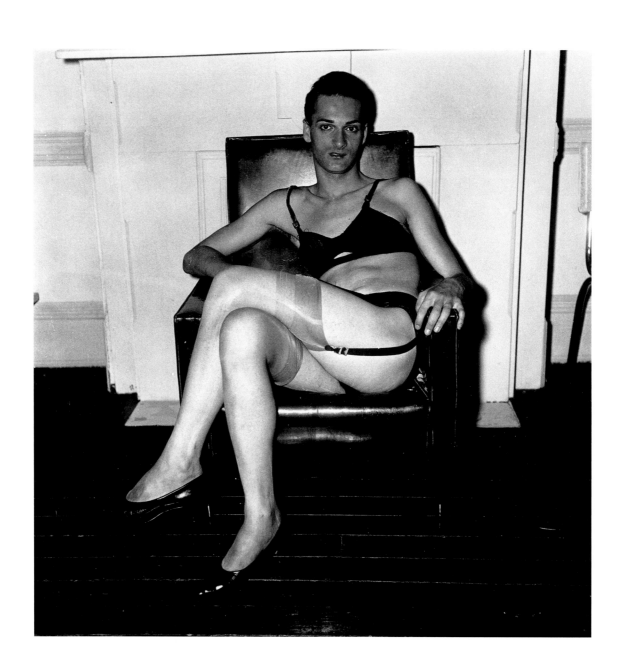

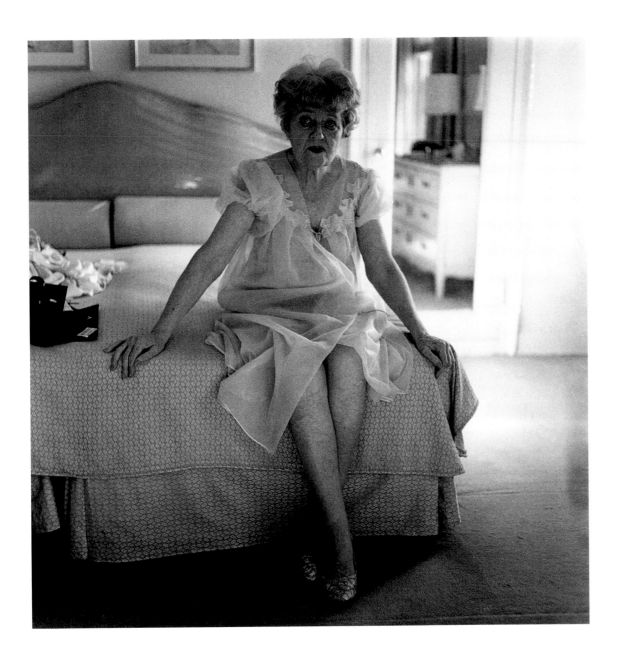

opposite:
*Seated man in a bra and stockings, N.Y.C.*, 1967
above:
*Woman in her negligee, N.Y.C.*, 1966

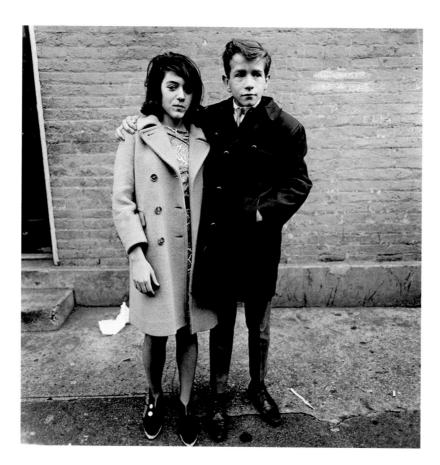

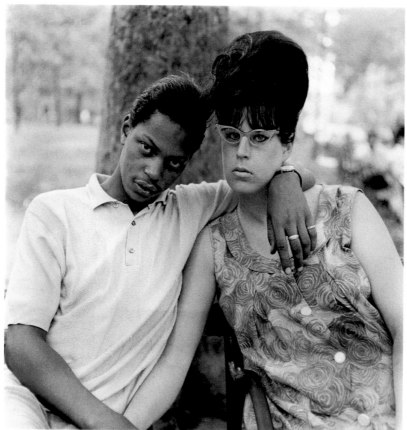

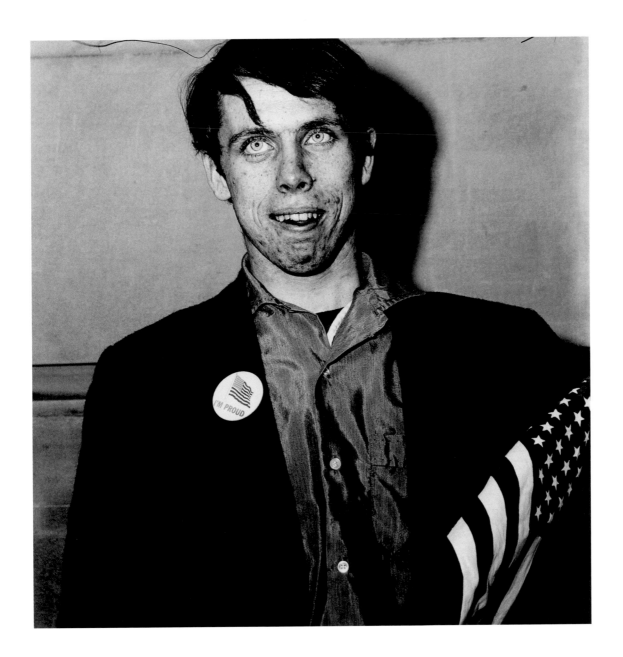

opposite top:
*Teenage couple on Hudson Street, N.Y.C.*, 1963
opposite bottom:
*A young man with his pregnant wife in*
*Washington Square Park, N.Y.C.*, 1965
above:
*Patriotic young man with a flag, N.Y.C.*, 1967

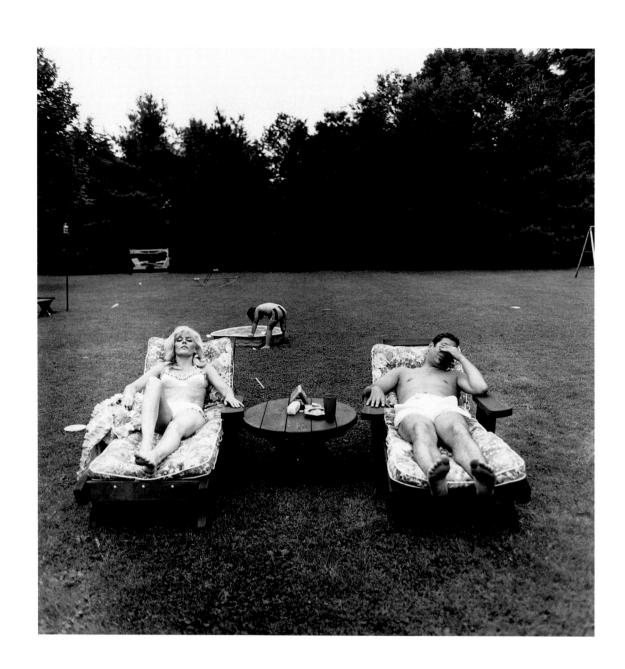

opposite:
*A family on their lawn one Sunday in*
*Westchester, N.Y.*, 1968
above:
*A castle in Disneyland, Cal.*, 1962

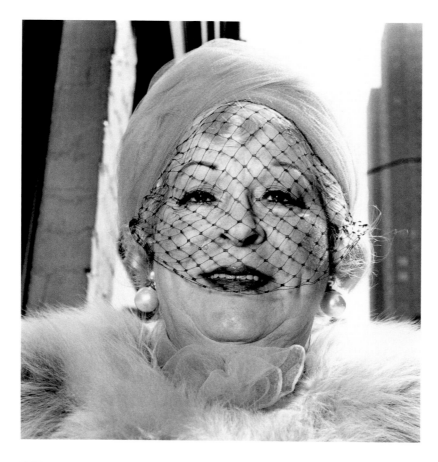

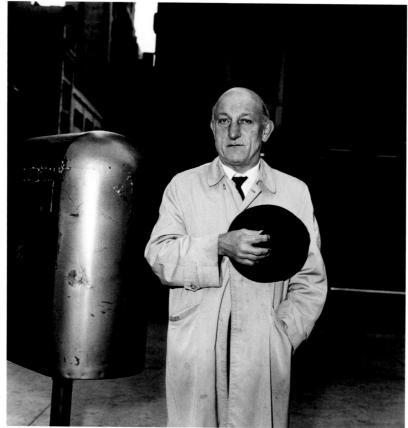

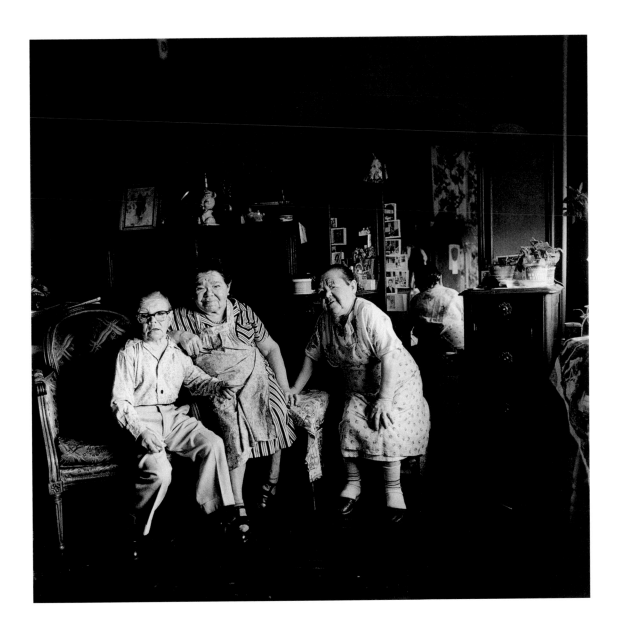

opposite top:
*Woman with a veil on Fifth Avenue, N.Y.C.*, 1968
opposite bottom:
*Man at a parade on Fifth Avenue, N.Y.C.*, 1969
above:
*Russian midget friends in a living room on*
*100th Street, N.Y.C.*, 1963

**BRASSAÏ**

French, born Gyula Halász in Brasso, Transylvania, Hungary (now Romania), 1899; immigrated to France in 1924. Studied at the Academy of Fine Arts, Budapest, 1918-19; received his B.A. from Berlin Hochschule Academy in 1922. Worked as an artist and journalist from 1924-30. Began taking pictures in 1930 and worked freelance for *Minotaure*, *Verve*, and *Harper's Bazaar* until the German occupation in 1940. In 1945 began working for *Picture Post*, *Lilliput*, *Coronet*, *Labyrinthe*, *Réalités*, *Plaisirs de France*, and *Harper's Bazaar* until 1963. Recipient: Emerson Medal, London, 1934; Gold Medal, Daguerre Centennial Exhibition, Budapest, 1937; Gold Medal, Biennale de Fotografia, Venice, 1957; Prize, Cannes Film Festival, 1956; Obelisk of Honor, Photokina, Cologne, 1963; American Society of Magazine Photographers Award, with Ansel Adams, 1966; Medal, City of Arles, France, 1974; Premier Grand Prix National de la Photographie de la Légion d'Honneur, 1976. Died in Nice, 1984.

The Ralph M. Parsons Foundation
Photography Collection

THE SECRET PARIS OF THE 30's
New York: Pantheon Books, 1976.
Translated from the French by Richard Miller.

91 of 123 black-and-white silver prints,
each signed.

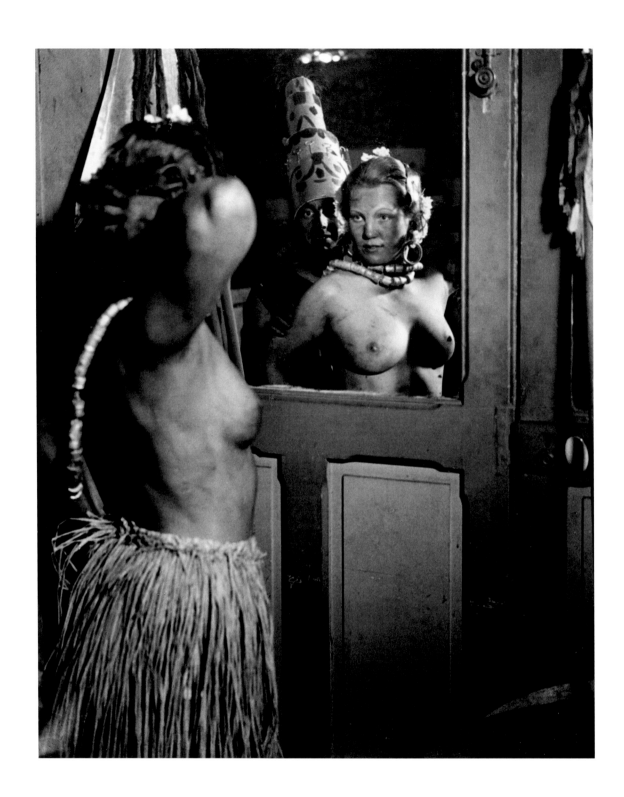

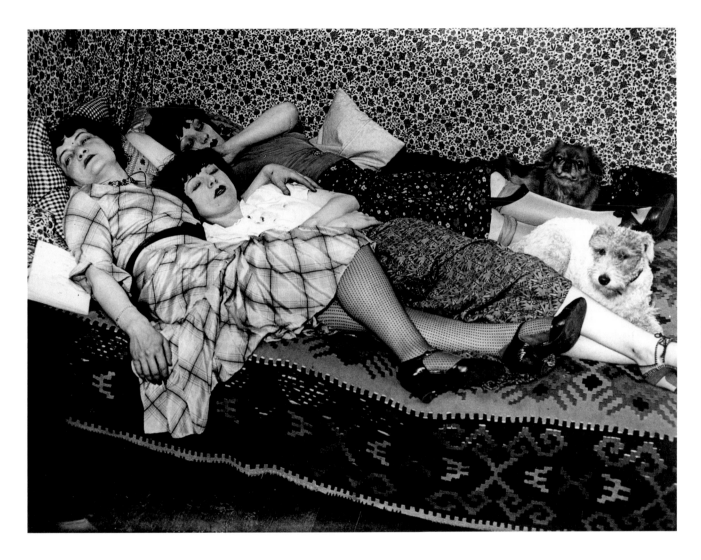

opposite:
*The Bal des Quat'z Arts. A couple*
*getting "dressed," c. 1931*
above:
*Kiki with her friends Thérèse Treize de Caro*
*and Lily, c. 1932*

opposite:

*A prostitute playing Russian billiards, Boulevard*

*Rochechouart, Montmartre,* c. 1932

above left:

*Conchita with sailors in a cafe on the*

*Place d'Italie,* c. 1933

above right:

*A happy group at the Quatre Saisons,* c. 1932

opposite top:
*A fortuneteller in her wagon,*
*Boulevard Saint-Jacques, c. 1933*
opposite bottom:
*Police during a raid in Montmartre, c. 1931*
above:
*Conchita's dance at "Her Majesty, Woman,"*
*Boulevard Auguste-Blanqui, c. 1931*

**ROBERT FRANK**

Swiss, born in Zurich, Switzerland, 1924; moved to United States in 1947, and to Canada in 1970. Educated in Zurich, apprenticed to Hermann Eidenbenz (Basel, 1940-41) and Michael Wolgensinger (Zurich, 1942). Following military service became a still photographer for Gloria Films in Zurich. In New York became a freelance photographer for *Fortune*, *Life*, *Look*, and *McCall's* under Alexey Brodovitch, art editor for *Harper's Bazaar*. Independent photographer and filmmaker in New York, 1956-69, and in Cape Breton, Nova Scotia, since 1970. Involved in film-making with Allen Ginsberg, Larry Rivers, Peter Orlovsky, and Jack Kerouac. Visiting instructor in filmmaking at University of California, Davis, in 1977. Recipient: Guggenheim Fellowship, 1955 and 1956; first prize, San Francisco Film Festival, 1959; filmmaking grant from the Creative Artists Public Service Program of New York, 1971; Peer Award for "Distinguished Career in Photography" by The Friends of Photography in San Francisco, 1986; the Erna and Victor Hasselblad Photographic Prize, 1996. Lives in Mabou, Nova Scotia.

The Ralph M. Parsons Foundation
Photography Collection

THE AMERICANS
Millerton, N.Y.: Aperture, 1978.
Introduction by Jack Kerouac from 1959.

83 of 83 black-and-white silver prints,
each signed.

opposite:
*Convention hall – Chicago*, 1956
above:
*St. Francis, gas station and*
*City Hall – Los Angeles*, 1956

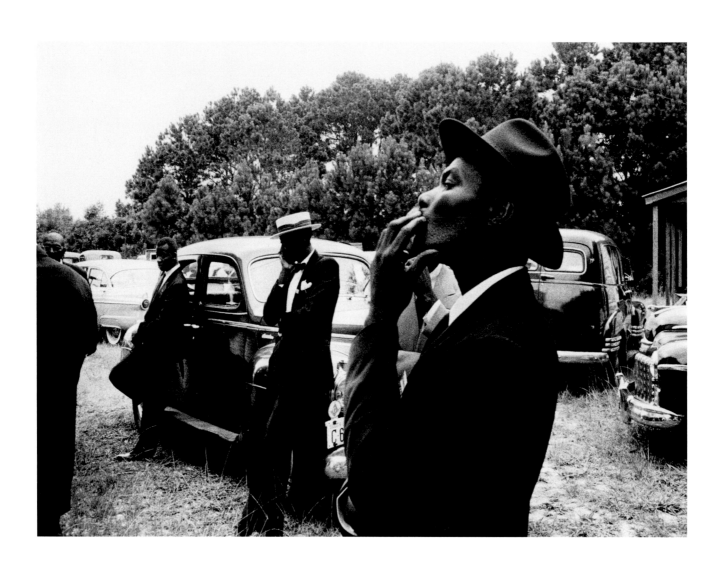

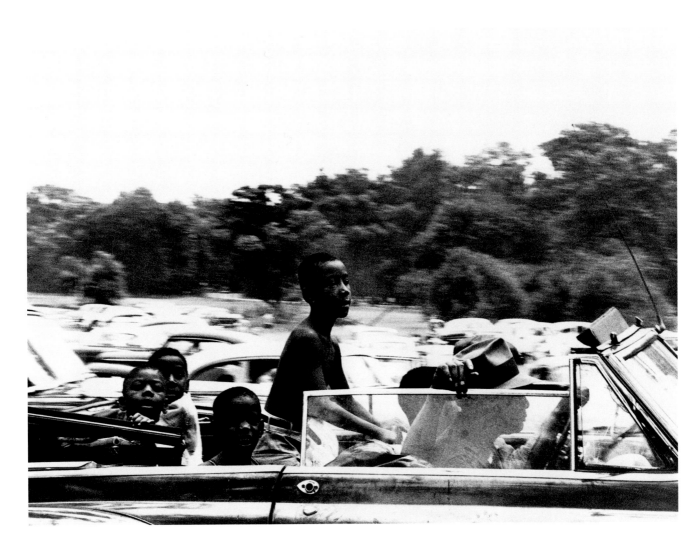

opposite:
*Funeral – St. Helena, South Carolina*, 1955
above:
*Belle Isle – Detroit*, 1955-1956

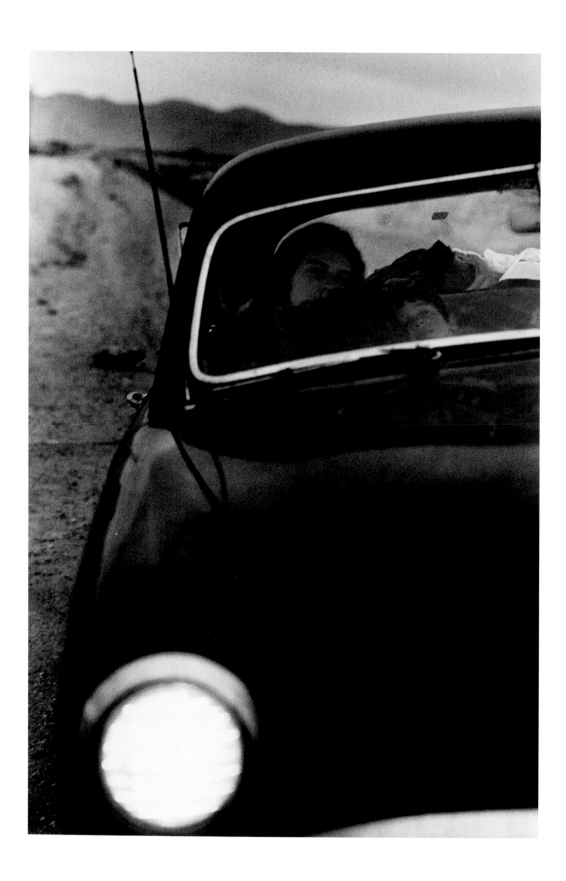

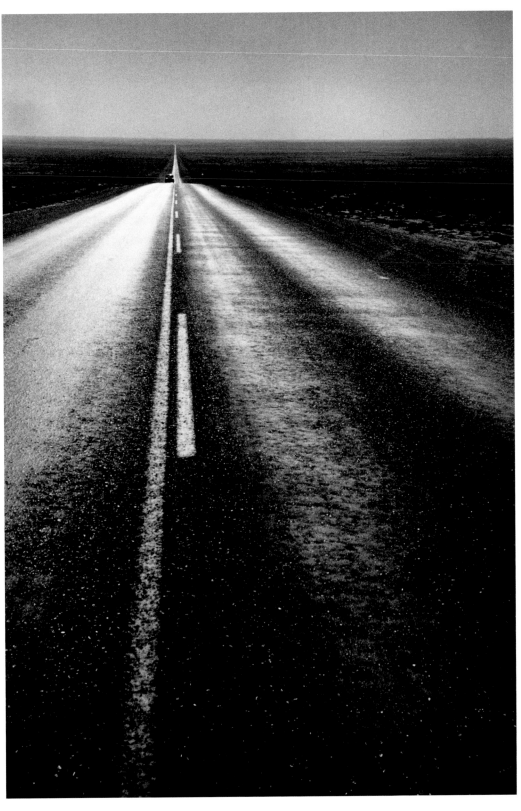

opposite:
*U.S. 90, en route to Del Rio, Texas,* 1955
above:
*U.S. 285, New Mexico,* 1955

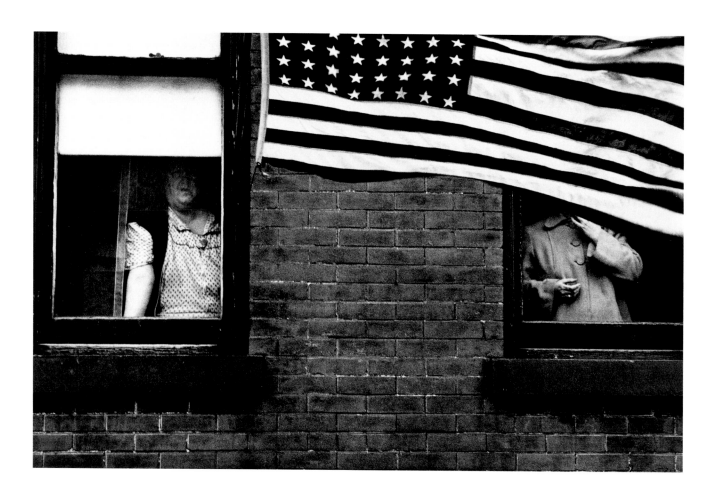

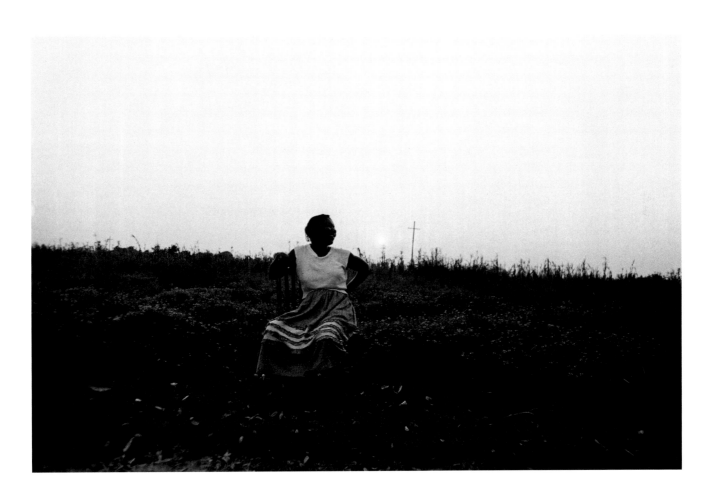

opposite:

*Parade – Hoboken, New Jersey*, 1955

above:

*Beaufort, South Carolina*, 1955

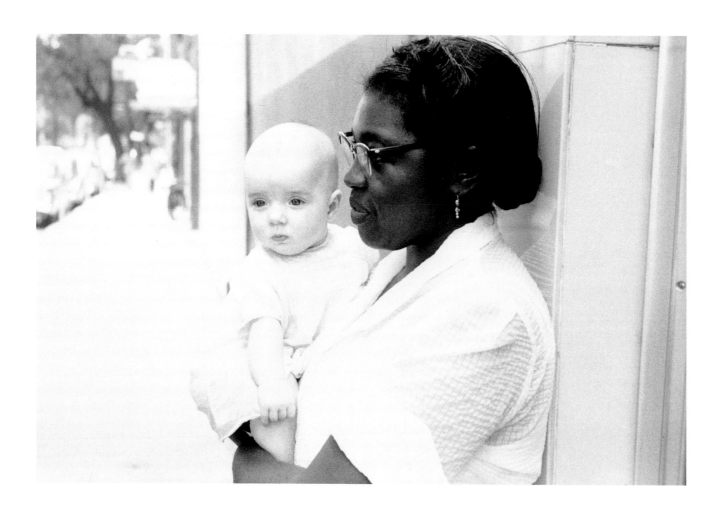

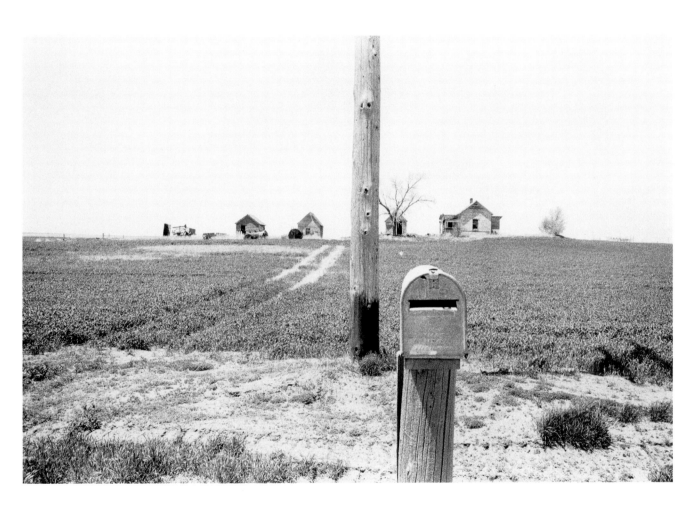

opposite:
*Charleston, South Carolina,* 1955
above:
*U.S. 30 between Ogallala and North Platte,*
*Nebraska,* 1955

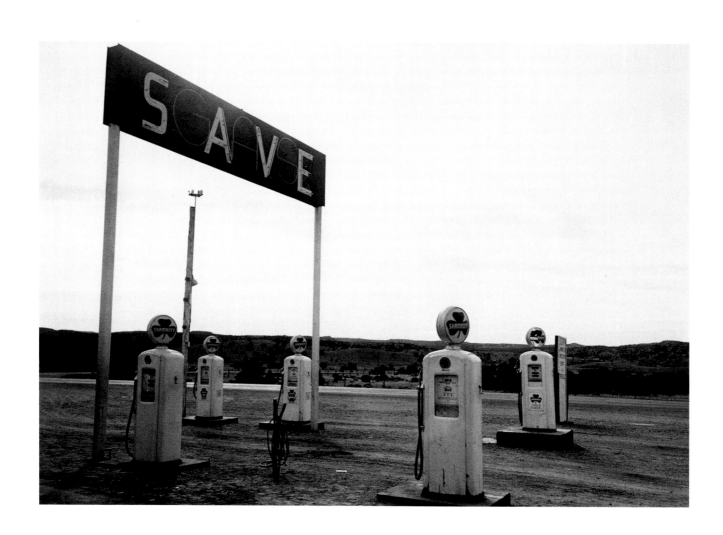

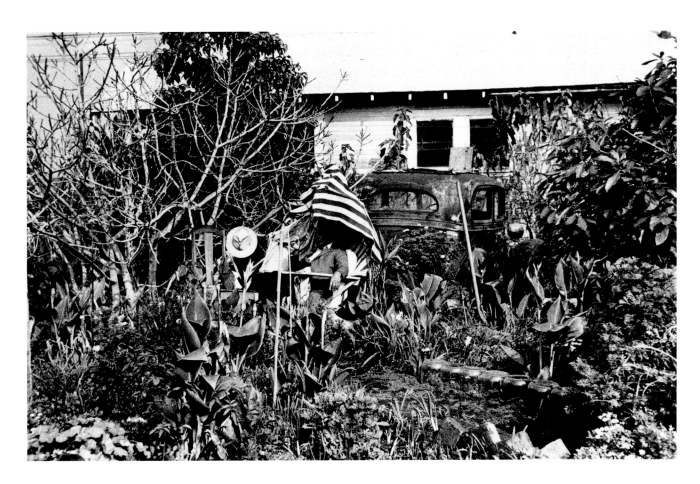

opposite:
*Santa Fe, New Mexico*, 1955
above:
*Backyard – Venice West, California*, 1956

## LEE FRIEDLANDER

American, born in Aberdeen, Washington, 1934. Studied photography at Art Center College of Design, Los Angeles, 1953-55, under Edward Kaminski. Freelance photographer working for *Esquire*, *McCall's*, *Collier's*, *Art in America* since 1955. Artist-in-Residence, University of Minnesota, Minneapolis, 1966; Guest Lecturer, University of California, Los Angeles, 1970; Mellon Professor of Fine Arts, Rice University, Houston, 1977. Recipient: Guggenheim Fellowship, 1960, 1962, 1977; National Endowment for the Arts Fellowship, 1972, 1977, 1978, 1979, 1980; Friends of Photography Peer Award, 1980; Medal of Paris, 1981; Edward MacDowell Medal, 1986; John D. and Catherine T. MacArthur Foundation Award, 1990. Lives in New City, New York.

The Ralph M. Parsons Foundation
Photography Collection

THE AMERICAN MONUMENT
New York: The Eakins Press Foundation, 1976.
Excerpt by Walt Whitman; afterword by
Leslie George Katz.

213 of 213 black-and-white silver prints,
each signed.

CHERRY BLOSSOM TIME IN JAPAN
Book of 25 photogravures printed by
Thomas Palmer from photographs by
Lee Friedlander, 1986, each gravure signed
and editioned 24 of 50.

FACTORY VALLEYS
New York: Callaway Editions, 1982. Excerpt from "Scenery and George Washington or a History of the United States of America" by Gertrude Stein; afterword by Leslie George Katz.

62 of 62 black-and-white silver prints, each signed.

FLOWERS AND TREES
New City, N.Y.: Haywire Press, 1981.

40 of 40 black-and-white silver prints, each signed.

LEE FRIEDLANDER: PHOTOGRAPHS
New City, N.Y.: Haywire Press, 1978. Excerpt entitled "A Visit From Albertine" from *The Guermantes Way* by Marcel Proust.

137 of 137 black-and-white silver prints, each signed.

LEE FRIEDLANDER PORTRAITS
Boston: Little, Brown & Company, 1985. Foreword by R.B. Kitaj.

71 of 71 black-and-white silver prints, each signed.

LEE FRIEDLANDER: SELF PORTRAIT
New City, N.Y.: Haywire Press, 1998 (2nd ed.). Introduction by Lee Friedlander; afterword by John Szarkowski.

44 of 46 black-and-white silver prints, each signed.

THE HIRSHHORN MUSEUM
AND SCULPTURE GARDEN,
WASHINGTON, D.C.
New City, N.Y.: Haywire Press, 1975-77.

52 black-and-white silver prints, each signed.

SHILOH
New City, N.Y.: Haywire Press, 1981.

32 black-and-white photographs by Lee Friedlander of Shiloh National Military Park, Tennessee, taken in 1977.

Editioned portfolio 1 of 20, each signed.

WORK FROM THE SAME HOUSE:
PHOTOGRAPHS & ETCHINGS
London: Petersburg Press, 1969.

16 loose images of photographs and etchings on 46 x 76 cm. paper, watermarked and handmade by Hodgkinson for this publication. Photographs printed by Lee Friedlander and etchings by Jim Dine. Edition 61 of 75.

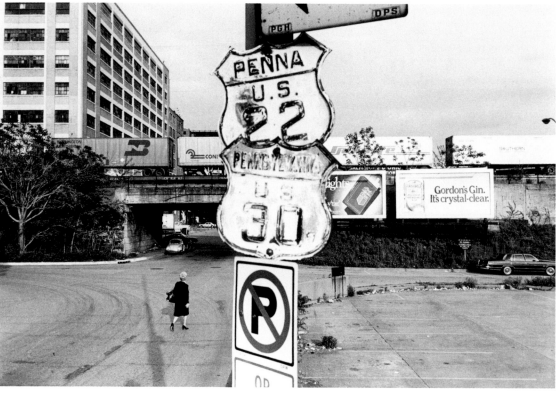

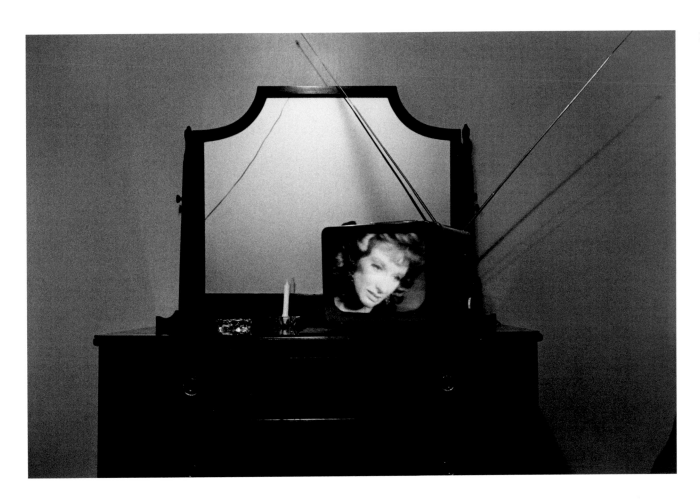

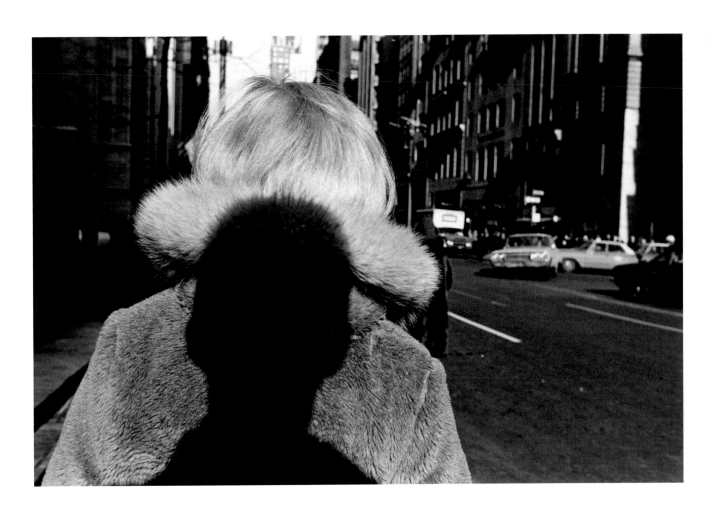

opposite:
*Denver, Colorado,* 1965
above:
*New York City,* 1966

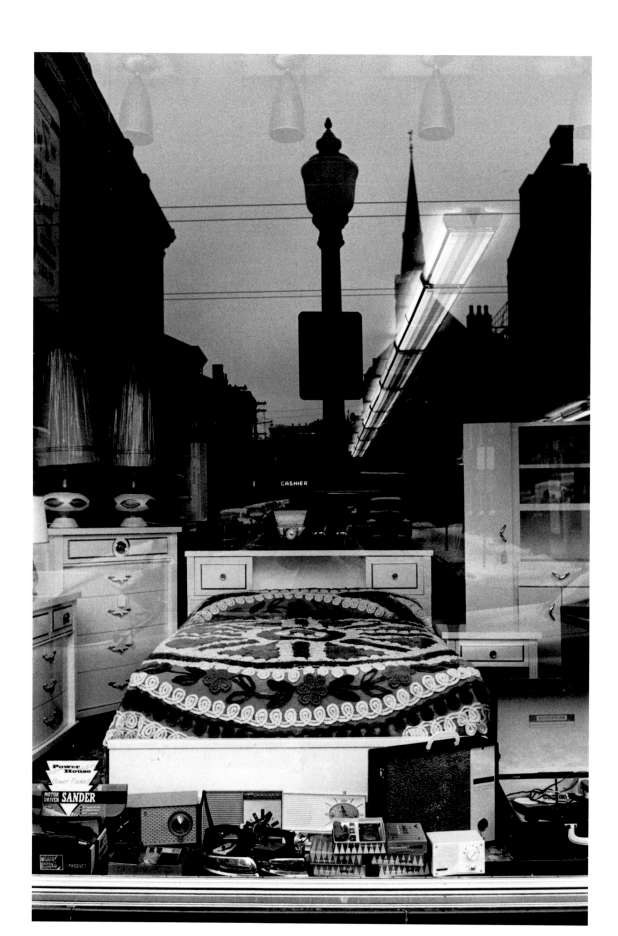

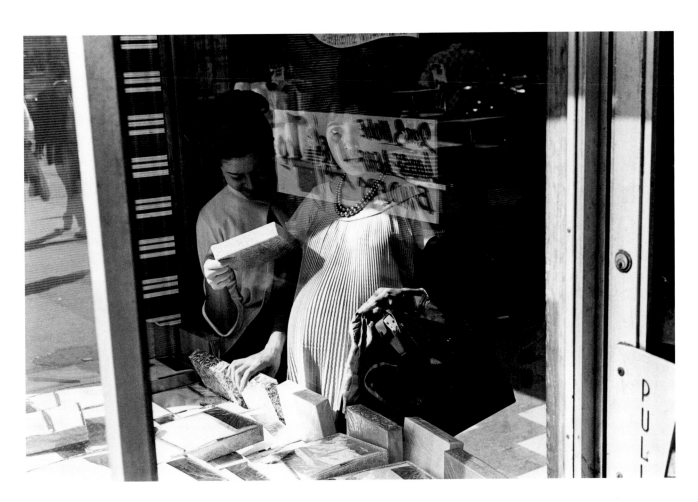

opposite:
*Cincinnati, Ohio*, 1963
above:
*New York City*, 1963

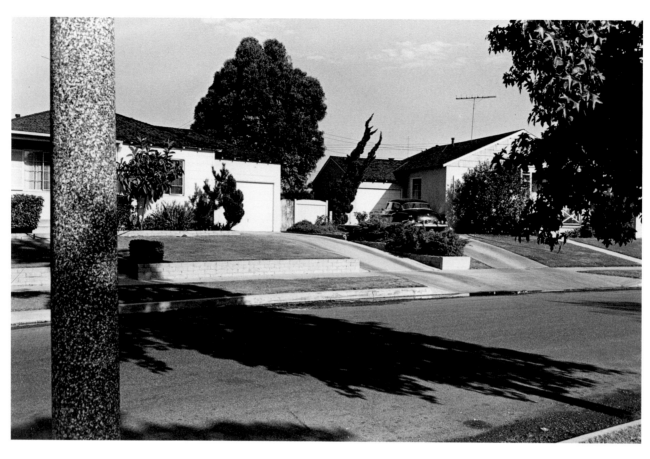

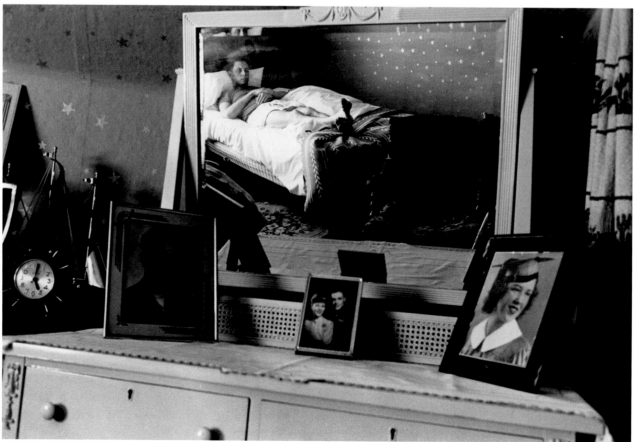

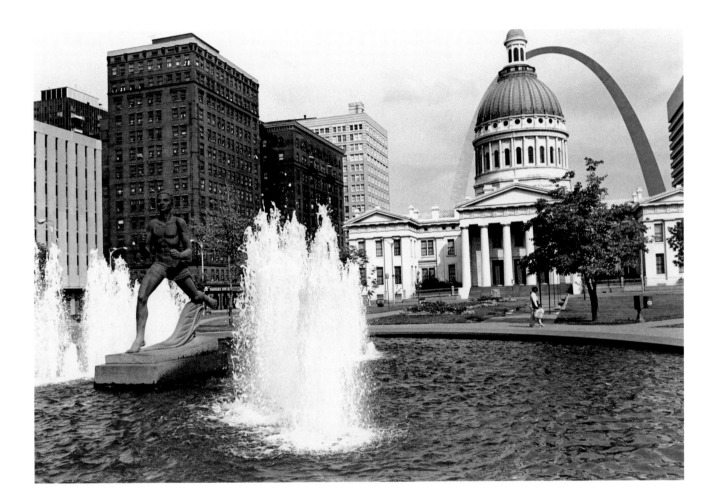

opposite top:
*Los Angeles, California,* 1972
opposite bottom:
*Aloha, Washington 1967,* 1967
above:
*St. Louis, Missouri,* 1972

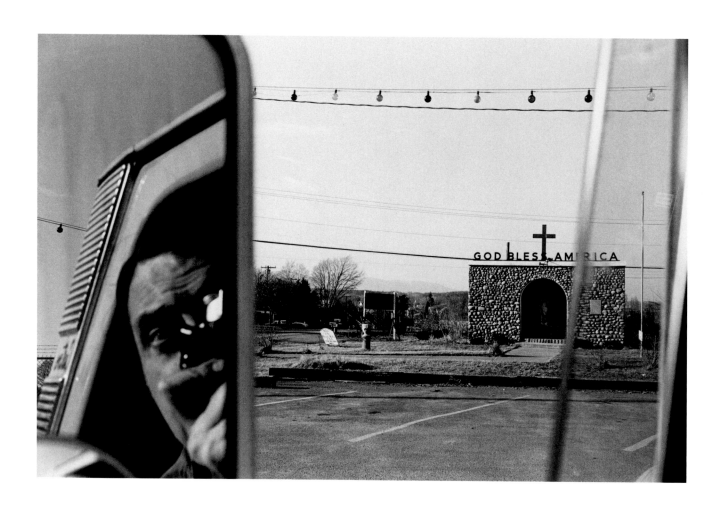

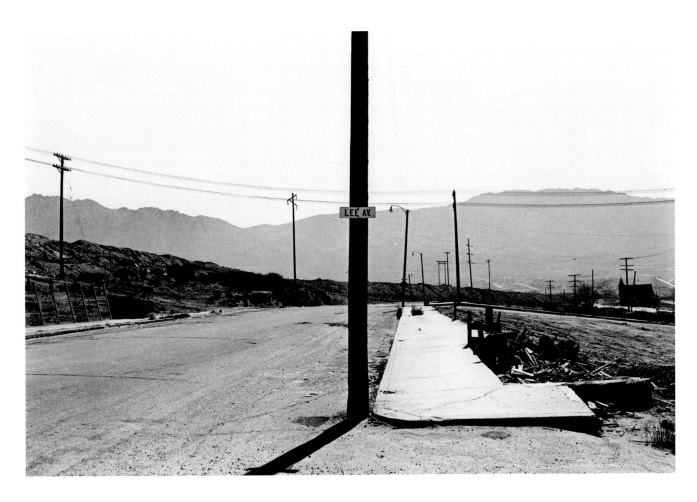

opposite:

*Route 9W, New York,* 1969

above:

*Butte, Montana,* 1970

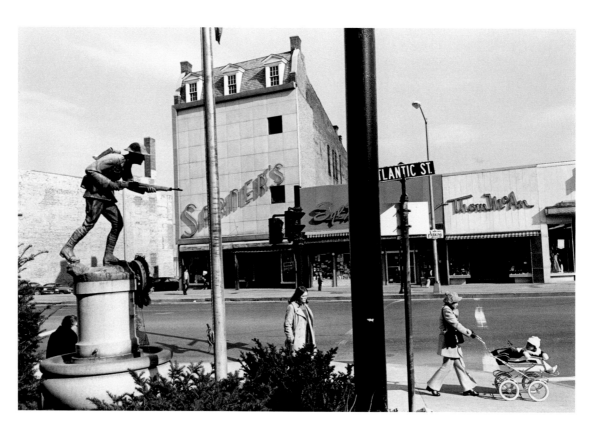

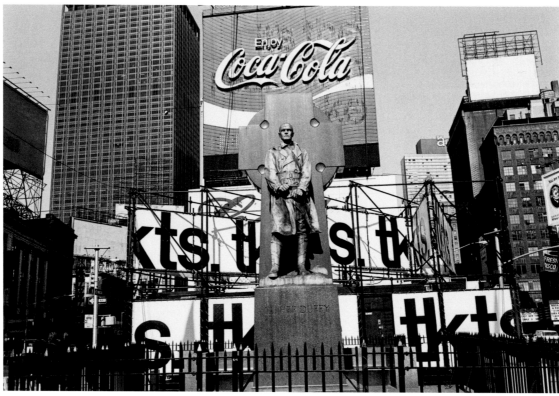

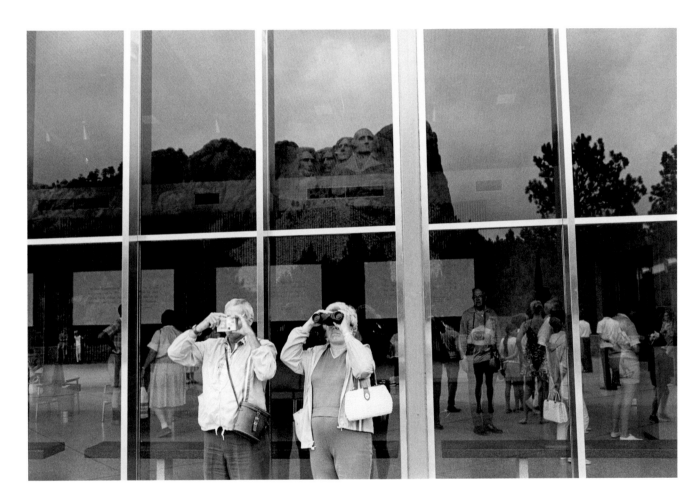

opposite top:

*Doughboy. Stamford, Connecticut,* 1974

opposite bottom:

*Father Duffy. Times Square, New York,*

*New York,* 1974

above:

*Mount Rushmore. South Dakota,* 1969

## HELEN LEVITT

American, born in New York, 1918. Studied at Art Student's League, New York, 1956-57. Has worked as a freelance photographer since 1939 and as a filmmaker since 1947. Recipient: Photography Fellowship, The Museum of Modern Art, New York, 1946; Guggenheim Fellowship, 1959, 1960; Ford Foundation Film Grant, 1964; Creative Artists Public Service Fellowship, New York, 1974; National Endowment for the Arts Photography Fellowship, 1976; Guggenheim Memorial Foundation Fellowship, 1981; Master of Photography Award, International Center of Photography, 1997. Lives in New York City.

The Ralph M. Parsons Foundation
Photography Collection

A WAY OF SEEING
New York: Horizon Press, 1981.
Essay by James Agee from 1946.

68 of 68 black-and-white silver prints,
each signed.

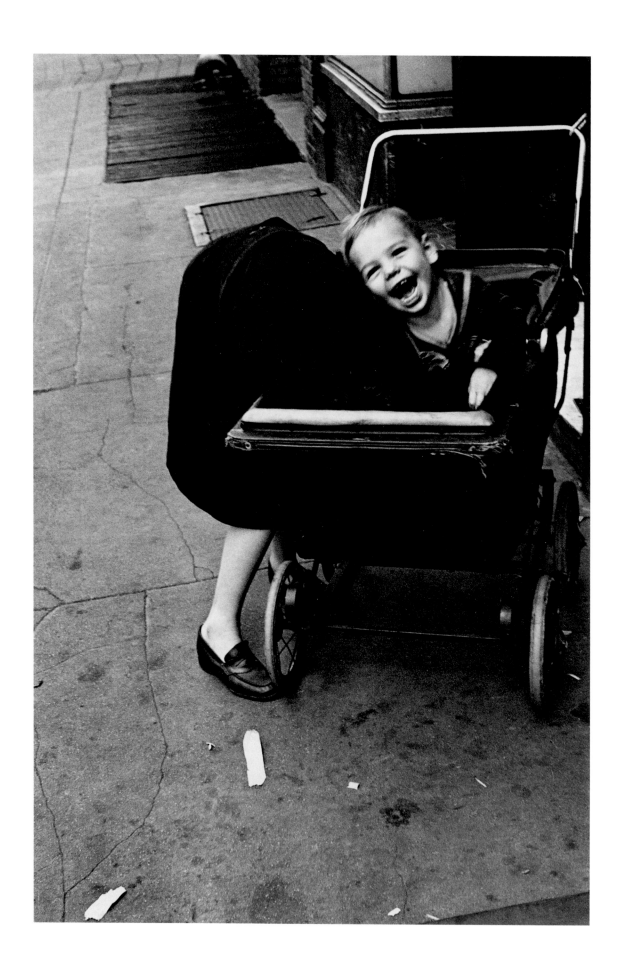

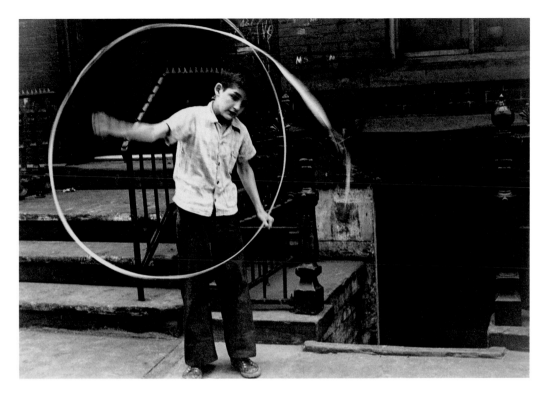

opposite and above top:

*N.Y.*, c. 1945

above bottom:

*N.Y.*, c. 1942

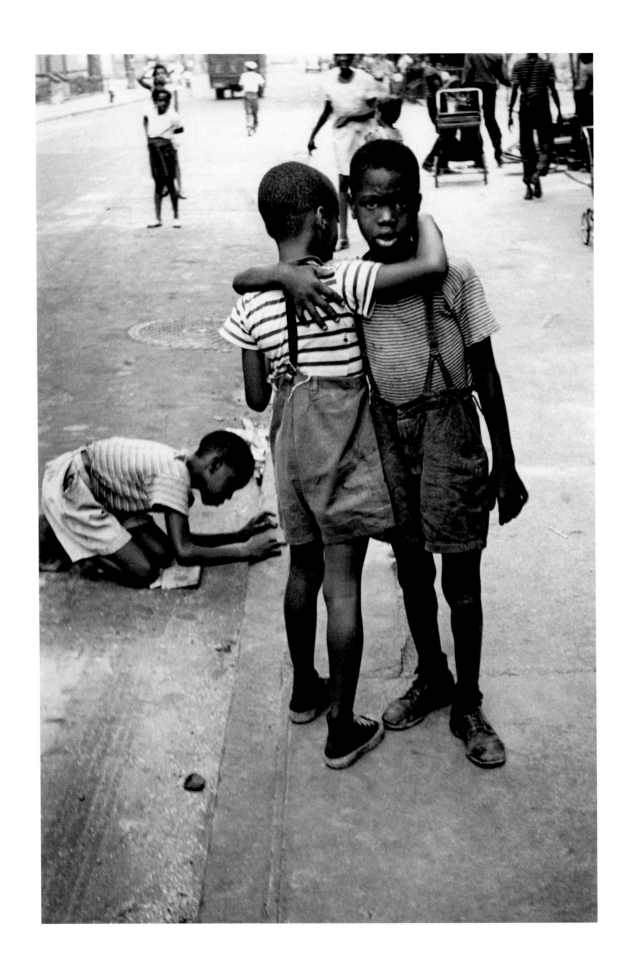

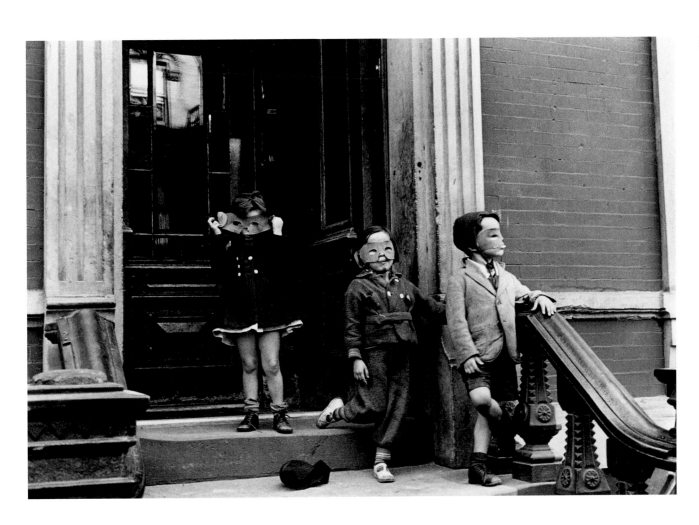

both:

*N.Y.*, c. 1942

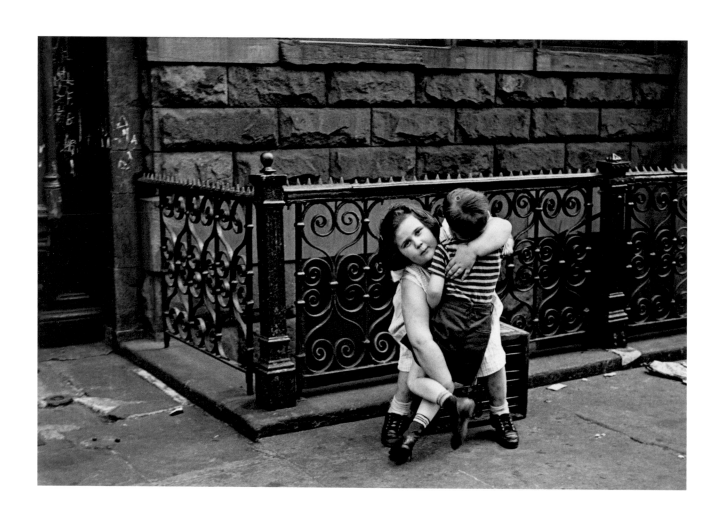

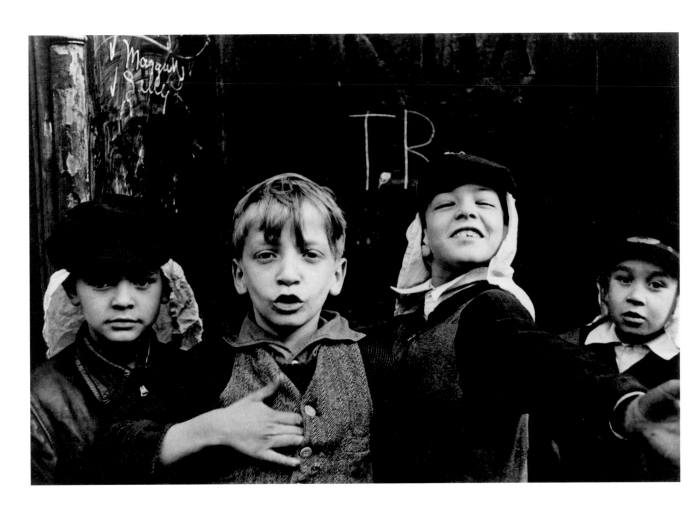

both:

*N.Y.*, c. 1942

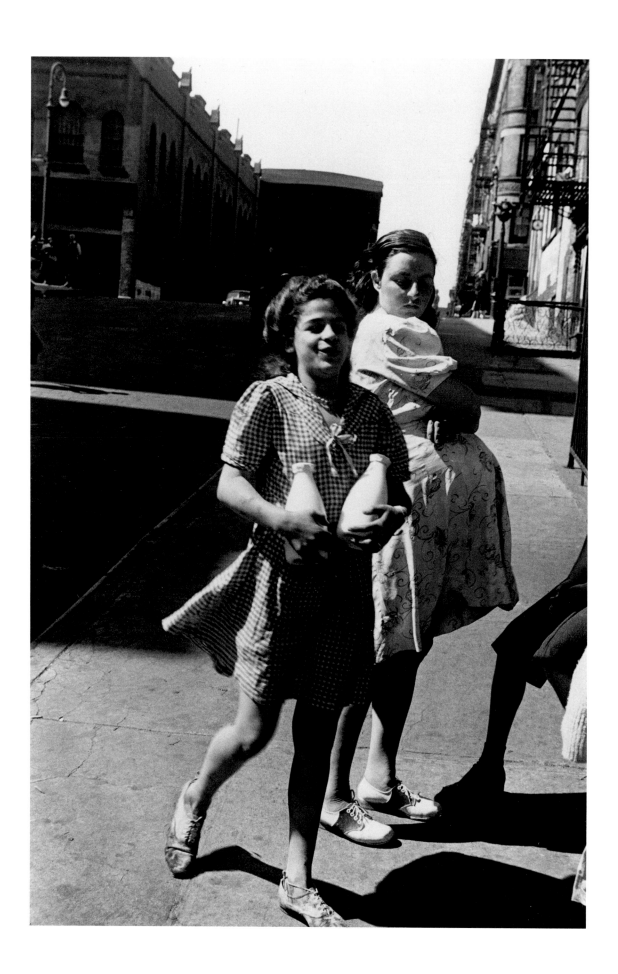

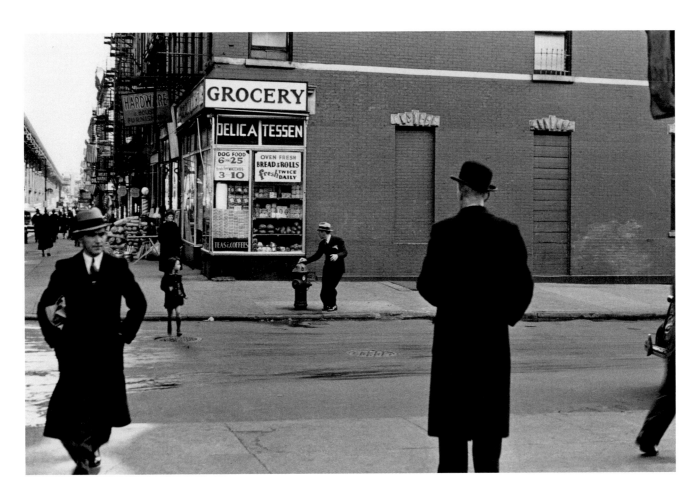

opposite:
*N.Y.*, c. 1945
above:
*N.Y.*, c. 1942

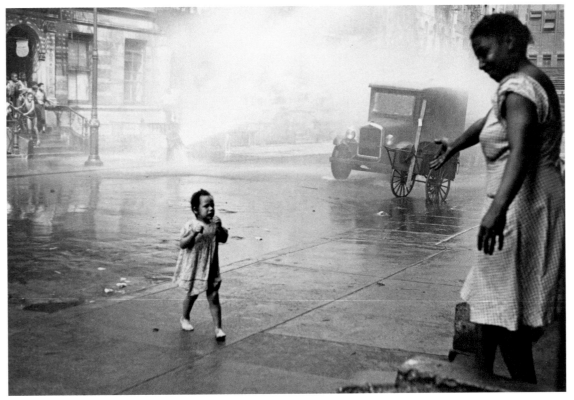

**DANNY LYON**

American, born in Brooklyn, New York, 1942. Studied history at the University of Chicago, 1959-63, B.A., 1963. Self-taught photographer. Staff Photographer, Chicago Outlaws Motorcyclists's Club, 1956-66. Staff Member and Photographer, Student Non-Violent Coordinating Committee, Atlanta, Georgia, 1963-64. Independent photographer and filmmaker since 1969. Associate, Magnum Photos co-operative agency, New York, since 1967. Recipient: Guggenheim Fellowship in Photography, 1969, and in Filmmaking, 1979; National Endowment for the Arts grants/fellowships, 1974, 1981, 1983, 1989; Rockefeller Fellowship, 1990; Honorary Doctorate of Fine Arts, The Art Institute of Boston, 1995. Associate Professor, SUNY Buffalo, non-fiction film, 1986; Adjunct Professor, Columbia University, non-fiction film, 1987 and 1988, and Queensborough Community College, 1997-98. Married to Nancy Weiss Lyon; father of four children. Lives on a farm in New York.

The Ralph M. Parsons Foundation
Photography Collection

CONVERSATIONS WITH THE DEAD
RFG Publishing Inc., 1984.

Edition I of XII artist's proof sets.
76 black-and-white silver prints, each signed.

MERCI GONAÏVES
Clintondale, N.Y.: Bleak Beauty Books, 1988.
Text by Danny Lyon.

37 of 37 black-and-white silver prints,
each signed.

THE BIKERIDERS
Santa Fe, N.M.: Twin Palms Publishers, 1997.

48 of 48 black-and-white silver prints,
each signed.

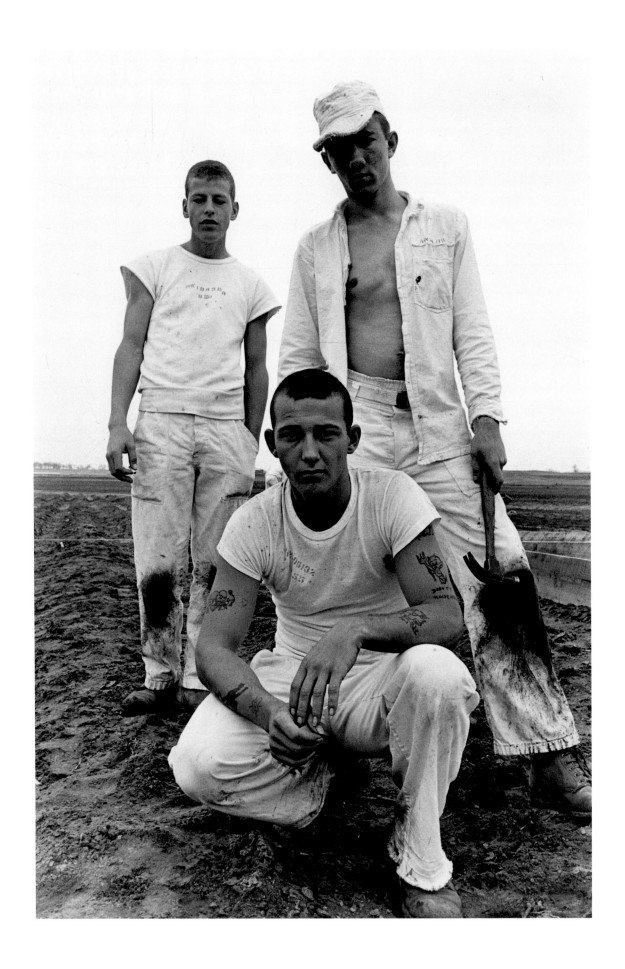

both:

*Untitled*, c. 1967-69

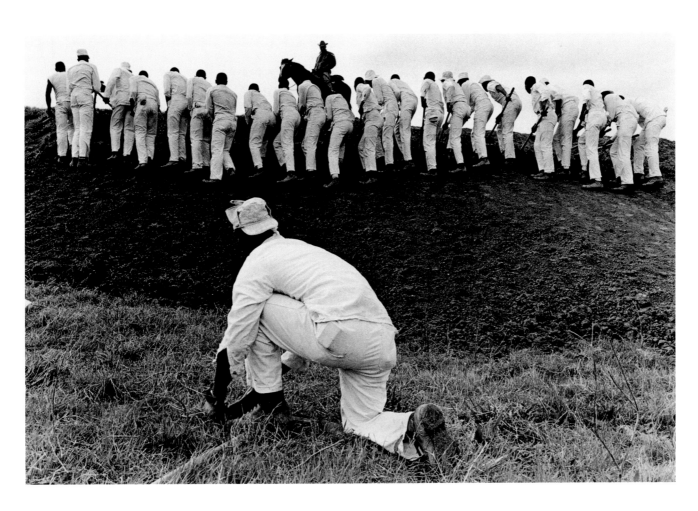

both:

*Untitled*, c. 1967-69

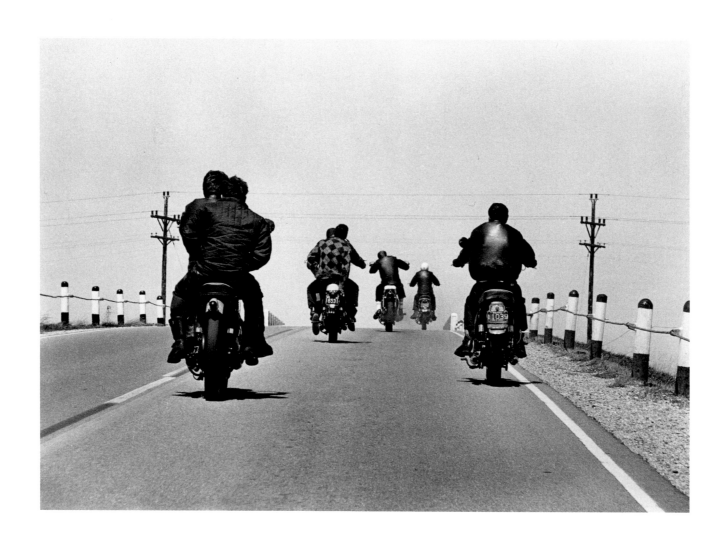

opposite:
*Untitled*, 1962
above left:
*Untitled*, 1965
above right:
*Untitled*, 1965

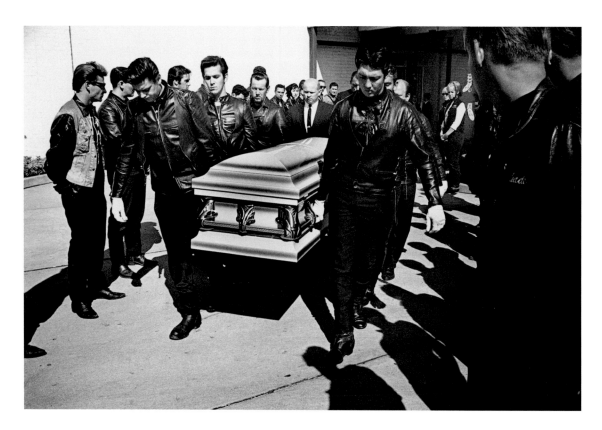

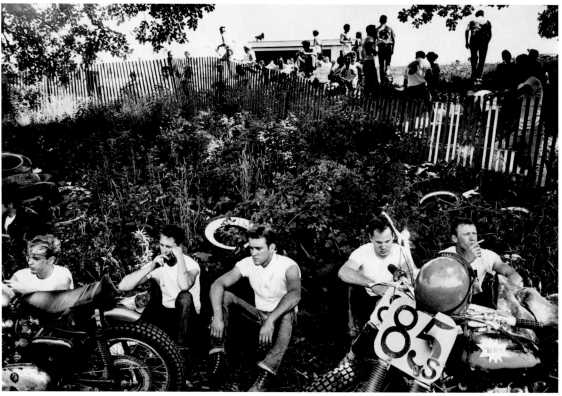

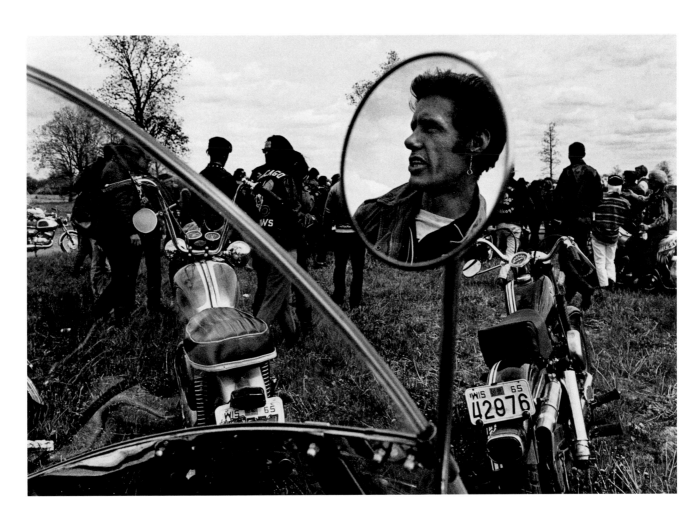

all:

*Untitled,* 1966

# ROGER MERTIN

American, born in Bridgeport, Connecticut, 1942. University of Bridgeport, 1960-61; Rochester Institute of Technology, New York, 1961-65, B.F.A. in photography. Studied under Nathan Lyons in private workshops and at the Visual Studies Workshop in Rochester, New York, 1969-72, M.F.A. Married Joan Schultz in 1964 (divorced, 1972). Worked as a photographic technician, Eastman Kodak Company, Rochester, 1965-66; Head of the Reproduction Center, 1966-67; Assistant Curator, 1968-69, George Eastman House, Rochester; Instructor, Rochester Institute of Technology, 1969-74. Instructor, 1973-74, and since 1975, Assistant Professor of Photographic Arts, University of Rochester. Recipient: Creative Artists Public Service Fellowship, New York, 1974; Guggenheim Photography Fellowship, 1974; National Endowment for the Arts Photography Fellowship, 1976; Sponsored Project, Light Work, Syracuse, New York, 1985; Minnesota State Arts Board, Artist Assistance Fellowship, 1998; McKnight Foundation Artist Fellowship for Photography, 1999. Lives in Rochester and St. Paul, Minnesota.

The Ralph M. Parsons Foundation
Photography Collection

PLASTIC LOVE DREAMS
26 black-and-white silver prints, each signed.

ROGER MERTIN: RECORDS, 1976-78
Exhibition catalogue. Chicago: Chicago Center
for Contemporary Photography, Columbia
College, 1978. Edited and with an afterword
by Charles Desmarais.

46 of 46 black-and-white silver prints,
each signed.

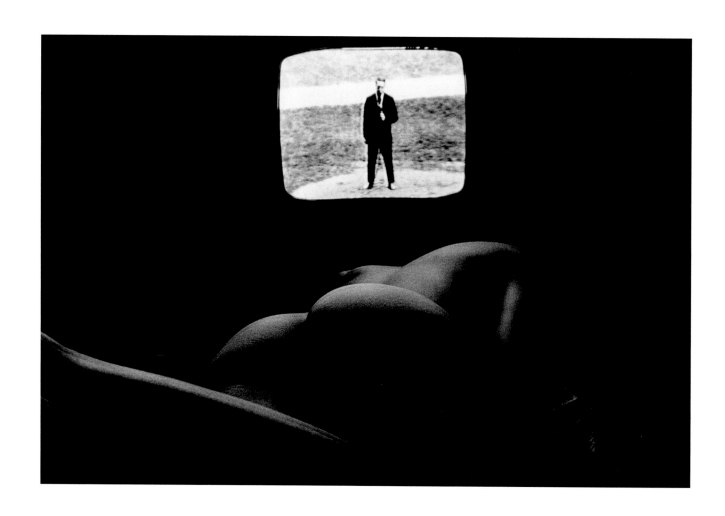

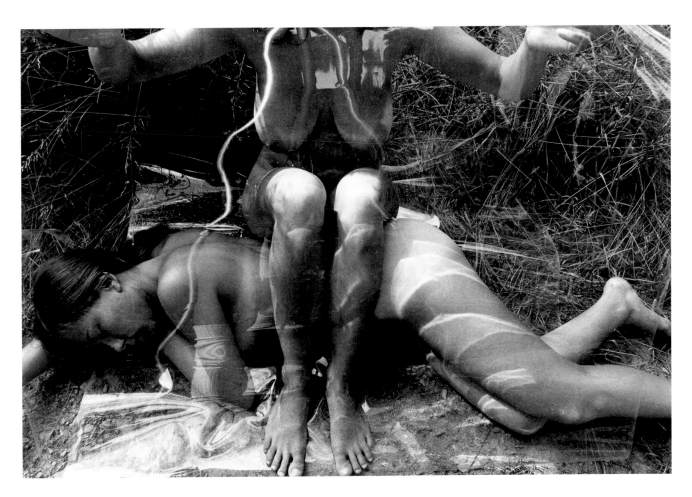

opposite:
*Untitled*, 1968
above:
*Untitled*, 1969

opposite top:
*Sylvan Lake*, 1977
opposite bottom:
*New York State*, 1977
above:
*Holcomb, New York*, 1977

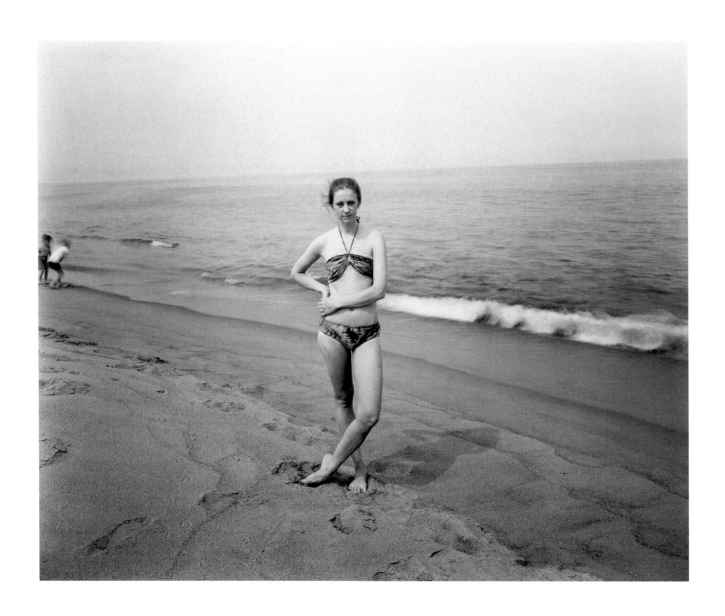

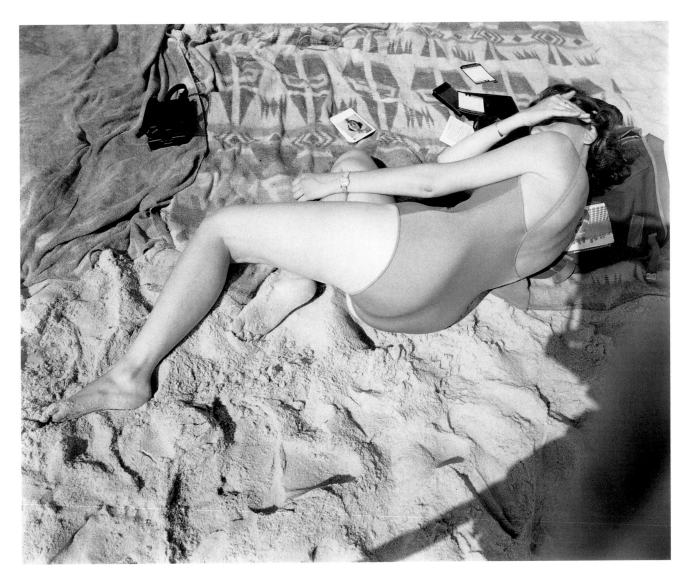

opposite:
*Sandi, Plum Island,* 1977
above:
*Laurie, Bridgehampton, New York,* 1977

opposite top:
*Poultneyville Orchard*, 1977
opposite bottom:
*Stratford, Connecticut*, 1977
above:
*Pennsylvania Roadside*, 1977

# JOHN PFAHL

American, born in New York City, 1939. Syracuse University, New York, 1957-61, B.F.A. in graphic design. Served in the United States Army, Fort Belvoir, Virginia, 1961-63. Syracuse University, New York, 1968, M.F.A. in communications. Married Bonnie Gordon in 1965. Associate Professor, School of Photographic Arts and Science, Rochester Institute of Technology, Rochester, New York, 1968-84. Adjunct Professor, University of Buffalo, New York, since 1990. Recipient: Creative Artists Public Service Grant, 1975, 1979; National Endowment for the Arts Photography Fellowship, 1977, 1990. Honorary Doctorate of Fine Arts, Niagara University, Niagara Falls, New York, 1990. Lives in Buffalo, New York.

The Ralph M. Parsons Foundation
Photography Collection

ALTERED LANDSCAPES: THE
PHOTOGRAPHS OF JOHN PFAHL
Carmel, Calif.: The Friends of Photography in
association with Robert Freidus Gallery, 1981.
Introduction by Peter C. Bunnell.

152 of 152 color coupler prints,
each signed and numbered.

ARCADIA REVISITED:
NIAGARA RIVER & FALLS FROM
LAKE ERIE TO LAKE ONTARIO / PHO-
TOGRAPHS BY JOHN PFAHL
Albuquerque, N.M.: University of New Mexico
Press, in association with the Buscaglia-Castellani
Art Gallery at Niagara University, 1985. Essays by
Estelle Jussim and Anthony Bannon.

52 of 52 color coupler prints, plus two additional
prints, each signed and numbered.

PICTURE WINDOWS
Boston: Little, Brown & Company, 1987.
Introduction by Edward Bryant.

57 photographs in the portfolio, 32 in the
publication, each signed and numbered.

POWER PLACES PORTFOLIO
40 color coupler prints, each signed and num-
bered.

SMOKE PORTFOLIO
12 color coupler prints, each signed and num-
bered, edition 3 of 25.

WATERFALLS PORTFOLIO
10 color coupler prints, each signed and num-
bered, edition 6 of 30.

opposite top:
*Amusement Area in Niagara Falls, Ontario,* 1985
opposite bottom:
*View of the Lewiston-Queenston Bridge,* 1986
above:
*Grain Elevators in Buffalo Harbor,* 1985

opposite:

*Diablo Dam, Skagit River, Washington,* 1982

above:

*The Geysers Power Plant, Mayacamas Mountains,*

*California,* 1983

PFAHL POWER PLACES **131**

opposite top:
*Bruce Mansfield Plant, Shippingport,*
*Ohio River, Pennsylvania,* 1981-84
opposite bottom:
*Four Corners Power Plant (morning),*
*Farmington, New Mexico,* 1982
above:
*Offshore Drilling Island (THUMBS),*
*Long Beach, California,* 1984

opposite top:
*Pacific Gas and Electric Plant,*
*Morro Bay, California,* 1983
opposite bottom:
*Palo Verde Nuclear Plant, Centennial Wash,*
*Arizona,* 1984
above:
*Trojan Nuclear Plant, Columbia River,*
*Oregon,* 1982

# GARRY WINOGRAND

American, born in New York City, 1928. Served in the United
States Air Force, 1945-47. Studied painting at City College of New
York, 1947-48; Columbia University, New York, 1948-51; studied
photography under Alexey Brodovitch, New School for Social
Research, New York, 1951. Married dancer Adrienne Lubow in
1952 (children Laurie, Ethan; divorced); married Eileen
Winogrand (daughter Melissa). Freelance photographer in New
York and Los Angeles, 1952-69. Taught at the New School for
Social Research; The School of The Art Institute of Chicago;
Institute of Design, Illinois Institute of Technology; Instructor of
Photography, University of Texas at Austin, 1973-84. Recipient:
Guggenheim Fellowship, 1964, 1969, 1978; New York Council of
the Arts Award, 1971; National Endowment for the Arts Grant,
1975. Died of cancer in Tijuana, Mexico, 1984.

The Ralph M. Parsons Foundation
Photography Collection

THE ANIMALS
New York: The Museum of Modern Art, 1969.
Afterword by John Szarkowski.

46 of 46 black-and-white silver prints,
each signed.

PUBLIC RELATIONS
New York: The Museum of Modern Art, 1977.
Introduction by Tod Papageorge.

69 of 69 black-and-white silver prints,
each signed.

WOMEN ARE BEAUTIFUL
New York: Light Gallery Books, Inc., 1975.
Essay by Helen Gary Bishop; excerpt by
Garry Winogrand.

85 of 85 black-and-white silver prints,
each signed and editioned.

opposite:
*Opening Night, Metropolitan Opera House,*
*Lincoln Center, New York, 1967, 1967*
above:
*Apollo 11 Press Conference, Cape Kennedy,*
*Florida, 1969, 1969*

opposite:
*Elliot Richardson Press Conference,*
*Austin, 1973,* 1973
above:
*Easter Sunday, Central Park,*
*New York, 1971,* 1971

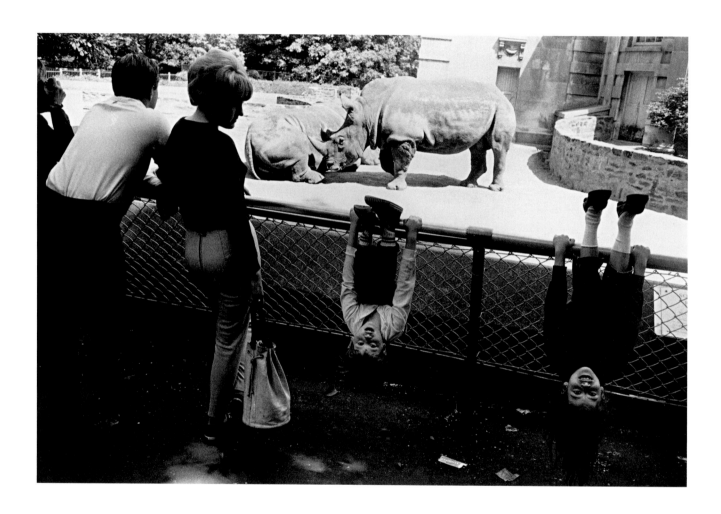

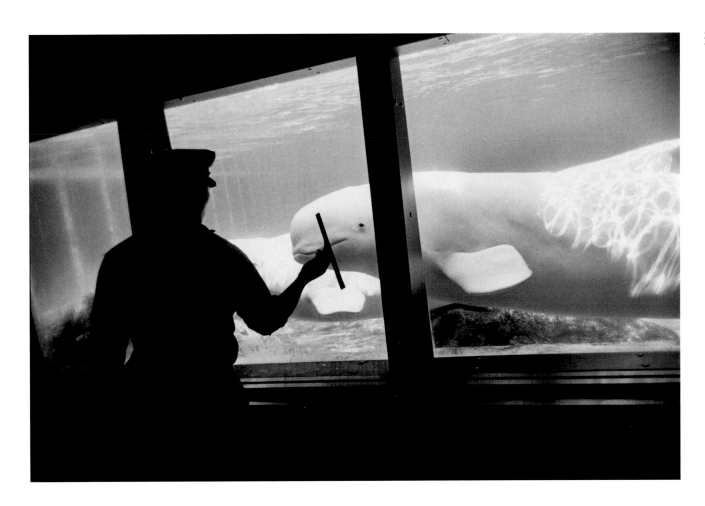

opposite:
*Untitled*, 1961
above:
*Untitled*, c. 1963

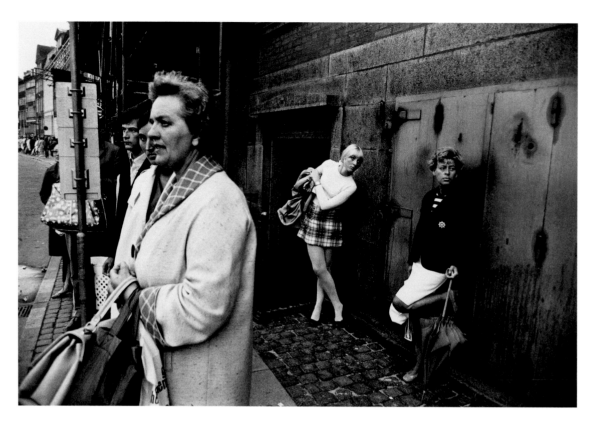

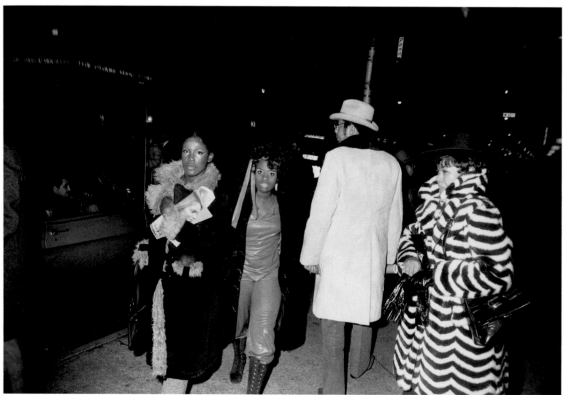

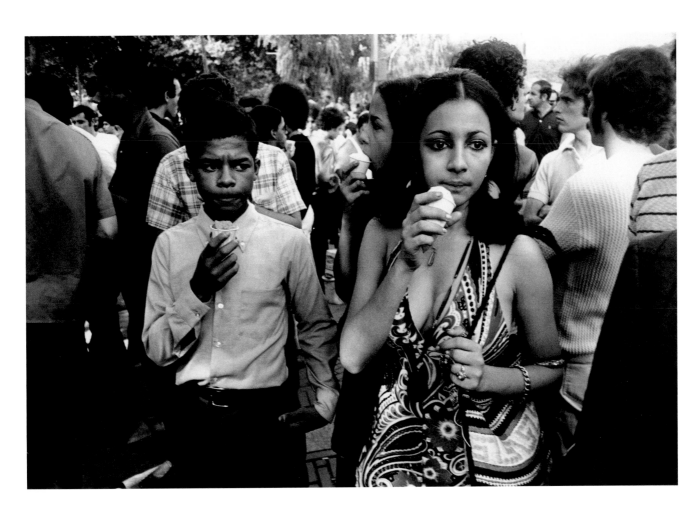

opposite top:
*London*, c. 1975
opposite bottom:
*Untitled*, 1964-75
above:
*Untitled*, 1964-75

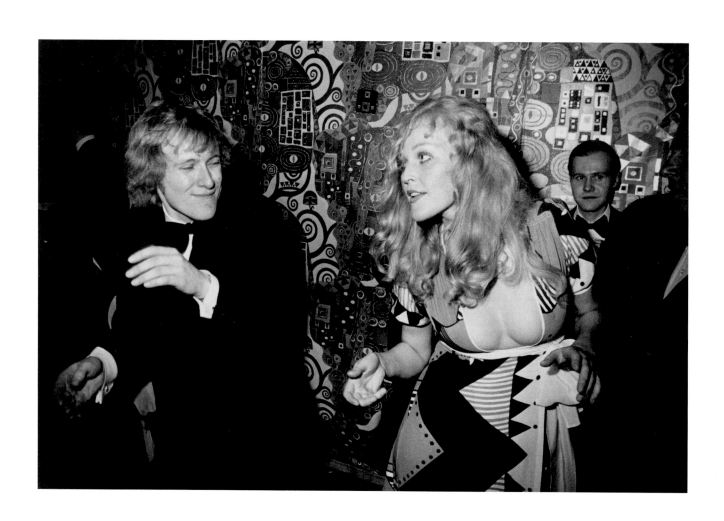

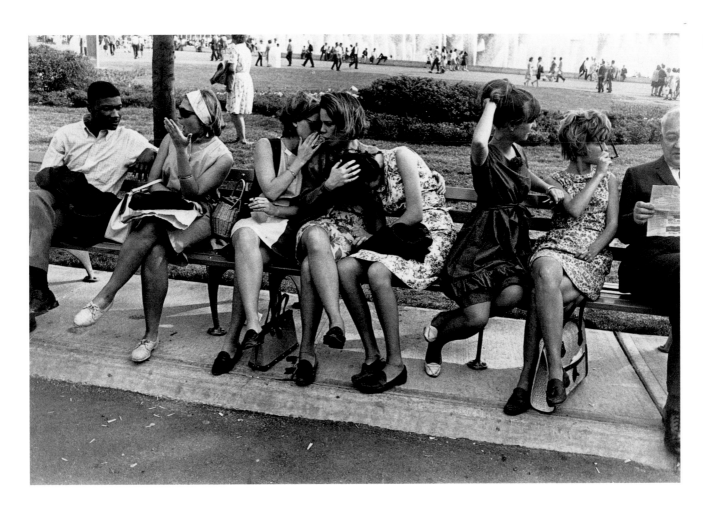

opposite:
*Untitled*, 1964-75
above:
*World's Fair, N.Y.*, 1964

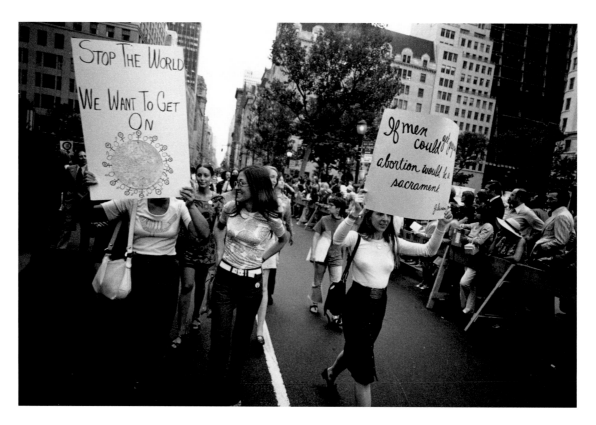

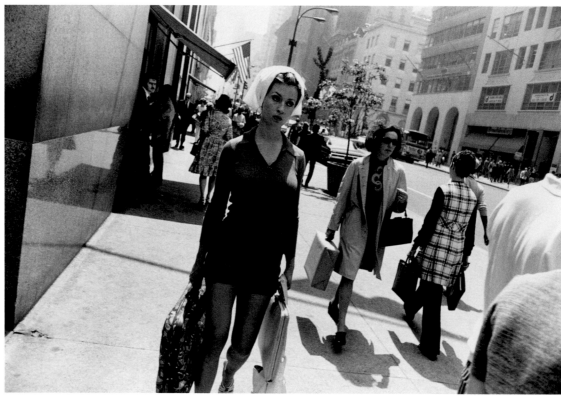

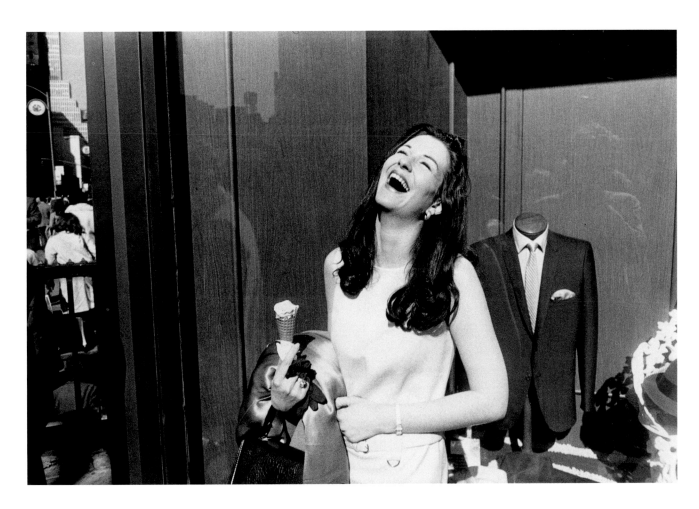

opposite top and bottom:
*Untitled,* 1964–75
above:
*New York,* 1968

New York, ca. 1967

Los Angeles, 1969

beyond the pleasures it afforded his own private speculations, he decided to give up all commercial assignments.

WITH THE FELLOWSHIP Winogrand started to photograph what he called in his application to the Guggenheim Foundation the "effect of the media on events," and, until 1973, worked energetically on the project. With a few exceptions, the photographs in this book were taken at that time, while Winogrand, armed with what could be described as passion, fury, and a crone's curiosity, photographed marches, rallies, press conferences, games, strikes, demonstrations, moratoria, funerals, parades, award ceremonies, dinners, museum openings, victory celebrations, a birthday party, and one moon shot.

For Winogrand these events all shared the fact that they were public occasions, and that they had been called to order as much for the benefit of the media that recorded them as for the direct pleasure or ritual relief of those participating in them. This, at least, is what interested him when he started the project. In fact, he seems to have thought of many of these events as scenes of portage to which machinery was carried, dropped into place, started, stopped, and picked up and carried away again after having filmed and taped a predictable sequence of speeches, cheers, and songs.

By the late 1960s many of us had learned the cues and techniques of public performance. Although Americans have always tended to improvise their social arrangements—at least those more complicated than the ones required to conduct business—at that particular time in our history even the unacknowledged systems of checks and balances that ordinarily help us distinguish our public from our private lives were willfully ignored. For if most of us were managing to lead what we thought of as "normal lives"— and as many of the photographs in this book reveal, were taking a fierce pleasure in doing so—it was the most cruelly significant event of that time, the Vietnam War, that seemed to shape what we were.

Winogrand would say that his project had little to do with the war, and that what he was interested in was the extraordinary relationship that existed between the media and public occasions. Nevertheless, what he could not disagree with is the evidence his pictures present of the collective hysteria that locked us into "the Sixties," until 1972, when the economy

Page from Garry Winogrand's *Public Relations*,
with original text by Tod Papageorge,
as compiled by Robert Freidus.

What remains of documentary photography? In 1981, Martha Rosler posed this provocative question, framing her observations as "after-thoughts" around the possible demise and resuscitation of the photographic document.[1] She approached the subject as an artist long committed to the tools of photography and to a highly conceptual and socially inscribed practice of image-making. It is from this position that she is able to wonder, with some sense of loss, at the history of documentary photography. Making these observations during the Reagan years, when mass culture's indifference to human suffering was at its most flagrant, Rosler was justifiably cynical about the potential of documentary pictures, and of any reformist agenda potentially located within them, to have a present or future agency towards social change. The Gulf War, erupting a full decade after Rosler made her remarks, forever (again) altered the nature of reportage. The initial shock of seeing war live on our television sets is well-covered territory—the video-game "theater" of combat, the destruction somehow directional and visually beyond our reach. We now have myriad other forms that have taken the air out of documentary: live-action and faux-documentary format shows such as *Cops* and *America's Most Wanted*; the constant white noise of C-SPAN; and, in Los Angeles, the "broadcast-interruptus" of freeway chases which invariably end in impotent non-confrontation. Speaking from the early 1980s, before the internet and its effects on visual communication, Rosler's position was informed by 1970s conceptualism and its turning-inside-out of the photographic object.

Now, at the turn of the century, the remains of documentary persist as an idea. At this moment of proliferating, constructed color photography and endless, monumentalizing video and film installation, how can we renegotiate the territory between what Allan Sekula described as "the old myth of photographic truth and the new myth of photographic untruth?"[2] Much of the writing that exists on Diane Arbus, Brassaï, Robert Frank, Lee Friedlander, Helen Levitt, Danny Lyon, Roger Mertin, John Pfahl, and Garry Winogrand, the major figures of The Ralph M. Parsons Foundation Photography Collection, relies on biography and anecdote. While several young scholars, often schooled in disciplines outside photographic history, are beginning to work on Brassaï, Arbus, and Winogrand, there is surprisingly little discussion of the pictures outside issues of technique, personal accounts, and myth-making.

Prior to its formulation as the core of MOCA's photography collection, each body of work represented in "The Social Scene" was originally collected as a discrete entity by a single collector, Robert Freidus.[3] Whenever possible, photographs were assembled and collated into complete photographic books with the intention of replicating the sequencing of the original monographs or published portfolios in which they originally appeared. These books came to the museum bound in oversize, finely produced volumes composed of photographs, with text, where it occurs, reproduced *in situ* adjacent to the original works of art. Convenient for curators and visiting scholars, the photographs have remained stored in their books until this exhibition. Clearly the ambitious, original goal of the archive was to

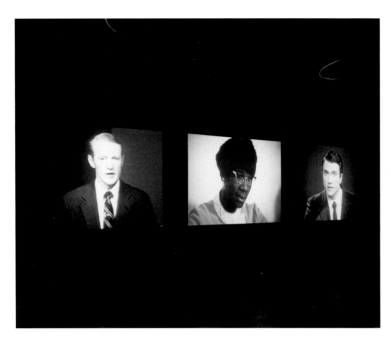

retrace, in broad strokes, the shift of photography from pre- to postwar, from Europe to America. And many of the key figures and styles are here: from the street photography of Brassaï in the 1930s, to the postwar, American social-documentary project of Swiss immigrant Frank; from Levitt, representative of the New York School; to Arbus, Winogrand, and Friedlander, the three major figures of the "new documents" era of the 1960s; and the social-documentary projects of Lyon. The inheritors of Lyon's project, Nan Goldin and Larry Clark, are not represented in the Parsons Collection but are part of the museum's original acquisition. There are also extensive holdings of social-landscape photographers John Pfahl and Roger Mertin, whose conceptually based interventions into the urban landscape are in keeping with the experiments initiated by Friedlander in the 1960s.

Though the Freidus Collection as purchased no longer exists as such, the narrative of that collection is a legacy that persists within MOCA's permanent collection. "The Social Scene" attempts to both problematize the bookish narrative of the monolithic collection as it was originally compiled, and to highlight both the themes that cut across its chronology and the editorial sensibilities that inform our primary reading of it. Thus, the exhibition which coin-cides with this publication is organized into six thematic areas: American Icons—Issues and Ideas; Character Studies; Innocence Lost; Natural Occurrences; Picture Making; and Social Space. While this is the kind of revision museums often undertake with their permanent collections, it is our hope that this exhibition, rather than being reductive, provides a useful articulation of some underlying cultural ideas which informed the authors of these astounding, iconic pictures.

In the mid-1960s, a new kind of critical writing on photography began to productively dismantle the field as it stood, initiated largely by practicing artists whose critique and role as teachers became a central part of their own practice. I am thinking here of Martha Rosler; Allan Sekula, still an influential teacher at California Institute of the Arts; Jeff Wall, whose critical writing has provided a theoretical foundation for a generation of conceptual photographers; Catherine Lord, Dean at University of California at Irvine; Lewis Baltz; Deborah Bright; and others. As a maker of pictures in a documentary mode and executive editor of *Artforum* from 1974 to 1976, Max Kozloff supported new writing on photography and published writers like Sekula and Rosler, as well as an issue of the magazine devoted entirely to photography.[4]

During the last decade, a younger generation of artists, unlike their predecessors, have embraced the mantle of photographer and incorporated the history of documentary into their teaching. Their own work participates in a complex reinvention of this and other photographic conventions. Gregory Crewdson and Catherine Opie at Yale University are producing some of the most interesting students in the country. James Welling and Uta Barth at the

STAN DOUGLAS
Detail of the video installation *Evening*,
ICA, London, 1994
Courtesy David Zwirner, New York

University of California, Los Angeles, and Christopher Williams at Art Center, are other West Coast examples. The recent inclusion of photography by Robert Adams, Walker Evans, Levitt, and Winogrand in Documenta X (the last of the century) was an interesting re-reading of the mode as quintessentially American. Documentary can be understood in terms of a re-visioning of the urban environment.[5] In an age when digital media threatens to render moot the ideas of originality and reproducibility, an honorific return to documentary in all of its forms is surely an interesting evolution. Like the oft-prophesied, never-actualized death of painting, one supposes artists will always take or make pictures.

In 1994, the Canadian artist Stan Douglas made a video installation called *Evening*. A monumental and disarming work, the installation addressed the sinister change in broadcast news that occurred during the 1960s. The sound and screens are organized in such a way that the viewer alternately experiences all three stations simultaneously or, standing in front of one screen, hears each of three fictional television stations undergo the transition to "Happy Talk." Originating in Canada, the widespread commodification of the friendly, talking-head news anchor performing "Happy Talk" was invented in response to the tremendous social upheaval epitomized by watershed events such as the Vietnam War, the 1960 Chicago Democratic Convention, and the Civil Rights Movement. According to Douglas, "the introduction of 'Happy Talk' may also be regarded as a hysterical response to the news of the late 1960s, and... could be used to give closure to stories about the Vietnam War and civic dissent by theatrical rather than editorial means."[6]

Douglas's work garnered wide acclaim when it was exhibited in 1995 at The Museum of Modern Art, New York (MOMA), as part of an exhibition of film and video installations entitled "Video Spaces: Eight Installations."[7] Particular

significance may be drawn from the fact that this work was shown at MOMA, home of the now legendary "New Documents" exhibition curated by John Szarkowski in 1967. During the 1960s, the American self-perception, based on years of vernacular images and photographic essays such as Walker Evans's *American Photographs* and Robert Frank's postwar *The Americans*, embraced a new national vision. Furthermore, changes in broadcast and print journalism—the wide availability and traffic of images representing the outside world to home—profoundly altered the mass tolerance for social engagement through images. Prior to the 1960s, art schools did not teach photography as a separate discipline because it was seen as a commercially driven trade.

It is from within this context that the highly influential hybrid of the "New Documents" exhibition emerged, the history of which has been discussed at some length elsewhere in this volume. MOMA invented what Christopher Phillips has vividly called "the judgement seat of photography." By becoming, in 1939, the first museum to institutionalize the collection and exhibition of photography, one hundred years after the medium's invention, MOMA had argued strongly for a bifurcated history of picture taking—clearly dividing modernist from documentary practice. Phillips has argued that MOMA's history of exhibitions has, among other things, orchestrated the shift from the photographic subject to that of the artist as the locus of value:

> Photography will hereafter be found in departments of photography or divisions of art and photography. Thus ghettoized, it will no longer primarily be *useful* within other discursive practices; it will no longer serve the purposes of information, documentation, evidence, illustration, reportage.[8]

During a forty-year history, traced by Phillips, numerous exhibitions brought vernacular photographs into the museum and raised them to the level of art. The unknown, unclaimed

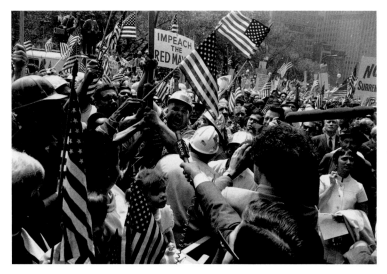

visions of Lisette Model, Weegee, Bellocq, and others were "discovered" and hung alongside their high-art counterparts.[9] "New Documents" took the so-called private work of these photographers, who relied on magazine work to make a living, and contextualized it in the world's greatest repository of modern art. Contrary to MOMA's earlier, salon-style arrangements of individual pictures by many photographers (in fact based on the universalizing aesthetic of the magazine layout), a large selection of photographs by Arbus, Friedlander, and Winogrand were framed and hung in a single band around the room. By entitling the exhibition "Documents," Szarkowski conflated the documentary, informational, and artistic or modernist readings of pictures by these great magazine photographers, who had themselves made a separation between their public/commercial and private/art work. It was in the critical writing in the wake of the exhibition that these photographers began to be referred to as "new documentarians;" "new" signifying art and "documentarians" the hallowed tradition from which they emerged.

During the same year as "New Documents," the artist Dan Graham published *Homes for America*, a notational, photographic essay in which visual information about vernacular, suburban housing was presented in the format of an art magazine. Both projects highlighted a fundamental reversal or crisis within the medium: journalistic pictures invited into the institution to be viewed as art (Arbus, Friedlander, Winogrand at MOMA), versus art moving into the magazine format to be viewed as information (Graham in *Arts Magazine*). To some extent, the Parsons Collection, comprised of photographic books, functions as historical information within the context of contemporary art. Organizing the present exhibition thematically around the social, rather than highlighting the individual accomplishments of these monumental artists, foregrounds this question. Attempting to look beyond their canonized status as photographic icons, the present configuration asks what can be learned from these pictures about the milieu in which they were made?

In this light, I would like to first address one of the most resonant series within the collection, Winogrand's *Public Relations*, published in 1969. Understood as quintessentially American, pictures of Mohammad Ali, Norman Mailer, the Apollo 11 Moon Shot, and politicians such as a young Jesse Jackson are contextualized, as they were in Catherine David's Documenta X, as signifiers of a nation coming to know and represent itself. In a significant number of the pictures the true subject is the ubiquitous and invasive presence of the media and, specifically, the camera. Pictured in all its then-primitive technology—huge clusters of microphones, awkwardly placed booms, light trees thrust near the faces of public figures—the photographer, in the guise of the newspaper media, is omnipresent. As author of the pictures, Winogrand is implicated as both photojournalist and subjective observer.

Winogrand as "new documentarian" has not been much addressed by revisionist historians

left:
GARRY WINOGRAND
*Hard-Hat Rally, New York, 1969*, 1969
opposite:
GARRY WINOGRAND
*Untitled*, 1964-75

and critics. His work is neither as conceptually inclined as Friedlander's, nor as receptive to issues of identity construction (not to mention mythologizing and martyrdom) as Arbus's, and this may partially explain Winogrand's renewed popularity. His enormous body of work seems to nervously occupy the realm of documentary while also retreating to the personal. In the existing conventional literature, there is much speculation about the restlessness of his camera. One has the sense that Winogrand's process was indeed one of angling and jostling his machine as close to his subjects as he could get. Certainly this is true of the MOMA pictures within *Public Relations*, and is fully evident in *Women are Beautiful,* on which he was working at the same time. Socialites and artists, waiters who look like Truman Capote and bow-tied art patrons are all pictured in precarious blackness with the glare of the spotlight washing their decked cleavages and bald heads. The harsh glare of the flash exposes this cast of characters to the photographer's scrutiny—he is both complicit imposter and reluctant participant. The fact that his subjects seem primarily unaware of his pre-sence is further evidence of how accustomed to the camera, how staged a certain echelon of reality had become, by the end of the 1960s. Within *Public Relations*, the equation of these characters with the anointed news anchors, student agitators, and scrambling politicians suggests an unruly mass of humanity in all its democracy and tackiness. There is something both hilarious and elegiac about Winogrand's view of the present through which he moves and the social space he inhabits.

Though the radical documentary project as defined by the Farm Security Administration photographers is neutralized in Winogrand—certainly the basic rules of knowing one's subject are relaxed—these pictures describe and enact an important cultural shift that can only be ascribed to the 1960s. While Winogrand always maintained he had no interest in, or even awareness of, the social subtext of his pictures, he stated in the

Guggenheim fellowship application which enabled the *Public Relations* project that his goal was to record "the effect of the media on events."[10] The pictures function as a social document of the era when "Happy Talk" supplanted hard talk and fostered a national glazing-over of some of the most critical social issues of our time. Though Winogrand spoke of leaving the photojournalistic world as early as the late 1950s, he was unable to break from it completely and continued to take assignments until 1969.[11]

If the camera as the tool of the media can be understood as the subject in *Public Relations*, then it seems not too far a transgression to reinsert the social into the pictures and to wonder how this sociological understanding of visual culture becomes expressed in the anthropology of *Women are Beautiful*. This latter project was Winogrand's favorite, and he is often quoted in his blatant and uncritical sexualizing of his subject. The book, not published until 1975, is made up of two kinds of pictures. First there are the flirtatious, quintessential pictures we know

disinterested subjects do appear to be young, professional women. Winogrand's prurience aside, these women stare-down the camera as they move past.

As photojournalism was collapsing into the oblivion of broadcast journalism, and as video was taking over as the dominant format, Winogrand's portrait of the camera in its fading milieu also became a kind of discovery of its essential nature. It is this photographic subject which is exploited so freely and brilliantly by Lee Friedlander. Describing his lifelong subject as "the American social landscape and its conditions,"[12] Friedlander is the inheritor of Evans's project and brackets street photography and the conceptualist embrace of the photograph as information. His work also provocatively and self-consciously synthesizes the ongoing discussion in the 1960s about art versus photography, a battle that seems beside the point today but still rages in some photography circles. Published in 1976, *The American Monument* is an essay, a kind of quirky outsider's guide, on the subject of vernacular architecture and the American monument tradition. In what remains one of the most thoughtful texts on Friedlander's work, Martha Rosler describes the pictures:

> Friedlander's presentation is exhaustive yet cool, the effect markedly distanced. The voraciousness of a view that yields, in good focus and wide tonal range, every detail in what passes for a perfectly ordinary scene, the

and love. Women, overwhelmingly young and white, caught in the crosswalk or sidewalk, in what now seem like the girlish fashions of the day. Many of the women are surprised or seem coyly aware of the presence of the camera and the man behind it, as well as of each other being photographed. Interspersed among these, however, are a significant number of less-reproduced pictures of groups of women, women within larger groups, and women of color inhabiting both of these categories. Winogrand seems not to exoticize them any more than he does his Madison Avenue blondes. Is any kind of feminist reading of these pictures possible? It is these lesser-known pictures that have preoccupied me and that, I think, suggest another reading. There are, for example, several pictures of women demonstrating for equal rights and reproductive freedom. Without the benefit of further study into the exact dates of these pictures, it is noteworthy that they are here, in the context of women, rather than in the undifferentiated melange of *Public Relations*. The presence of these pictures within the series re-informs the more conventional portraits of the working girls. And many of the most distracted or

often kitschy subject handled in a low-key way, the complete absence of glamour, and the little jokes, these put intelligence and humor where sentiment or anger might have been. Distancing is everywhere evident …. Art-making here entails a removal from temporal events, even though the act of recording requires a physical presence, often duly noted.[13]

Rosler also distinguishes between occurrences in the world versus occurrences in the camera. Indeed, Friedlander seems always inside and outside his pictures at the same time. He exploits the inherent collapse that can occur within the space of photographs, in many cases making humorous use of the cacophony of street signs, neon, bits of nature, and the occasional pedestrian who passes through. It is as if he takes the subjects of documentary—people, places, American politics, the urban environment—and renders them neutral and opaque. I am reminded of Szarkowski's shock at seeing Evans's *America* for the first time and gazing upon his archive of American vernacular architecture—"just facts," he describes. What Friedlander sees are not the universalizing truths of humanity, but a kind of strange, crystalline abstraction in which the subject, again, is the vision and the construction of a picture. His work has the look of documentary, but with the banality and detachment of *Homes for America*.

Friedlander's self-portraits are fascinating. One senses that he merely moved a little to the left or right in order to fully implicate himself in the pictures by recording a shadow, a reflection, or the camera itself. The images of the artist slumped in a chair or the reflection of his soft, pale body in the mirror of an airless hotel room disrupt any reading of the series as having patriotic or monumentalizing overtones. In several shots, Friedlander is apparently alone, with only the television as company. The omnipresent television, seen consistently from Frank's *The Americans* forward, seems in Friedlander's pictures to be

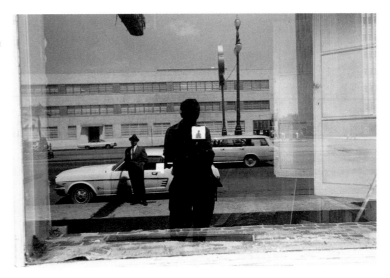

particularly emblematic of a culture of alienation. The room is dark, few details are discernable, but the artificial light emanates from a television that, from now on, will never go off.

In a recent article arguing for a kind of realism in documentary practice, Vancouver-based photographer Roy Arden reminds us that, historically, "Anything vaguely arty has usually been consigned to the documentary category."[14] In an effort to articulate photography's move in and out of the "arty," other terms that have entered the lexicon of the documentary subject include amateur, vernacular, social documentary, social landscape, new documentary, as well as realist. Walker Evans (perhaps being a bit coy) referred to his own approach as a "documentary style," apparently allowing for other approaches to the vernacular in which he was not involved. An interesting outgrowth of social documentary and the rubric of "New Documents" was "New Topographics," an exhibition organized in 1975 by the International Museum of Photography at George Eastman House in Rochester, New York. Highlighting a formalist, reductive approach to the ex-urban landscape, this exhibition profoundly influenced two decades of representation of the American West. The subsequent backlash went something like this: if the new topographics

photographers purported to be at all political in their intentions for these portraits of confrontation between nature and suburbia, their pictures must carry more discursive signs of this social agenda. Photographers such as John Pfahl reacted against what they saw as an aestheticizing, watering down of critical issues at stake in the topographic subject at the beginning of the 1970s.

Pfahl has made a career of photographing nature by embracing the formalist vocabulary of nineteenth-century landscape painting tropes. His serene *Arcadia Revisited* pictures comprise a re-photographic project that references early American expeditions around the Hudson River Valley, taking as their source engravings made as a record of exploration. Pfahl subtly comments on the changes visited on the region by industry and over suburbanization. The southeastern United States historically has been a rich place for documentary work. Not far from New York, photographers, including Evans, found quintessentially American scenes for the taking: the remains of the pre-industrial city, and its attendant poverty and desolation; the post-industrial landscape of nuclear power stations and other signs of so-called progress; proximity to the South, where evidence of the Civil War and racial tensions enervate social exchange and can be apprehended in a carefully selected picture. In the tradition of Walker Evans's Middleton, Pennsylvania, Friedlander's *Factory Valleys*, as well as Pfahl's *Altered Landscapes* (1981) and *Power Places* (1981-84), take advantage of this rich territory.

Danny Lyon's striking social documentary series *The Bikeriders* and *Conversations with the Dead* define a particular legacy of social documentary that holds currency among contemporary practitioners as diverse as Allan Sekula, Nan Goldin, and Catherine Opie. In 1966, Nathan Lyons organized "Contemporary Photographers: Toward a Social Landscape," including the work of Duane Michaels, Bruce

Davidson, Lyon, and Winogrand. From 1967 to 1968 Lyon insinuated himself and his camera into a group of bikers based in Chicago. Living in close quarters with this subcultural group, Lyon was able to picture how he saw and experienced them in the context of their lives. The pictures have a formal beauty and a quietness that belie their social subtext. Unlike Larry Clark, whose later monograph, *Teenage Lust*, is far from neutral in its view of grungy adolescent life and sexuality, Lyon's portraits are distanced even as they are close-up. Retrieving many of the symbols of Americana publicized by Frank—the flag, religion, the freedom of the open road, and a piece of hard, shiny machinery to represent it— Lyon imbues his subjects with dignity. The black-and-white pictures are permeated with a rather open sense of longing and nostalgia for a more innocent time. Women are present, family units are intact, and the men seem frozen in a sweet James Dean reverie. In one poignant shot, reminiscent of Frank's Southern funeral photographs, they bury their own.

*The Bikeriders* is filled with such iconic pictures, and such American icons—the bike, the open road, the white cotton T-shirt and jeans— that it becomes complicated to read its significance apart from its function as a precursor to representations of the socially marginalized. Lyon is an acknowledged forerunner of Clark and Goldin, and it is an easy leap to find antecedents in Opie and in Cindy Sherman's performance of gender typologies. Lyon's *Bikeriders* pictures are so formally arranged that one loses a sense of the access to his subject that enabled Lyon to confer the intense dignity and quietude which permeates these scenes. Unlike Goldin's later *The Ballad of Sexual Dependency*, which seems to enact the poignant but almost unnatural cohabitation of

her friends and lovers, Lyon's mood is distanced and fragile. His otherwise gritty subject is aestheticized and mediated by the camera.

*Conversations with the Dead*, Lyon's later investigation of prison life, is filled with equally, formally attractive pictures but appears immediately tougher in terms of its subject. Martha Rosler has rather grimly stated that "documentary testifies, finally, to the bravery... of the photographer."[15] Though his Texas prisons of the 1960s seem remarkably quiet, orderly places, the pictures do evidence Lyon's social conscience if nothing else. As in *The Bikeriders*, there is a filmic sense of Lyon being present and mute, there and not there, without a trace of, say, Winogrand's periodic run-ins with his subject or Arbus's "hand grenade" volatility. There is no question that Lyon formalizes the moments of racial tension, dehumanization, and loneliness that are represented. But the project's radicality is the fact of its existence and the humanity returned to his subject. Today, images of social unrest from the 1960s look sweet and truly pre-millennial in their apparent optimism. The remains and potential of social documentary lie here in this twilight of American reportage.

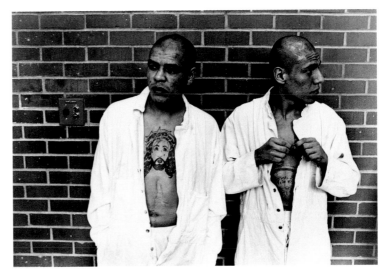

Notes

1.  Martha Rosler, "In, Around, and Afterthoughts (on documentary photography)," in Richard Bolton, ed., *The Contest of Meaning: Critical Histories of Photography* (Cambridge, Mass: The MIT Press, 1989), 303. The original version of Rosler's text was published in 1981 in *3 Works* (Halifax: Nova Scotia College of Art and Design Press, 1981), 59-87.
2.  Allan Sekula, "Walker Evans and the Police," in *Walker Evans & Dan Graham* (Rotterdam: Witte de With; and Munster: Westfälisches Landesmuseum für Kunst und Kulturgeschichte, 1992), 193. This catalogue and the exhibition it accompanied is, to my mind, one of the only and most interesting curatorial re-readings of documentary photography and its contemporary manifestation.
3.  The collection was originally amassed by the New York gallerist and photography collector Robert Freidus and was purchased directly from him.
4.  Photography Issue, *Artforum* 15, no. 1 (September 1976). At this time the magazine was run by a photography-oriented staff and was still incorporated as "California Artforum Inc." John Coplans was Editor; Kozloff, Executive Editor; and Nancy Foote, Managing Editor.
5.  In the introduction to the Documenta "short guide,"

Catherine David articulates the inclusion of American "documentary" photography in the following way: "At a time when advertising, television, the new media, and the digital sophistication of virtual worlds are 'swallowing the real in its spectacular representation' (Gruzinski), it seems particularly appropriate to foreground the processes of analysis and distancing at work in the practices of drawing and of documentary photography since the 1960s and sometimes even before (Walker Evans, Garry Winogrand, Helen Levitt, Robert Adams, ...). These practices find significant (if indirect) developments in the works of [artists] who have been able to discover contemporary forms of non-spectacular dramatization." In *Documenta X: The Short Guide* (Ostfildern, Germany: Cantz Verlag, 1997), 9.
6.  Stan Douglas, "Artist's Writings," *Stan Douglas* (London: Phaidon Press Limited, 1998), 122.
7.  *Video Spaces: Eight Installations*, exh. cat. (New York: The Museum of Modern Art, 1995). Text by Barbara London. *Evening* was first exhibited at The Renaissance Society, Chicago, in 1995.
8.  Christopher Phillips, in *The Contest of Meaning*. Originally published in *October*, no. 22 (Fall 1982): 27-63.
9.  As we speak, appearing to reinvent itself again, MOMA has hung "art" photographs next to paintings in its millennial exhibition, "Modern*Starts*: People, Places and Things." See Peter Schjeldahl, "The Reinvention of MOMA," *The New Yorker* (17 January 2000): 84-85.
10. John Szarkowski, *Winogrand: Figments From the Real World*, exh. cat. (New York: The Museum of Modern Art, 1988), 33.
11. *Ibid.*, 30.
12. Rod Slemmons, "A Precise Search for the Elusive," in *Like a One-Eyed Cat: Photographs by Lee Friedlander, 1956-1987*, exh. cat. (Seattle: Seattle Art Museum, 1989), III.
13. Martha Rosler, "Lee Friedlander's Guarded Strategies," *Artforum* 13, no. 8 (April 1975): 47-48. Rosler opens a discussion of Friedlander in relationship to Pop, which is not elaborated in the literature except for a brief mention in Slemmons's catalogue text in conjunction with Friedlander's retrospective.
14. Roy Arden, "Kennedy Bradshaw," *Canadian Art* (Winter 1998): 40-41.
15. Rosler, "In, Around, and Afterthoughts (on documentary photography)," 308.

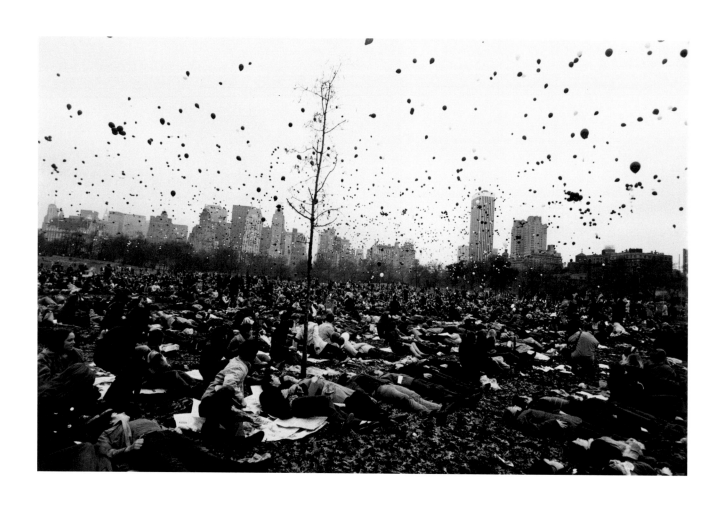

GARRY WINOGRAND
*Peace Demonstration, Central Park, New York, 1970*, 1970

**DIANE ARBUS**

DIANE ARBUS

◊ *A castle in Disneyland, Cal.,*
1962
Silver print
image: 15 x 15 in.
overall: 20 x 16 in.
95.23.9
p.53

*The Junior Interstate*
*Ballroom Dance Champions,*
*Yonkers, N.Y.,* 1962
Silver print
image: 14 x 14 1/2 in.
overall: 20 x 16 in.
95.23.3

*A house on a hill, Hollywood,*
*Cal.,* 1963
Silver print
image: 14 1/2 x 14 1/2 in.
overall: 20 x 16 in.
95.23.73

*A husband and wife in the*
*woods at a nudist camp, N.J.,*
1963
Silver print
image: 14 3/4 x 14 3/4 in.
overall: 20 x 16 in.
95.23.23

*A widow in her bedroom,*
*N.Y.C.,* 1963
Silver print
image: 14 1/2 x 14 1/2 in.
overall: 20 x 16 in.
95.23.68

*Retired man with his wife at*
*home in nudist camp one*
*morning, N.J.,* 1963
Silver print
image: 14 1/4 x 14 3/4 in.
overall: 20 x 16 in.
95.23.5

◊ *Russian midget friends in a*
*living room on 100th Street,*
*N.Y.C.,* 1963
Silver print
image: 14 1/2 x 14 3/4 in.
overall: 20 x 16 in.
95.23.1
p.55

◊ *Teenage couple on Hudson*
*Street, N.Y.C.,* 1963
Silver print
image: 14 3/4 x 14 3/4 in.
overall: 20 x 16 in.
95.23.43
p.50

*Two boys smoking in Central*
*Park, N.Y.C.,* 1963
Silver print
image: 14 1/2 x 14 1/2 in.
overall: 20 x 16 in.
95.23.57

*A young couple on a bench in*
*Washington Square Park,*
*N.Y.C.,* 1965
Silver print
image: 14 1/2 x 14 1/2 in.
overall: 20 x 16 in.
95.23.49

◊ *A young man with his*
*pregnant wife in Washington*
*Square Park, N.Y.C.,* 1965
Silver print
image: 14 1/2 x 14 1/2 in.
overall: 20 x 16 in.
95.23.37
p.50

*A lobby in a building,*
*N.Y.C.,* 1966
Silver print
image: 14 1/2 x 14 1/2 in.
overall: 20 x 16 in.
95.23.24

◊ *Woman in her negligee,*
*N.Y.C.,* 1966
Silver print
image: 14 1/2 x 14 1/4 in.
overall: 20 x 16 in.
95.23.66
p.49

*Boy with a straw hat waiting to*
*march in a pro-war parade,*
*N.Y.C.,* 1967
Silver print
image: 15 1/2 x 15 in.
overall: 20 x 16 in.
95.23.13

◊ *Patriotic young man with a*
*flag, N.Y.C.,* 1967
Silver print
image: 14 3/4 x 14 1/2 in.
overall: 20 x 16 in.
95.23.41
p.51

◊ *Seated man in a bra and*
*stockings, N.Y.C.,* 1967
Silver print
image: 14 7/8 x 14 3/4 in.
overall: 20 x 16 in.
95.23.54
p.48

*A woman in a bird mask,*
*N.Y.C.,* 1967
Silver print
image: 14 1/2 x 14 3/4 in.
overall: 20 x 16 in.
95.23.48

◊ *A family on their lawn one*
*Sunday in Westchester, N.Y.,*
1968
Silver print
image: 15 x 15 1/4 in.
overall: 20 x 16 in.
95.23.7
p.52

*Girl in a coat lying on her*
*bed, N.Y.C.,* 1968
Silver print
image: 14 1/2 x 14 3/4 in.
overall: 20 x 16 in.
95.23.14

*Topless dancer in her dressing*
*room, San Francisco, Cal.,*
1968
Silver print
image: 14 3/4 x 14 3/4 in.
overall: 20 x 16 in.
95.23.40

◊ *Woman with a veil on Fifth*
*Avenue, N.Y.C.,* 1968
Silver print
image: 14 5/8 x 14 3/4 in.
overall: 20 x 16 in.
95.23.58
p.54

◊ *Man at a parade on Fifth*
*Avenue, N.Y.C.,* 1969
Silver print
image: 14 1/2 x 14 1/2 in.
overall: 20 x 16 in.
95.23.36
p.54

*Transvestite at her birthday*
*party, N.Y.C.,* 1969
Silver print
image: 14 1/2 x 14 1/2 in.
overall: 20 x 16 in.
95.23.27

*Woman on a park bench on a*
*sunny day, N.Y.C.,* 1969
Silver print
image: 14 1/2 x 14 3/4 in.
overall: 20 x 16 in.
95.23.39

*Untitled (6),* 1970-71
Silver print
image: 15 1/4 x 15 in.
overall: 20 x 16 in.
95.23.79

**BRASSAÏ** [Gyula Halász]

THE SECRET PARIS OF
THE 30'S

◊ *The Bal des Quat'z Arts. A*
*couple getting "dressed,"*
c. 1931
Silver print
image: 10 1/2 x 8 5/8 in.
overall:11 7/8 x 9 1/2 in.
95.24.80
p.58

*Big Albert's gang, Place*
*d'Italie,* c. 1931
Silver print
image: 10 1/4 x 8 1/8 in.
overall: 11 3/4 x 8 7/8 in.
95.24.23

◊ *Conchita's dance at "Her*
*Majesty, Woman," Boulevard*
*Auguste-Blanqui,* c. 1931
Silver print
image: 9 1/8 x 11 3/4 in.
overall: 9 1/8 x 11 3/4 in.
95.24.4
p.63

*An opium smoker asleep,*
c. 1931
Silver print
image: 9 3/8 x 11 7/8 in.
overall:9 3/8 x 11 7/8 in.
95.24.93

◊ *Police during a raid in*
*Montmartre,* c. 1931
Silver print
image: 11 3/4 x 9 1/4 in.
overall: 11 3/4 x 9 1/4 in.
95.24.22
p.62

*Street Fair on the Place*
*d'Italie,* c. 1931
Silver print
image: 11 3/4 x 9 3/4 in.
overall: 11 3/4 x 9 3/4 in.
95.24.2

*Supper with the cesspool*
*cleaners, Saint-Paul district,*
c. 1931
Silver print
image: 7 7/8 x 11 in.
overall: 8 1/2 x 11 3/8 in.
95.24.18

*Two girls looking for tricks,*
*Boulevard Montparnasse,*
c. 1931
Silver print
image: 10 5/8 x 8 in.
overall: 11 7/8 x 9 3/8 in.
95.24.47

◊ *Young couple wearing a*
*two-in-one suit at the Bal de*
*la Montagne Sainte-*
*Geneviève,* c. 1931
Silver print
image: 11 3/4 x 9 3/8 in.
overall: 11 3/4 x 9 3/8 in.
95.24.89
p.42

*Clochards under the Pont-*
*Neuf. In the distance, the*
*Pont des Arts,* c. 1932
Silver print
image: 11 7/8 x 9 1/4 in.
overall: 11 7/8 x 9 1/4 in.
95.24.13

*Couple at the Bal Nègre, Rue*
*Blomet,* c. 1932
Silver print
image: 10 1/8 x 8 1/8 in.
overall: 11 7/8 x 9 1/8 in.
95.24.68

*A couple at Le Monocle,*
c. 1932
Silver print
image: 10 7/8 x 8 1/4 in.
overall: 15 1/4 x 11 1/8 in.
95.24.84

*An English girl in her dressing*
*room at the Folies-Bergère,*
c. 1932
Silver print
image: 11 1/4 x 8 3/4 in.
overall: 11 1/4 x 8 3/4 in.
95.24.74

◊ *A happy group at the Quatre*
*Saisons,* c. 1932
Silver print
image: 11 5/8 x 9 1/4 in.
overall: 11 5/8 x 9 1/4 in.
95.24.39
p.61

◊ Kiki with her friends
Thérèse Treize de Caro and
Lily, c. 1932
Silver print
image: 8 1/8 x 11 1/4 in.
overall: 11 1/8 x 13 3/8 in.
95.24.73
p.59

A lady of the evening, Rue de
Lappe, c. 1932
Silver print
image: 11 1/8 x 8 7/8 in.
overall: 12 x 9 3/8 in.
95.24.44

Le Monocle, the bar. On the
left is Lulu de Montparnasse,
c. 1932
Silver print
image: 10 7/8 x 9 in.
overall: 12 x 9 3/8 in.
95.24.86

Lovers, Place d'Italie, c. 1932
Silver print
image: 9 3/4 x 7 3/4 in.
overall: 14 1/2 x 10 7/8 in.
95.24.30

"Madame," c. 1932
Silver print
image: 11 3/8 x 8 in.
overall: 11 3/8 x 8 in.
95.24.59

Members of Big Albert's
Gang, Place d'Italie, c. 1932
Silver print
image: 11 x 8 7/8 in.
overall: 12 x 9 3/8 in.
95.24.21

◊ Mirrored wardrobe in a
brothel, Rue Quincampoix,
c. 1932
Silver print
image: 15 1/4 x 11 1/8 in.
overall: 15 1/4 x 11 1/8 in.
95.24.57
p.44

Miss Diamonds in the Bar de
la Lune, Montmartre, c. 1932
Silver print
image: 11 1/4 x 8 5/8 in.
overall: 12 x 9 3/8 in.
95.24.42

A novice prostitute, Place
d'Italie, 1932
Silver print
image: 11 7/8 x 8 3/8 in.
overall: 11 7/8 x 8 3/8 in.
95.24.50

◊ A prostitute playing Russian
billiards, Boulevard
Rochechouart, Montmartre,
c. 1932
Silver print
image: 15 1/2 x 11 1/8 in.
overall: 15 1/2 x 11 1/8 in.
95.24.40
p.60

The Rue Quincampoix and its
hôtels de passe, c. 1932
Silver print
image: 11 1/8 x 8 3/8 in.
overall: 11 1/8 x 8 3/8 in.
95.24.53

At Suzy, introductions,
c. 1932
Silver print
image: 11 1/4 x 8 3/4 in.
overall: 11 7/8 x 9 in.
95.24.62

The same from behind, 1932
Silver print
image: 12 1/4 x 8 1/2 in.
overall: 12 1/4 x 8 1/2 in.
95.24.46

Young female invert, Le
Monocle, c. 1932
Silver print
image: 14 1/8 x 10 7/8 in.
overall: 15 1/2 x 11 5/8 in.
95.24.85

◊ Conchita with sailors in a
cafe on the Place d'Italie,
c. 1933
Silver print
image: 10 7/8 x 8 1/2 in.
overall: 10 7/8 x 8 1/2 in.
95.24.6
p.61

◊ A fortuneteller in her
wagon, Boulevard Saint-
Jacques, c. 1933
Silver print
image: 10 3/4 x 8 3/8 in.
overall: 11 3/4 x 9 1/4 in.
95.24.8
p.62

## ROBERT FRANK

THE AMERICANS

Assembly line — Detroit, 1955
Gelatin-silver print
image: 8 3/4 x 13 1/4 in.
overall: 11 x 13 7/8 in.
95.28.50

Barbershop through screen
door — McClellanville, South
Carolina, 1955
Gelatin-silver print
image: 8 5/8 x 13 in.
overall: 11 x 13 7/8 in.
95.28.38

◊ Beaufort, South Carolina,
1955
Gelatin-silver print
image: 9 1/4 x 13 5/8 in.
overall: 11 x 13 7/8 in.
95.28.55
p.73

◊ Belle Isle — Detroit, 1955-56
Gelatin-silver print
image: 7 3/4 x 12 1/2 in.
overall: 11 x 13 7/8 in.
95.28.77
p.69

Butte, Montana, 1955
Gelatin-silver print
image: 9 1/8 x 13 5/8 in.
overall: 11 x 13 7/8 in.
95.28.15

◊ Charleston, South Carolina,
1955
Gelatin-silver print
image: 8 1/2 x 12 3/4 in.
overall: 11 x 13 7/8 in.
95.28.13
p.74

Coffee shop, railway station —
Indianapolis, 1955-56
Gelatin-silver print
image: 8 3/4 x 12 7/8 in.
overall: 11 x 13 7/8 in.
95.28.70

Crosses on scene of highway
accident — U.S. 91, Idaho,
1955
Gelatin-silver print
image: 12 1/4 x 8 in.
overall: 13 7/8 x 11 in.
95.28.49

Drive-in movie — Detroit,
1955
Gelatin-silver print
image: 8 5/8 x 13 in.
overall: 11 x 13 7/8 in.
95.28.46

Drugstore — Detroit, 1955
Gelatin-silver print
image: 12 7/8 x 8 3/4 in.
overall: 13 7/8 x 11 in.
95.28.69

Elevator — Miami Beach, 1955
Gelatin-silver print
image: 8 1/8 x 12 1/8 in.
overall: 11 x 13 7/8 in.
95.28.44

Factory — Detroit, 1955
Gelatin-silver print
image: 13 1/8 x 8 1/2 in.
overall: 13 7/8 x 11 in.
95.28.63

◊ Fourth of July — Jay, New
York, 1955
Gelatin-silver print
image: 12 x 8 in.
overall: 13 7/8 x 11 in.
95.28.17
p.6

◊ Funeral — St. Helena, South
Carolina, 1955
Gelatin-silver print
image: 8 1/2 x 12 5/8 in.
overall: 11 x 13 7/8 in.
95.28.4
p.68

Funeral — St. Helena, South
Carolina, 1955
Gelatin-silver print
image: 12 1/2 x 8 1/8 in.
overall: 13 7/8 x 11 in.
95.28.56

Georgetown, South Carolina,
1955
Gelatin-silver print
image: 12 3/4 x 8 3/8 in.
overall: 13 7/8 x 11 in.
95.28.23

Los Angeles, 1955
Gelatin-silver print
image: 13 1/4 x 8 7/8 in.
overall: 13 7/8 x 11 in.
95.28.61

Men's room, railway station —
Memphis, Tennessee, 1955
Gelatin-silver print
image: 8 1/2 x 12 7/8 in.
overall: 11 x 13 7/8 in.
95.28.52

Metropolitan Life Building —
New York City, 1955
Gelatin-silver print
image: 11 1/2 x 7 3/4 in.
overall: 13 7/8 x 11 in.
95.28.27

Mississippi River, Baton
Rouge, Louisiana, 1955
Gelatin-silver print
image: 8 1/2 x 12 5/8 in.
overall: 11 x 13 7/8 in.
95.28.47

◊ Motorama — Los Angeles,
1955
Gelatin-silver print
image: 8 1/8 x 11 7/8 in.
overall: 11 x 13 7/8 in.
95.28.11
p.25

New York City, 1955
Gelatin-silver print
image: 10 5/8 x 7 1/8 in.
overall: 13 7/8 x 11 in.
95.28.12

◊ Parade — Hoboken, New
Jersey, 1955
Gelatin-silver print
image: 8 5/8 x 13 1/4 in.
overall: 11 x 13 7/8 in.
95.28.1
p.72

Public park — Ann Arbor,
Michigan, 1955-56
Gelatin-silver print
image: 7 7/8 x 11 7/8 in.
overall: 11 x 13 7/8 in.
95.28.80

◊ Restaurant — U.S. 1 leaving
Columbia, South Carolina,
1955
Gelatin-silver print
image: 8 1/8 x 12 3/8 in.
overall: 11 x 13 7/8 in.
95.28.45
p.32

Rodeo — Detroit, 1955
Gelatin-silver print
image: 7 3/4 x 11 5/8 in.
overall: 11 x 13 7/8 in.
95.28.5

Rodeo — New York City, 1955
Gelatin-silver print
image: 12 1/4 x 7 3/4 in.
overall: 13 7/8 x 11 in.
95.28.65

◊ Santa Fe, New Mexico, 1955
Gelatin-silver print
image: 8 5/8 x 12 7/8 in.
overall: 11 x 13 7/8 in.
95.28.42
p.76

St. Petersburg, Florida,
1955-56
Gelatin-silver print
image: 8 1/2 x 13 in.
overall: 11 x 13 7/8 in.
95.28.33

Trolley — New Orleans,
1955
Gelatin-silver print
image: 9 x 13 1/2 in.
overall: 11 x 13 7/8 in.
95.28.18

◊ U.S. 285, New Mexico, 1955
Gelatin-silver print
image: 13 1/4 x 8 3/4 in.
overall: 13 7/8 x 11 in.
95.28.36
p.71

◊ U.S. 30 between Ogallala
and North Platte, Nebraska,
1955
Gelatin-silver print
image: 8 5/8 x 13 1/8 in.
overall: 11 x 13 7/8 in.
95.28.30
p.75

◊ U.S. 90, en route to Del
Rio, Texas, 1955
Gelatin-silver print
image: 13 1/8 x 8 1/2 in.
overall: 13 7/8 x 11 in.
95.28.83
p.70

View from hotel window —
Butte, Montana, 1955
Gelatin-silver print
image: 8 3/4 x 13 in.
overall: 11 x 13 7/8 in.
95.28.26

Yom Kippur — East River,
New York City, 1955
Gelatin-silver print
image: 7 x 10 3/8 in.
overall: 11 x 13 7/8 in.
95.28.16

◊ Backyard — Venice West,
California, 1956
Gelatin-silver print
image: 7 7/8 x 12 in.
overall: 11 x 13 7/8 in.
95.28.39
p.77

Bank — Houston, Texas, 1956
Gelatin-silver print
image: 12 1/2 x 8 in.
paper: 13 7/8 x 11 in.
95.28.62

*Cafe – Beaufort, South Carolina*, 1956
Gelatin-silver print
image: 8 7/8 x 13 1/4 in.
overall: 11 x 13 7/8 in.
95.28.22

*Canal Street – New Orleans*, 1956
Gelatin-silver print
image: 7 1/4 x 10 7/8 in.
overall: 11 x 13 7/8 in.
95.28.19

*Car accident – U.S. 66, between Winslow and Flagstaff, Arizona*, 1956
Gelatin-silver print
image: 8 1/4 x 13 3/4 in.
overall: 11 x 13 7/8 in.
95.28.35

*Chicago*, 1956
Gelatin-silver print
image: 13 3/8 x 9 1/8 in.
overall: 13 7/8 x 11 in.
95.28.79

◊ *Convention hall – Chicago*, 1956
Gelatin-silver print
image: 6 1/4 x 9 3/8 in.
overall: 11 x 13 7/8 in.
95.28.51
p.66

*Covered car – Long Beach, California*, 1956
Gelatin-silver print
image: 9 x 13 3/8 in.
overall: 11 x 13 7/8 in.
95.28.34

*Department store – Lincoln, Nebraska*, 1956
Gelatin-silver print
image: 8 x 12 in.
overall: 11 x 13 7/8 in.
95.28.64

*Indianapolis*, 1956
Gelatin-silver print
image: 8 5/8 x 12 3/4 in.
overall: 11 x 13 7/8 in.
95.28.82

*Movie premiere – Hollywood*, 1956
Gelatin-silver print
image: ·2 1/4 x 8 1/4 in.
overall: 13 7/8 x 11 in.
95.28.66

*Movie premiere – Hollywood*, 1956
Gelatin-silver print
image: 13 x 8 1/2 in.
overall: 13 7/8 x 11 in.
95.28.9

*Navy Recruiting Station, Post Office – Butte, Montana*, 1956
Gelatin-silver print
image: 12 1/2 x 8 1/4 in.
overall: 13 7/8 x 11 in.
95.28.7

*Ranch Market – Hollywood*, 1956
Gelatin-silver print
image: 8 x 12 3/8 in.
overall: 11 x 13 7/8 in.
95.28.14

◊ *St. Francis, gas station and City Hall – Los Angeles*, 1956
Gelatin-silver print
image: 8 x 12 in.
overall: 11 x 13 7/8 in.
95.28.48
p.67

*San Francisco*, 1956
Gelatin-silver print
image: 13 1/4 x 8 7/8 in.
overall: 13 7/8 x 11 in.
95.28.72

*Television studio – Burbank, California*, 1956
Gelatin-silver print
image: 8 1/2 x 12 3/4 in.
overall: 11 x 13 7/8 in.
95.28.60

## LEE FRIEDLANDER

### FACTORY VALLEYS

◊ *AKRON, OHIO*, 1980
Silver print
image: 7 1/2 x 11 1/4 in.
overall: 11 x 14 in.
95.36.14
p.80

*CANTON, OHIO*, 1980
Silver print
image: 11 1/4 x 7 1/2 in.
overall: 14 x 11 in.
95.36.1

*CANTON, OHIO*, 1980
Silver print
image: 7 1/2 x 11 1/4 in.
overall: 11 x 14 in.
95.36.54

*CANTON, OHIO*, 1980
Silver print
image: 11 1/4 x 7 1/2 in.
overall: 14 x 11 in.
95.36.61

*CLEVELAND, OHIO*, 1980
Silver print
image: 7 1/2 x 11 1/4 in.
overall: 11 x 14 in.
95.36.44

*CLEVELAND, OHIO*, 1980
Silver print
image: 11 1/4 x 7 1/2 in.
overall: 14 x 11 in.
95.36.45

*PITTSBURGH, PENNSYLVANIA*, 1980
Silver print
image: 7 1/2 x 11 1/4 in.
overall: 11 x 14 in.
95.36.3

*PITTSBURGH, PENNSYLVANIA*, 1980
Silver print
image: 7 1/2 x 11 1/4 in.
overall: 11 x 14 in.
95.36.8

◊ *PITTSBURGH, PENNSYLVANIA*, 1980
Silver print
image: 7 1/2 x 11 1/4 in.
overall: 11 x 14 in.
95.36.23
p.80

*PITTSBURGH, PENNSYLVANIA*, 1980
Silver print
image: 7 1/2 x 11 1/4 in.
overall: 11 x 14 in.
95.36.33

### FLOWERS AND TREES

*Untitled, Hudson Valley, New York*, 1976
Gelatin-silver print
image: 7 1/2 x 11 1/4 in.
overall: 11 x 14 in.
95.33.25

*Untitled, New City, New York*, 1976
Gelatin-silver print
image: 11 1/4 x 7 1/2 in.
overall: 14 x 11 in.
95.33.27

*Untitled, Washington, D.C.*, 1976
Gelatin-silver print
image: 11 1/4 x 7 1/2 in.
overall: 14 x 11 in.
95.33.17

*Untitled, Berkeley, California*, 1977
Silver print
image: 7 1/2 x 11 1/4 in.
overall: 11 x 14 in.
95.33.32

*Untitled, Crarryville, New York*, 1977
Silver print
image: 11 1/4 x 7 1/2 in.
overall: 14 x 11 in.
95.33.13

*Untitled, Honolulu, Hawaii*, 1977
Silver print
image: 11 1/4 x 7 1/2 in.
overall: 14 x 11 in.
95.33.39

### LEE FRIEDLANDER: PHOTOGRAPHS

◊ *Portland, Maine*, 1962
Silver print
image: 7 3/8 x 11 1/8 in.
overall: 11 x 14 in.
95.32.22
p.81

◊ *Cincinnati, Ohio*, 1963
Silver print
image: 11 x 7 3/8 in.
overall: 14 x 11 in.
95.32.1
p.84

*New York City*, 1963
Silver print
image: 7 1/2 x 11 1/8 in.
overall: 11 x 14 in.
95.32.9

◊ *New York City*, 1963
Silver print
image: 7 1/8 x 10 3/4 in.
overall: 11 x 14 in.
95.32.13
p.85

◊ *Denver, Colorado*, 1965
Silver print
image: 7 3/8 x 11 1/8 in.
overall: 11 x 14 in.
95.32.20
p.82

◊ *New York City*, 1965
Silver print
image: 7 1/2 x 11 1/8 in.
overall: 11 x 14 in.
95.32.14
p.2

◊ *New York City*, 1966
Silver print
image: 7 3/8 x 11 1/8 in.
overall: 11 x 14 in.
95.32.31
p.83

◊ *New Orleans, Louisiana*, 1968
Silver print
image: 7 3/8 x 11 1/8 in.
overall: 11 x 14 in.
95.32.67
p.155

*Mobile, Alabama*, 1969
Silver print
image: 7 3/8 x 11 1/8 in.
overall: 11 x 14 in.
95.32.77

◊ *Route 9W, New York*, 1969
Silver print
image: 7 1/2 x 11 1/4 in.
overall: 11 x 14 in.
95.32.63
p.88

◊ *Butte, Montana*, 1970
Silver print
image: 7 3/8 x 11 1/8 in.
overall: 11 x 14 in.
95.32.82
p.89

*Hillcrest, New York*, 1970
Silver print
image: 7 3/8 x 11 in.
overall: 11 x 14 in.
95.32.71

◊ *Bellows Falls, Vermont*, 1971
Silver print
image: 7 3/8 x 11 1/8 in.
overall: 11 x 14 in.
95.32.86
p.35

*New York City*, 1971
Silver print
image: 7 3/8 x 11 1/8 in.
overall: 11 x 14 in.
95.32.58

*Aspen, Colorado*, 1972
Silver print
image: 6 3/4 x 10 1/4 in.
overall: 11 x 14 in.
95.32.74

◊ *Los Angeles, California*, 1972
Silver print
image: 7 3/8 x 11 1/4 in.
overall: 11 x 14 in.
95.32.117
p.86

*Putney, Vermont*, 1972
Silver print
image: 7 3/8 x 11 1/8 in.
overall: 11 x 14 in.
95.32.134

◊ *St. Louis, Missouri*, 1972
Silver print
image: 7 1/2 x 11 1/4 in.
overall: 11 x 14 in.
95.32.88
p.87

*Arches National Park, Utah*, 1974
Silver print
image: 7 1/2 x 11 1/8 in.
overall: 11 x 14 in.
95.32.96

*Spokane, Washington*, 1974
Silver print
image: 7 3/8 x 11 1/8 in.
overall: 11 x 14 in.
95.32.66

*Cambridge, Massachusetts*, 1975
Silver print
image: 11 1/4 x 7 1/2 in.
overall: 14 x 11 in.
95.32.112

### LEE FRIEDLANDER: SELF PORTRAIT

*Spain 1964*, 1964
Silver print
image: 7 1/2 x 11 1/4 in.
overall: 11 x 14 in.
95.29.6

*Philadelphia, Pennsylvania 1965*, 1965
Silver print
image: 7 1/2 x 11 1/4 in.
overall: 11 x 14 in.
95.29.17

*Southern United States 1966*, 1966
Silver print
image: 7 1/2 x 11 1/4 in.
overall: 11 x 14 in.
95.29.7

◊ *Aloha, Washington 1967*, 1967
Silver print
image: 7 1/2 x 11 1/4 in.
overall: 11 x 14 in.
95.29.37
p.86

◊ *Colorado 1967*, 1967
Silver print
image: 7 1/2 x 11 1/4 in.
overall: 11 x 14 in.
95.29.11
p.34

*Louisiana 1968*, 1968
Silver print
image: 7 1/2 x 11 1/4 in.
overall: 11 x 14 in.
95.29.25

*Westport, Connecticut 1968*, 1968
Silver print
image: 11 1/4 x 7 1/2 in.
overall: 14 x 11 in.
95.29.27

THE AMERICAN
MONUMENT

*Bunker Hill Monument and Statue of William Prescott. Boston, Massachusetts*, 1974
Silver print
image: 11 1/8 x 7 1/2 in.
overall: 14 x 11 in.
95.31.6

*Chief Massasoit. Salt Lake City, Utah*, 1974
Silver print
image: 7 x 11 1/4 in.
overall: 11 x 14 in.
95.31.60

*Civil War Seacoast Mortar. Saint Augustine, Florida*, 1974
Silver print
image: 7 1/2 x 11 1/4 in.
overall: 11 x 14 in.
95.31.93

*Dorr I. Sprague, First From Battleboro to Die in World War I. Battleboro, Vermont*, 1974
Silver print
image: 7 1/2 x 11 1/4 in.
overall: 11 x 14 in.
95.31.130

◊ *Doughboy. Stamford, Connecticut*, 1974
Silver print
image: 7 1/2 x 11 1/4 in.
overall: 11 x 14 in.
95.31.149
p.90

◊ *Father Duffy. Times Square, New York, New York*, 1974
Silver print
image: 7 1/2 x 11 1/4 in.
overall: 11 x 14 in.
95.31.115
p.90

*Hungry Horse Clearing Ball. Flathead National Forest, Montana*, 1974
Silver print
image: 7 1/2 x 11 1/4 in.
overall: 11 x 14 in.
95.31.89

*In Honor of Those Who Served. Watertown, New York*, 1974
Silver print
image: 11 1/4 x 7 1/2 in.
overall: 14 x 11 in.
95.31.47

*J. S. T. Stranahan and Memorial Arch. Grand Army Plaza, Brooklyn, New York*, 1974
Silver print
image: 11 1/4 x 7 1/2 in.
overall: 14 x 11 in.
95.31.203

*Little Round Top. Gettysburg National Military Park*, 1974
Silver print
image: 7 1/2 x 11 1/4 in.
overall: 11 x 14 in.
95.31.179

◊ *Mount Rushmore. South Dakota*, 1969
Silver print
image: 7 1/2 x 11 1/4 in.
overall: 11 x 14 in.
95.31.99
p.91

*Order of Elks Cemetery, Greenwood Cemetery. New Orleans, Louisiana*, 1973
Silver print
image: 11 1/4 x 7 1/2 in.
overall: 14 x 11 in.
95.31.52

*Site of the First Mormon Sunday School. Salt Lake City, Utah*, 1974
Silver print
image: 7 1/2 x 11 1/4 in.
overall: 11 x 14 in.
95.31.124

*Sixth and Fortieth Iowa Regiments. Vicksburg National Military Park*, 1974
Silver print
image: 11 1/4 x 7 1/2 in.
overall: 14 x 11 in.
95.31.161

*War Dead. Bellevue, Idaho*, 1974
Silver print
image: 11 x 7 1/2 in.
overall: 14 x 11 in.
95.31.83

*William Harris Hardy. Gulfport, Mississippi*, 1974
Silver print
image: 7 1/2 x 11 1/4 in.
overall: 11 x 14 in.
95.31.115

*Spirit of the American Doughboy. Saint Albans, Vermont*, 1975
Silver print
image: 7 1/2 x 11 1/4 in.
overall: 11 x 14 in.
95.31.159

**HELEN LEVITT**

A WAY OF SEEING

*Gypsy N.Y.*, c. 1942
Silver print
image: 10 7/8 x 8 1/4 in.
overall: 14 x 11 in.
95.41.42

*Bronx, N.Y.*, c. 1942
Silver print
image: 6 3/4 x 9 1/2 in.
overall: 11 x 14 in.
95.41.55

◊ *N.Y.*, c. 1942
Silver print
image: 7 1/2 x 9 1/2 in.
overall: 11 x 14 in.
95.41.1
p.95

*N.Y.*, c. 1942
Silver print
image: 7 7/8 x 4 3/8 in.
overall: 14 x 11 in.
95.41.4

◊ *N.Y.*, c. 1942
Silver print
image: 7 1/2 x 11 in.
overall: 11 x 14 in.
95.41.7
p.97

◊ *N.Y.*, c. 1942
Silver print
image: 2 1/2 x 9 5/8 in.
overall: 11 x 14 in.
95.41.8
p.99

*N.Y.*, c. 1942
Silver print
image: 10 1/4 x 6 3/4 in.
overall: 14 x 11 in.
95.41.9

*N.Y.*, c. 1942
Silver print
image: 11 1/4 x 7 3/4 in.
overall: 14 x 11 in.
95.41.14

◊ *N.Y.*, c. 1942
Silver print
image: 10 3/8 x 7 in.
overall: 14 x 11 in.
95.41.19
p.102

*N.Y.*, c. 1942
Silver print
image: 11 1/8 x 7 1/2 in.
overall: 14 x 11 in.
95.41.21

*N.Y.*, c. 1942
Silver print
image: 6 1/2 x 9 1/4 in.
overall: 11 x 14 in.
95.41.24

*N.Y.*, c. 1942
Silver print
image: 6 5/8 x 9 1/2 in.
overall: 11 x 14 in.
95.41.27

◊ *N.Y.*, c. 1942
Silver print
image: 9 x 6 1/4 in.
overall: 14 x 11 in.
95.41.32
p.96

*N.Y.*, c. 1942
Silver print
image: 10 x 6 3/8 in.
overall: 14 x 11 in.
95.41.36

*N.Y.*, c. 1942
Silver print
image: 6 1/8 x 9 1/4 in.
overall: 11 x 14 in.
95.41.37

◊ *N.Y.*, c. 1942
Silver print
image: 10 1/4 x 11 1/4 in.
overall: 11 x 14 in.
95.41.39
p.98

*N.Y.*, c. 1942
Silver print
image: 7 1/8 x 9 3/8 in.
overall: 11 x 14 in.
95.41.41

*N.Y.*, c. 1942
Silver print
image: 6 3/4 x 9 1/2 in.
overall: 11 x 14 in.
95.41.43

◊ *N.Y.*, c. 1942
Silver print
image: 7 1/2 x 11 1/8 in.
overall: 11 x 14 in.
95.41.45
p.103

*N.Y.*, c. 1942
Silver print
image: 7 5/8 x 10 1/4 in.
overall: 11 x 14 in.
95.41.53

*N.Y.*, c. 1942
Silver print
image: 7 1/2 x 11 1/8 in.
overall: 11 x 14 in.
95.41.56

◊ *N.Y.*, c. 1942
Silver print
image: 6 3/4 x 10 3/8
overall: 11 x 14 in.
95.41.59
p.101

*N.Y.*, c. 1942
Silver print
image: 6 1/2 x 10 in.
overall: 11 x 14 in.
95.41.62

◊ *N.Y.*, c. 1942
Silver print
image: 5 1/2 x 8 3/8 in.
overall: 11 x 14 in.
95.41.68
p.103

*N.Y.*, c. 1945
Silver print
image: 10 1/4 x 6 3/4 in.
overall: 14 x 11 in.
95.41.13

◊ *N.Y.*, c. 1945
Silver print
image: 12 x 8 in.
overall: 14 x 11 in.
95.41.15
p.94

◊ *N.Y.*, c. 1945
Silver print
image: 7 x 10 1/4 in.
overall: 11 x 14 in.
95.41.17
p.95

*N.Y.*, c. 1945
Silver print
image: 7 1/8 x 11 1/8 in.
overall: 11 x 14 in.
95.41.18

*N.Y.*, c. 1945
Silver print
image: 9 3/4 x 7 in.
overall: 14 x 11 in.
95.41.23

*N.Y.*, c. 1945
Silver print
image: 7 3/4 x 11 3/4 in.
overall: 11 x 14 in.
95.41.51

◊ *N.Y.*, c. 1945
Silver print
image: 10 1/2 x 7 in.
overall: 14 x 11 in.
95.41.52
p.100

**DANNY LYON**

CONVERSATIONS WITH THE DEAD

*Untitled*, 1967-69
Silver print
image: 8 x 12 in.
overall: 11 x 14 in.
95.43.2

*Untitled*, 1967-69
Silver print
image: 11 3/4 x 8 in.
overall: 14 x 11 in.
95.43.6

◊ *Untitled*, 1967-69
Silver print
image: 8 x 12 in.
overall: 11 x 14 in.
95.43.7
p.157

◊ *Untitled*, 1967-69
Silver print
image: 8 x 12 in.
overall: 11 x 14 in.
95.43.8
p.107

◊ *Untitled*, 1967-69
Silver print
image: 11 3/4 x 8 in.
overall: 14 x 11 in.
95.43.11
p.106

*Untitled*, 1967-69
Silver print
image: 8 x 12 in.
overall: 11 x 14 in.
95.43.13

*Untitled*, 1967-69
Silver print
image: 8 x 12 in.
overall: 11 x 14 in.
95.43.15

◊ *Untitled*, 1967-69
Silver print
image: 8 x 12 in.
overall: 11 x 14 in.
95.43.17
p.109

◊ *Untitled*, 1967-69
Silver print
image: 8 x 12 in.
overall: 11 x 14 in.
95.43.19
p.108

*Untitled*, 1967-69
Silver print
image: 8 x 12 in.
overall: 11 x 14 in.
95.43.25

*Untitled*, 1967-69
Silver print
image: 8 x 12 in.
overall: 11 x 14 in.
95.43.28

*Untitled*, 1967-69
Silver print
image: 11 3/4 x 8 in.
overall: 14 x 11 in.
95.43.29

*Untitled*, 1967-69
Silver print
image: 8 x 12 in.
overall: 11 x 14 in.
95.43.39

*Untitled*, 1967-69
Silver print
image: 8 x 12 in.
overall: 11 x 14 in.
95.43.46

*Untitled*, 1967-69
Silver print
image: 8 x 12 in.
overall: 11 x 14 in.
95.43.49

*Untitled*, 1967-69
Silver print
image: 11 3/4 x 8 in.
overall: 11 x 14 in.
95.43.57

*Untitled*, 1967-69
Silver print
image: 8 x 12 in.
overall: 11 x 14 in.
95.43.62

*Untitled*, 1967-69
Silver print
image: 8 x 12 in.
overall: 11 x 14 in.
95.43.66

*Untitled*, 1967-69
Silver print
image: 8 x 12 in.
overall: 11 x 14 in.
95.43.75

THE BIKERIDERS

◊ *Untitled*, 1962
Silver print
image: 8 1/2 x 12 3/4 in.
overall: 11 x 14 in.
95.42.4
p.110

*Untitled*, 1964
Silver print
image: 12 1/2 x 8 1/2 in.
overall: 14 x 11 in.
95.42.12

*Untitled*, 1964
Silver print
image: 8 1/2 x 12 3/4 in.
overall: 11 x 14 in.
95.42.17

◊ *Untitled*, 1965
Silver print
image: 12 3/4 x 8 1/2 in.
overall: 14 x 11 in.
95.42.5
p.111

◊ *Untitled*, 1965
Silver print
image: 12 1/2 x 8 1/2 in.
overall: 14 x 11 in.
95.42.38
p.111

◊ *Untitled*, 1966
Silver print
image: 8 1/2 x 12 3/4 in.
overall: 11 x 14 in.
95.42.10
p.112

*Untitled*, 1966
Silver print
image: 8 1/2 x 12 3/4 in.
overall: 11 x 14 in.
95.42.16

*Untitled*, 1966
Silver print
image: 9 3/4 x 12 1/2 in.
overall: 11 x 14 in.
95.42.18

*Untitled*, 1966
Silver print
image: 12 1/2 x 8 1/2 in.
overall: 14 x 11 in.
95.42.21

*Untitled*, 1966
Silver print
image: 8 1/2 x 12 3/4 in.
overall: 11 x 14 in.
95.42.27

*Untitled*, 1966
Silver print
image: 12 1/2 x 8 1/2 in.
overall: 14 x 11 in.
95.42.29

*Untitled*, 1966
Silver print
image: 12 3/4 x 8 1/2 in.
overall: 14 x 11 in.
95.42.31

*Untitled*, 1966
Silver print
image: 8 1/2 x 12 3/4 in.
overall: 11 x 14 in.
95.42.39

*Untitled*, 1966
Silver print
image: 12 3/4 x 8 1/2 in.
overall: 14 x 11 in.
95.42.40

*Untitled*, 1966
Silver print
image: 12 3/4 x 8 1/2 in.
overall: 14 x 11 in.
95.42.42

◊ *Untitled*, 1966
Silver print
image: 8 1/2 x 12 3/4 in.
overall: 11 x 14 in.
95.42.44
p.113

◊ *Untitled*, 1966
Silver print
image: 8 1/2 x 12 3/4 in.
overall: 11 x 14 in.
95.42.47
p.112

*Untitled*, 1966
Silver print
image: 8 1/2 x 12 3/4 in.
overall: 11 x 14 in.
95.42.48

*Untitled*, 1967
Silver print
image: 9 1/2 x 9 3/4 in.
overall: 11 x 14 in.
95.42.33

**ROGER MERTIN**

PLASTIC LOVE DREAMS

◊ *Untitled*, 1968
Silver print
image: 7 1/2 x 11 1/4 in.
overall: 11 x 14 in.
95.45.26
p.116

◊ *Untitled*, 1969
Silver print
image: 7 1/2 x 11 1/4 in.
overall: 11 x 14 in.
95.45.8
p.117

ROGER MERTIN:
RECORDS

*Hailey, Idaho*, 1976
Silver print
image: 8 x 10 in.
overall: 8 x 10 in.
95.46.3

*Conesus Lake, New York*,
1977
Silver print
image: 8 x 10 in.
overall: 8 x 10 in.
95.46.17

◊ *Holcomb, New York*, 1977
Silver print
image: 8 x 10 in.
overall: 8 x 10 in.
95.46.15
p.119

*Lake Road, New York
Roadside*, 1977
Silver print
image: 8 x 10 in.
overall: 8 x 10 in.
95.46.44

◊ *Laurie, Bridgehampton,
New York*, 1977
Silver print
image: 8 x 10 in.
overall: 8 x 10 in.
95.46.28
p.121

*M. Mendon Ponds*, 1977
Silver print
image: 8 x 10 in.
overall: 8 x 10 in.
95.46.26

◊ *New York State*, 1977
Silver print
image: 8 x 10 in.
overall: 8 x 10 in.
95.46.11
p.118

◊ *Pennsylvania Roadside*, 1977
Silver print
image: 8 x 10 in.
overall: 8 x 10 in.
95.46.16
p.123

*Poultneyville Orchard*, 1977
Silver print
image: 8 x 10 in.
overall: 8 x 10 in.
95.46.36

*Poultneyville Orchard*, 1977
Silver print
image: 8 x 10 in.
overall: 8 x 10 in.
95.46.41

◊ *Poultneyville Orchard*, 1977
Silver print
image: 8 x 10 in.
overall: 8 x 10 in.
95.46.43
p.122

◊ *Sandi, Plum Island*, 1977
Silver print
image: 8 x 10 in.
overall: 8 x 10 in.
95.46.25
p.120

◊ *Stratford, Connecticut*,
1977
Silver print
image: 8 x 10 in.
overall: 8 x 10 in.
95.46.35
p.122

*Stratford, Connecticut*, 1977
Silver print
image: 8 x 10 in.
overall: 8 x 10 in.
95.46.34

◊ *Sylvan Lake*, 1977
Silver print
image: 7 3/4 x 8 3/4 in.
overall: 8 x 10 in.
95.46.9
p.118

*Webster, New York*, 1977
Silver print
image: 8 x 10 in.
overall: 8 x 10 in.
95.46.6

*Untitled*, 1977
Silver print
image: 8 x 10 in.
overall: 8 x 10 in.
95.46.30

**JOHN PFAHL**

ARCADIA REVISITED

◊ *Amusement Area in Niagara
Falls, Ontario*, 1985
Color coupler print
image: 12 1/2 x 18 1/4 in.
overall: 16 x 20 in.
95.50.35
p.126

*Electric Plant from Beaver
Island*, 1985
Color coupler print
image: 13 1/2 x 18 1/4 in.
overall: 16 x 20 in.
95.50.22

◊ *Untitled*, 1963
Silver print
image: 8 5/8 x 12 7/8 in.
overall: 11 x 14 in.
95.53.10
p.20

*Untitled*, 1963
Silver print
image: 8 3/4 x 13 1/8 in.
overall: 11 x 14 in.
95.53.16

◊ *Untitled*, c. 1963
Silver print
image: 8 5/8 x 12 7/8 in.
overall: 11 x 14 in.
95.53.18
p.141

*Untitled*, c. 1963
Silver print
image: 8 3/4 x 13 in.
overall: 11 x 14 in.
95.53.24

*Untitled*, c. 1963
Silver print
image: 8 3/4 x 13 in.
overall: 11 x 14 in.
95.53.26

WOMEN ARE BEAUTIFUL

◊ *World's Fair, N.Y.*, 1964
Gelatin–silver print
image: 8 3/4 x 13 in.
overall: 11 x 14 in.
95.55.20
p.145

◊ *Untitled*, 1964–75
Gelatin–silver print
image: 8 3/4 x 13 in.
overall: 11 x 14 in.
95.55.7
p.146

*Untitled*, 1964–75
Gelatin–silver print
image: 8 3/4 x 13 in.
overall: 11 x 14 in.
95.55.8

*Untitled*, 1964–75
Gelatin–silver print
image: 8 3/4 x 13 in.
overall: 11 x 14 in.
95.55.16

*Untitled*, 1964–75
Gelatin–silver print
image: 8 3/4 x 13 in.
overall: 11 x 14 in.
95.55.19

*Untitled*, 1964–75
Gelatin–silver print
image: 8 3/4 x 13 in.
overall: 11 x 14 in.
95.55.24

◊ *Untitled*, 1964–75
Gelatin–silver print
image: 8 3/4 x 13 in.
overall: 11 x 14 in.
95.55.28
p.33

*Untitled*, 1964–75
Gelatin–silver print
image: 13 x 8 3/4 in.
overall: 14 x 11 in.
95.55.30

◊ *Untitled*, 1964–75
Gelatin–silver print
image: 8 3/4 x 13 in.
overall: 11 x 14 in.
95.55.35
p.144

*Untitled*, 1964–75
Gelatin–silver print
image: 8 3/4 x 13 in.
overall: 11 x 14 in.
95.55.37

◊ *Untitled*, 1964–75
Gelatin–silver print
image: 13 x 8 3/4 in.
overall: 14 x 11 in.
95.55.43
p.153

*Untitled*, 1964–75
Gelatin–silver print
image: 8 3/4 x 13 in.
overall: 11 x 14 in.
95.55.52

◊ *Untitled*, 1964–75
Gelatin–silver print
image: 8 3/4 x 13 in.
overall: 11 x 14 in.
95.55.63
p.146

◊ *Untitled*, 1964–75
Gelatin–silver print
image: 8 7/8 x 13 1/8 in.
overall: 11 x 14 in.
95.55.69
p.143

◊ *Untitled*, 1964–75
Gelatin–silver print
image: 8 3/4 x 13 in.
overall: 11 x 14 in.
95.55.72
p.142

*Untitled*, 1964–75
Gelatin–silver print
image: 8 3/4 x 13 1/4 in.
overall: 11 x 14 in.
95.55.73

*London*, 1967
Gelatin–silver print
image: 13 x 8 3/4 in.
overall: 14 x 11 in.
95.55.31

◊ *New York*, 1968
Gelatin–silver print
image: 8 3/4 x 13 in.
overall: 11 x 14 in.
95.55.85
p.147

*Untitled*, 1968
Gelatin–silver print
image: 8 3/4 x 13 in.
overall: 11 x 14 in.
95.55.64

◊ *Untitled*, 1969
Gelatin–silver print
image: 8 3/8 x 13 in.
overall: 11 x 14 in.
95.55.81
p.22

◊ *London*, c. 1975
Gelatin–silver print
image: 8 3/4 x 13 in.
overall: 11 x 14 in.
95.55.56
p.142

# FURTHER READING

Compiled by Rebecca Morse

Within the critical literature of photography, the terms "documentary" and "social documentary" are often used interchangeably and, whenever possible, we have attempted to be inclusive of that discourse within this bibliography. Also cited are relevant articles that suggest the contemporary manifestation of a documentary photographic practice, often referred to as the "new documentary."

*12 Photographers of the American Social Landscape.* Exh. cat. Waltham, Mass.: Rose Art Museum, Brandeis University, 1967. Essay by Thomas H. Garver.

Beloff, Halla. "Social Interaction in Photographing." *Leonardo* 16, no. 1 (Summer 1983): 165-171.

Burgin, Victor. "Photographic Practice and Art Theory." *Studio International* 190, no. 976 (July/August 1975): 39-51.

————. "Photography, Phantasy, Function." In *Thinking Photography*, edited by Burgin, 177-216. London: Macmillan Press, 1982.

Chevrier, Jean-François. *Walker Evans & Dan Graham.* Exh. cat. Rotterdam, The Netherlands: Witte de With; and New York: Whitney Museum of American Art, 1992. Texts by Chevrier, Allan Sekula, and Benjamin H.D. Buchloh.

Crimp, Douglas. "Photographs at the End of Modernsim." In Crimp, *On the Museum's Ruins*, 2-31. Cambridge, Mass.: The MIT Press, 1993.

————. "The Museum's Old, the Library's New Subject." In Crimp, *On the Museum's Ruins*, 66-83. Cambridge, Mass.: The MIT Press, 1993.

Crump, James. "Quasi-Documentary: Evolution of a Photographic Style." *New Art Examiner* 23, no. 7 (March 1996): 22-28.

Curtis, James. *Mind's Eye, Mind's Truth: FSA Photography Reconsidered.* Philadelphia: Temple University Press, 1989.

*Documentary Photography.* New York: Time-Life Books, 1972.

Doherty, Robert J. *Social-documentary Photography in the USA.* Garden City, N.Y.: American Photographic Book Publishing Co., Inc., 1976.

Friedlander, Lee. "Portfolios." *Contemporary Photographer* 4, no. 4 (Fall 1963): 13.

Gibbs, Michael. "Documentary and Its Discontents." *Perspektief (Hemaandelijks Tijdschrift Voor Fotografie),* no. 23 (January-March 1986): 4-9.

Grundberg, Andy. "Photos That Lie." *Modern Photography* 24, no. 5 (May 1978): 102-107.

Hagen, Charles. *American Photographers of the Depression: Farm Security Administration Photographs, 1935-1942.* New York: Pantheon Books, 1982.

Jackson, J.B. "The Social Landscape." In *The Essential Landscape: The New Mexico Photographic Survey*, edited by Steven A. Yates, 45-48. Albuquerque: The University of New Mexico Press, 1985.

*Just Before the War: Urban America from 1935 to 1941 as seen by Photographers of the Farm Security Administration.* Exh. cat. Balboa, Calif.: Newport Harbor Art Museum; and Washington, D.C.: The Library of Congress, 1968. Introduction by Thomas H. Garver; prefatory notes by Arthur Rothstein, John Vachon, and Roy Stryker.

Kester, Grant H. "Toward a New Social Documentary." *Afterimage* 14, no. 8 (March 1987): 10-14.

Kozloff, Max. "Photography." *The Nation* 204, no. 18 (1 May 1967): 571-573.

————. "The Uncanny Portrait: Sander, Arbus, Samaras." *Artforum* 11, no. 10 (June 1973): 58-66.

Lange, Dorothea. "Documentary Photography." In *Photographers on Photography: A Critical Anthology*, edited by Nathan Lyons, 67-68. Englewood Cliffs, N.J.: Prentice-Hall, 1966.

Livingston, Jane. *The New York School: Photographs, 1936-1963*, New York: Stewart, Tabori & Chang, Inc., 1992.

Lyons, Nathan, ed. *Toward a Social Landscape: Bruce Davidson, Lee Friedlander, Garry Winogrand, Danny Lyon, Duane Michals*. Exh. cat. Rochester, N.Y.: George Eastman House, 1966.

*Mirrors and Windows: American Photography since 1960*. Exh. cat. New York: The Museum of Modern Art, 1978. Essay by John Szarkowski.

Neumaier, Diane. "Post-documentary." *Afterimage* 11, no. 6 (January 1984): 15-17.

Nickel, Douglas R. "American Photographs Revisited." *American Art* (Spring 1992): 79.

Phillips, Christopher. "The Judgment Seat of Photography." In *The Contest of Meaning: Critical Histories of Photography*, edited by Richard Bolton, 15-46. Cambridge, Mass.: The MIT Press, 1989.

Rosler, Martha. "Lee Friedlander's Guarded Strategies." *Artforum* 13, no. 8 (April 1975): 46-53.

————— . "Some Contemporary Documentary." *Afterimage* 11, nos. 1 & 2 (Summer 1983): 13-15.

————— . "In, Around, and Afterthoughts (on Documentary Photography)." In *The Contest of Meaning: Critical Histories of Photography*, edited by Richard Bolton, 302-341. Cambridge, Mass.: The MIT Press, 1989.

Rothstein, Arthur. *Documentary Photography*. Stoneham, Mass.: Butterworth Publishers, 1986.

Sekula, Allan. "Dismantling Modernism, Reinventing Documentary (Notes on the Politics of Representation)." In *Photography Against the Grain: Essay and Photo Works 1973-1983*, edited by Benjamin H.D. Buchloh. Halifax: The Press of the Nova Scotia College of Art and Design, 1984.

————— . "On the Invention of a Photographic Meaning." In *Photography in Print: Writings from 1816 to the Present*, edited by Vicki Goldberg, 452-473. Albuquerque: University of New Mexico Press, 1994.

Solomon-Godeau, Abigail. "Photography After Art Photography." In *Art After Modernism: Rethinking Representation*, edited by Brian Wallis, 74-85. New York: The New Museum of Contemporary Art, 1984.

————— . "Who is speaking thus? Some Questions about Documentary Photography." In Solomon-Godeau, *Photography at the Dock: Essays on Photographic History, Institutions, and Practices*, 169-183. Minneapolis: The University of Minnesota Press, 1997.

Stange, Maren. "Documentary Photography in American Social Reform Movements: The FSA Project and its Predecessors." *Views* 5, no. 2 (Winter 1983-84): 9-14.

————— . *Symbols of Ideal Life: Social Documentary Photography in America, 1890-1950*. New York: Cambridge University Press, 1989.

Steichen, Edward. "The FSA Photographers." In *Photography: Essays & Images: Illustrated Readings in the History of Photography*, edited by Beaumont Newhall, 266-270. New York: The Museum of Modern Art, 1980.

Szarkowski, John. "Photography and Mass Media." *Aperture* 13, no. 3 (1967).

Tagg, John. "A Socialist Perspective on Photography." In *Three Perspectives on Photography: Recent British Photography*, 70-71. Exh. cat. London: Hayward Gallery, 1979.

————— . "Power and Photography." In *Culture, Ideology and Social Process: A Reader*, edited by Paul Hill, Angela Kelly, and Tagg. London: Arts Council of Great Britain, 1981.

————— . "The Currency of the Photograph." In *Thinking Photography*, edited by Victor Burgin, 110-141. London: Macmillan Press, 1982.

Thornton, Gene. "The New Photography: Turning Traditional Standards Upside Down." *ARTnews* 77, no. 4 (April 1978): 74-78.

Trachtenberg, Alan. "Walker Evans's Message from the Interior: A Reading." *October* (Winter 1979): 5-16.

————— . *Reading American Photographs: Images as History, Mathew Brady to Walker Evans*. New York: Hill and Wang, 1989.

Wall, Jeff. "'Marks of Indifference:' Aspects of Photography in, or as, Conceptual Art." In Ann Goldstein and Anne Rorimer, *Reconsidering the Object of Art: 1965-1975*, 246-267. Exh. cat. Los Angeles: The Museum of Contemporary Art, 1995.

Westerbeck, Colin, and Joel Meyerowitz. *Bystander: A History of Street Photography*. Boston: Little, Brown, and Co., 1994.